The
Extraordinary
Beauty
of
Birds

The Extraordinary Beauty of Birds

Designs, Patterns and Details

Photographs by Deborah Samuel
Texts by Mark Peck

PRESTEL
Munich · London · New York

In Memory of Graham E Todd

For Pat McCarthy

Contents

Why Birds Matter

NEIL PEART

The truth of the matter is, the birds could very well live without us, but many – perhaps all – of us would find life incomplete, indeed almost intolerable without the birds.

Roger Tory Peterson (1908-1996)

Roger Tory Peterson was an important naturalist and author of many field guides – and he was my first hero. As a boy of five, growing up in Southern Ontario, I became fascinated with birds – hawks, hummingbirds, cardinals, bluebirds, orioles, goldfinches, grackles. I still have a special affection for robins, our harbingers of spring, and perhaps most of all for chickadees, the cheery spirits of Canadian winter.

Birds appeared to me like miraculous flying jewels, with all the grace and splendour of tropical fish. I delighted in their flickering silhouettes, rhythmic wingbeats, and distinctive calls and songs – the rusty-hinge squeak of the red-winged blackbird as much as the mournful fluting of the hermit thrush. Birds made the suburban lawns and woodlands as lively and exotic as a coral reef. Around our yard or on weekend hikes in springtime I would seek out their nests, thrilled to climb high and peek at their eggs and young. Finding a dead bird along the roadside made me sad, but I would always pause to study its plumage.

My grandmother, Lena Louise Peart, taught me their names in her bird books, four little volumes with yellow, green, blue, and red covers. She let me learn to draw the different species with tracing paper, and almost sixty years later, the impressions of my pencil in those pages are still visible – for I have those books now.

In 1957, when I was five, the Red Rose tea company introduced collectible cards of 'Songbirds of North America'.

Written and mainly illustrated by Roger Tory Peterson, these cards were objects of great desire although, despite my urgings, Mom and Dad drank coffee, and Grandma and Mrs Pirie next door did not buy enough tea for me to collect all forty-eight. The promotional photographs of Roger Tory Peterson showed him in the field, wearing weather-proof clothes and holding big binoculars. I felt my first ambition: to be a professional birdwatcher.

Life carried me in different directions, into music and words, but I never lost that passion for birds – they have been a gift to me always and everywhere. My travels around the world can be traced by the row of field guides on my bookshelf: Birds of North America, South America, East Africa, West Africa, Europe, Asia, Hawaii, Tahiti, Barbados, and more.

So having established that 'context', when my eyes rest on these sumptuous still lifes created by Deborah Samuel, I feel instinctive love for the subject, yet a fresh delight, even awe, at the forms, colours, and miracles of design. The only word seems to be 'gorgeous'.

William S. Burroughs wrote: 'The object of art is to make the reader or viewer or listener aware of what he knows but doesn't know that he knows. This is doubly true of photography.'

While Deborah's images might remind me of why I admire the rakish sleekness of the cedar waxwing, her eye takes mine – and every other viewer's – to the splendour of a feather, an egg, an intricately woven nest. We may have seen these objects before, but we have not seen them with this level of insight and care in the focus, frame, and lighting. It is truly a rarefied array of the kind of beauty we didn't know we knew.

Admiring these images gave rise to a new thought. Perhaps when we try to create music, weave words, or capture visions with paint or lens, we are simply trying to make something as beautiful as nature.

The Extraordinary Beauty of Birds

DEBORAH SAMUEL

The Extraordinary Beauty of Birds is the latest chapter in
a photographic odyssey that began with *Passing*, continued into
Elegy, and is now further elaborated with these images from
the avian world. In the beginning, *Passing* was about the cycle of
life - its splendour, its persistence, its conclusion. *Elegy* proposed
a reflection on mortality that examined the translucent beauty to
be found in skeletal remains. Luminous images settled in a velvety
black darkness, a darkness that gained no purchase on their light.
Leonard Cohen once famously sang, 'There is a crack, a crack in
everything, that's how the light gets in'.

 After darkness comes the light. Metaphorically and
spiritually, birds have become the agents of that transition. In
their flight they break free of the earth, with all its complications
and anxiety, and soar above it in a realm closer to heaven. They are
symbols of freedom and harbingers of whatever lies above. In 1958,
Ferlin Husky sang, 'On the wings of a snow white dove . . . A sign
from above, on the wings of a dove'.

 Birds inspire us. Their flight is transfixing. They are
compelled by mysterious instincts to feats of migratory endurance
far beyond their size and apparent strength. Their beauty is
limitless and rare. When we are weighed down with worries and
burdens, they lift our spirits. In our dreams, the bird expresses the
possibility of escape - the desire for liberty. Who can forget the film
Birdman of Alcatraz, a story of a man whose tender care of birds
helped him survive in prison? Historically, women and men have
festooned themselves with feathers to enhance their beauty or
to represent strength or nobility. A white dove with an olive branch

has long been one of the most popular international symbols of peace. But of course birds have also been seen as agents of loss, deception, and even horror. Think of Edgar Allan Poe's poem 'The Raven' or Alfred Hitchcock's film *The Birds.* Birds seem to embody our deepest emotions - their flight can literally carry us away.

Birdwatching is an enormously popular hobby throughout the world. In the United States alone, it is estimated that there are approximately 48 million dedicated 'birders'. As Joseph Wood Krutch puts it, 'it is the joy that cannot be analysed'. Birdwatchers will travel long distances to sit in motionless, meditative silence, hoping to see a bird. And failure does not deter them. What is it that captivates them, that inspires such passionate devotion? Perhaps it is the simple idea that when birds fly up above our heads and off into the vast horizon, it is not only profoundly beautiful but an act of liberation, an expression of life's boundless possibilities.

These photographs of feathers and nests, eggs and birds are the soaring conclusion to a meditation on what it means to be alive, following an exploration of the meaning of death and its inevitable place in life. With these images we take off into the limitless potential of living - its beauty, its abstraction, its endless options. Many of the photographs are stunningly beautiful - like the one showing the downy white feathers of an Osprey or the topography of the Black Sicklebill. In the diptych of an American Robin Egg and Nest there is the architecture of all life in one powerful image. The feathered eye of an Osprey looks back at you as if to remind you that you are not alone.

The Extraordinary Beauty of Birds is a magnificent document, full of unexpected portraits and of abstract ideas personified through art. This is one photographer's journey to the light, a celebration of the beauty in life.

The Art and Science of a Museum Collection

MARK PECK

A museum's mandate is to collect, conserve and exhibit objects of historical, scientific and cultural interest and to communicate the value of these objects to the public. To achieve this goal, objects in the collection should become an integral part of a story, should spark the imagination of the visitor, and encourage learning and further study. The stories can be told in many different ways. Through the proper use of science and art we can encourage a greater understanding of the world around us. Within a museum, there are public spaces and galleries to exhibit the artefacts, but the vast majority of the objects often remain out of the public eye, in large collection rooms designed for research and study, carefully labelled and wisely organised.

The Ornithology collection at the Royal Ontario Museum (ROM) is subdivided into four sections: skins, skeletons, nests and eggs, and blood and tissue. The collection rooms are full of wonders, touched with sadness. There are 12,000 nests and eggs, 45,000 skeletons, 40,000 blood and tissue samples and over 140,000 stuffed bird skins lying on their backs, neatly organised according to their taxonomic relationships. They are hidden away on many shelves in numerous cabinets, protected from excessive light levels, heat, extreme humidity and potential insect pests. Some of the specimens were prepared over 200 years ago and more are added to the collection every month. The skins, skeletons, and nests and eggs have come to the museum from a variety of sources including faunal surveys, bequests from private collectors, research studies and, more recently, from window strikes and road kill.

Traditionally, research specimens are prepared differently from the taxidermic mounts seen in the public displays and

galleries. Egg sets are 'blown' to remove their yolks and whites and then placed carefully on a bed of cotton in a cardboard box just large enough to contain the fragile clutch. Skeletons are cleaned by using dermestid beetles (which feed on carcasses), given a final cleansing with soap and water and then placed, disarticulated, into small, covered labelled boxes. Bird skins are turned inside out, much of their flesh and some of the skeleton are removed, and they are then returned to their original size and shape, stuffed with cotton and sewn back up. First and foremost, the collections are for scientific research but they are also made available for artists, for educational tours and interested members of the public. The exquisite beauty of each specimen endures, and from the deaths of these marvellous creatures scientists can derive knowledge which is then shared with the museum's visitors. Artists can achieve something else - they can, in a sense, bring a specimen back to life. Through the artist's vision and skill, the wonder and beauty of a bird that may have been dead for 150 years is revived.

My first opportunity to work with Deborah Samuel came during her preparation for her 2012 *Elegy* exhibition at the museum, but I had heard of her achievements long before that. I have worked in the Ornithology Department of the ROM for over thirty years. My education had focussed primarily on zoology but included a strong interest in photography. As well as university, I had attended the photography programme at Sheridan College, one of Deborah's alma maters, a few years after she had graduated. She was already making a name for herself in portraiture and fashion photography and she was held up in our classes as an example of the photographer we should strive to be. Shortly thereafter I began my career at the ROM but I continued my interest in photography and examples of Deborah's work continually surfaced.

During *Elegy*, Deborah spent days photographing skeletons in the collection room, immersing herself in her work but taking careful note of the skins, nests and eggs that were being researched and curated around her. During her breaks she toured the collections, learning about particular species or specimens that caught her interest. Her work continued for several weeks until *Elegy* had been completed. She went home to Santa Fe, New Mexico but came back

several months later, returned to the collection room and began taking photographs

The results are stunning. Deborah's wonderful images, rooted both in art and science, provide stimulation for both the left and right side of our brains and bring a fresh perspective and meaning to the beauty of evolution. Her skill as a photographer brings out the splendour of the simple feather, the sensuality that bursts from the 'eyelashes' of the Black Sicklebill, or the aerial ballet of the Tree Swallow, and the subtleties and complexities of the modest bird egg. The extraordinary patterns of colour and design inherent in birds are isolated and brought into sharp focus. She engages with viewers, challenging them to look closer and re-evaluate what they see. Her connection to nature gives us a far greater appreciation of the avian world and helps us to better connect with our extraordinary fellow creatures.

King Bird-of-paradise

Makira Starling

Copper Pheasant

Emu

Chipping Sparrow

Black Sicklebill

Reeve's Pheasant

Blue Jay

King of Saxony Bird-of-paradise

King of Holland Bird-of-paradise

Common Scimitar-bill

Common or European Starling

Resplendent Quetzal

Blue-winged Teal

Eastern Wood-pewee

Cedar Waxwing

American Woodcock

American Tree Sparrow

American Crow

Crimson Topaz

Red Knot

Baltimore Oriole

Mountain Bluebird

Great Argus

Hooded Pita

Indian Peafowl

Black-billed Magpie

Great Horned Owl

Mourning Dove

Rose-breasted Grosbeak

Satyr Tragopan

Southern Masked Weaver

Scarlet Ibis

Greater Rhea

Ostrich

Golden Pheasant

Rusty Blackbird

Common or Ring-necked Pheasant

Fork-tailed Flycatcher

Vervain Hummingbird

Greater Bird-of-paradise

Great Grey Owl

Two-barred or White-winged Crossbill

Scissor-tailed Flycatcher

Wild Turkey

Western Crested
Guineafowl

Common Murre

Brown-headed
Cowbird

Himalayan Monal

Long-tailed
Sylph

Osprey

Magnificent
Bird-of-paradise

Superb
Bird-of-paradise

Yellow-billed Cuckoo

American
Redstart

New Zealand Scaup

White
Bellbird

Hyacinth Macaw

Olive-backed
Sunbird

Wilson's Bird-of-paradise

Ruby-throated
Hummingbird

Domestic Duck

Southern Brown
Kiwi

Superb Lyrebird

Cooper's
Hawk

Least Flycatcher

Guianan Cock-of-the-rock

Golden-winged
Warbler

Mute Swan

Tree Swallow

Razorbill

Grey
Junglefowl

Willow Flycatcher

Shaft-tailed
Whydah

Sharp-
shinned Hawk

American Robin

Greater Racket-
tailed Drongo

Long-tailed
Duck

Bald Eagle

Red-billed
Blue Magpie

Blue and Yellow
Macaw

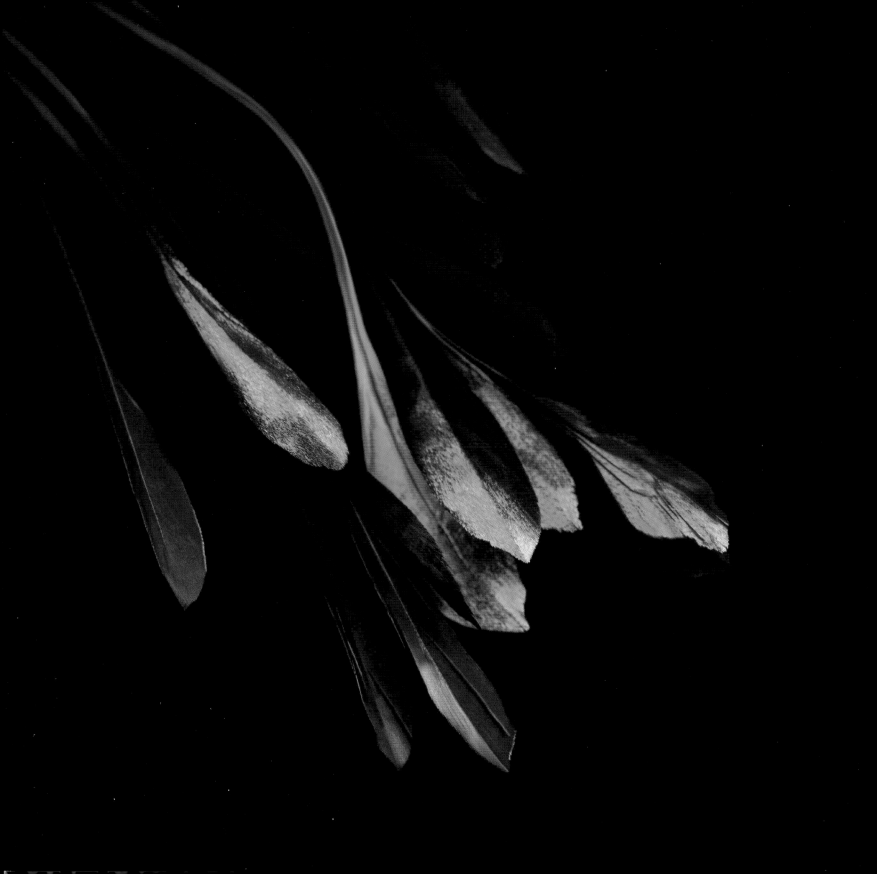

Himalayan Monal

PREVIOUS PAGE

The three monal species are among the most striking and iridescent of all pheasants. The Himalayan Monal, the national bird of Nepal, has a dazzling metallic green head crest, which is absent in the other species. The neck feathers are a shimmering copper, the back a glossy metallic blue, and the breast and belly a lustrous black. Its rufous tail is the only part of its plumage lacking an iridescent sparkle.

Great Argus

Eyespots (ocelli) are found on many different animals including insects, fish, reptiles, mammals and birds. Examples in birds include those on the tail of the peacock, the wings of the Sunbittern, the head of Pygmy-owls and the wing of the male Great Argus. Each secondary flight feather on a male may have between ten and twenty-five ocelli on the outer vane, running vertically along the rachis. Ocelli are thought to be a form of mimicry in some animals or may play a role in courtship and communication as is probably the case in peafowl and the Great Argus.

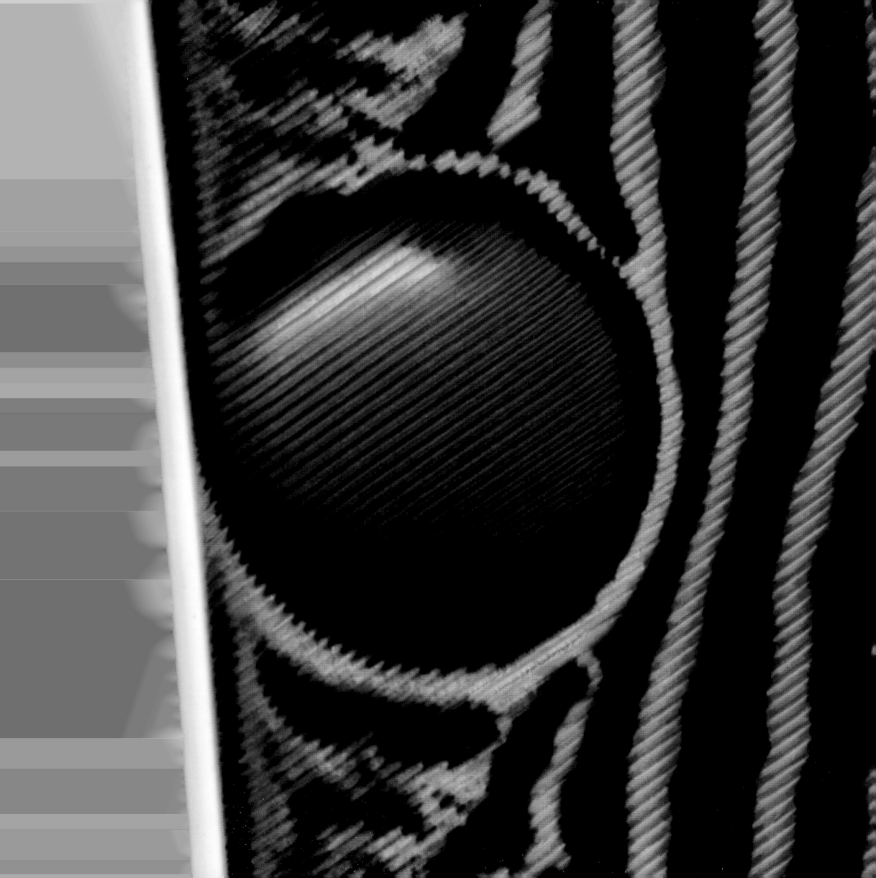

Cedar Waxwing

Cedar waxwings are found throughout most of North and Central America, with the exception of the Arctic. They are frugivores (fruit eaters) but supplement their sugary diet with insects during the summer breeding season. There are three species of waxwings throughout the world, and all have silky, shiny feathering, a short crest and a striking black mask. During the winter, waxwings congregate in large flocks and move around the country, foraging for berries.

———

Black Sicklebill

NEXT SPREAD

With its striking plumage, the Black Sicklebill provides one of the finest examples of sexual selection in birds. Sicklebills belong to the Bird-of-paradise family found in Papua New Guinea and northern Australia. In most members of the family, males are polygamous, and the selection by females of the 'biggest and brightest' has led to more elaborate and gaudy plumage evolving over time. The erectile black and iridescent blue pectoral feathers emanate from the sides of the breast and are raised around and behind the back of the head during courtship displays.

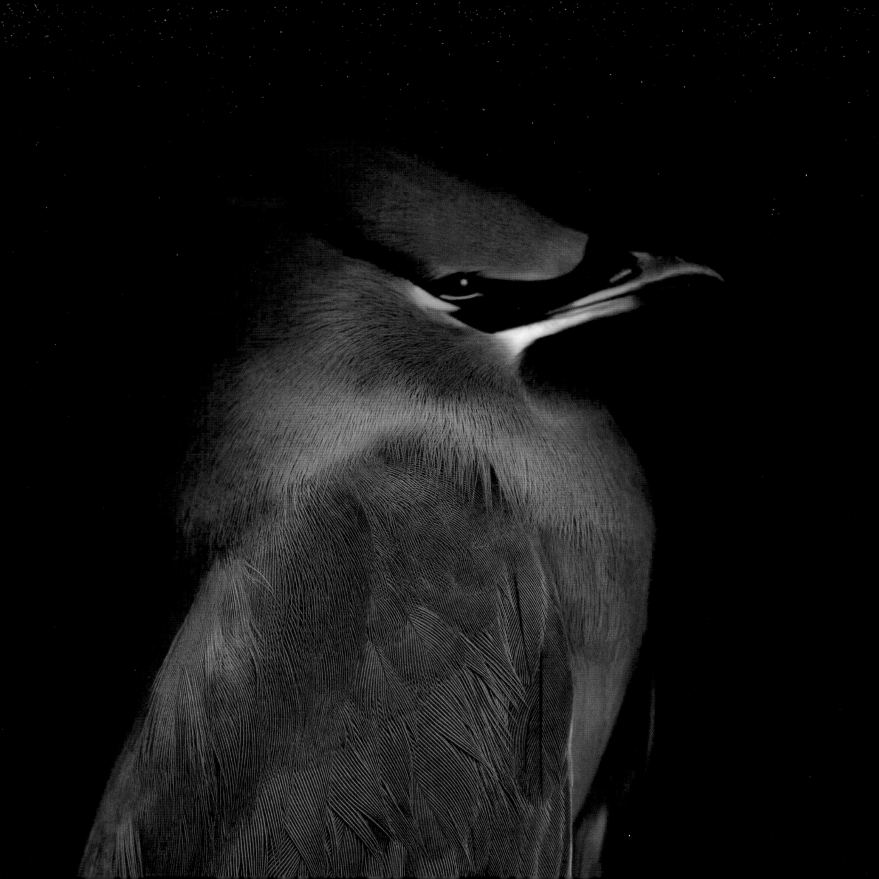

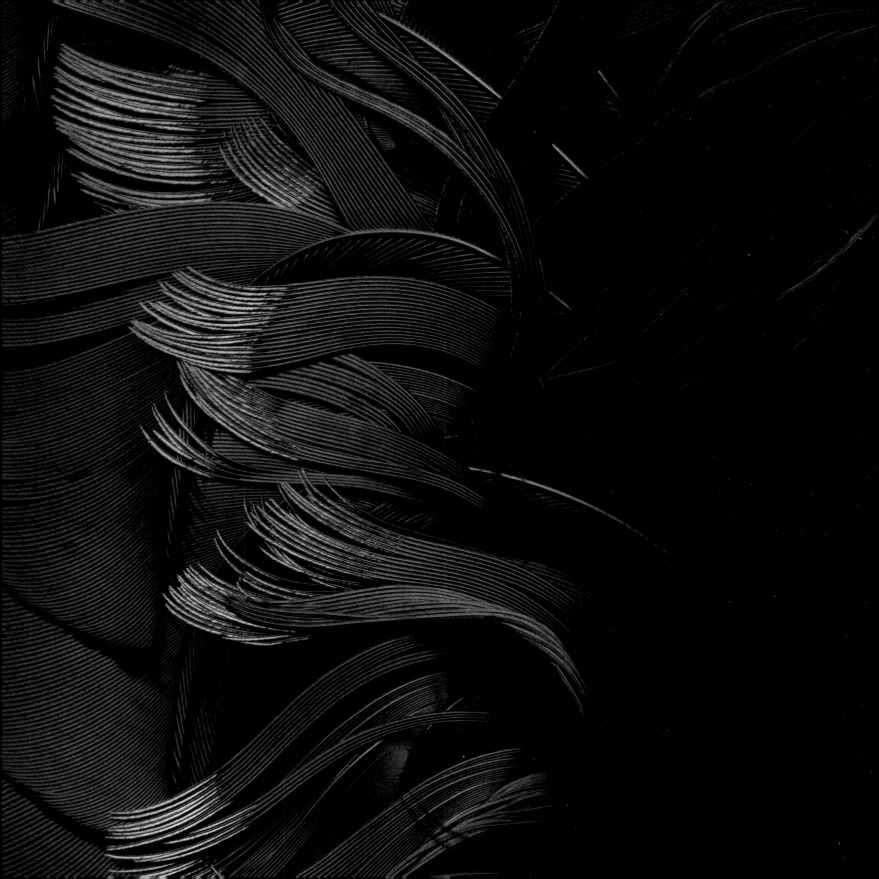

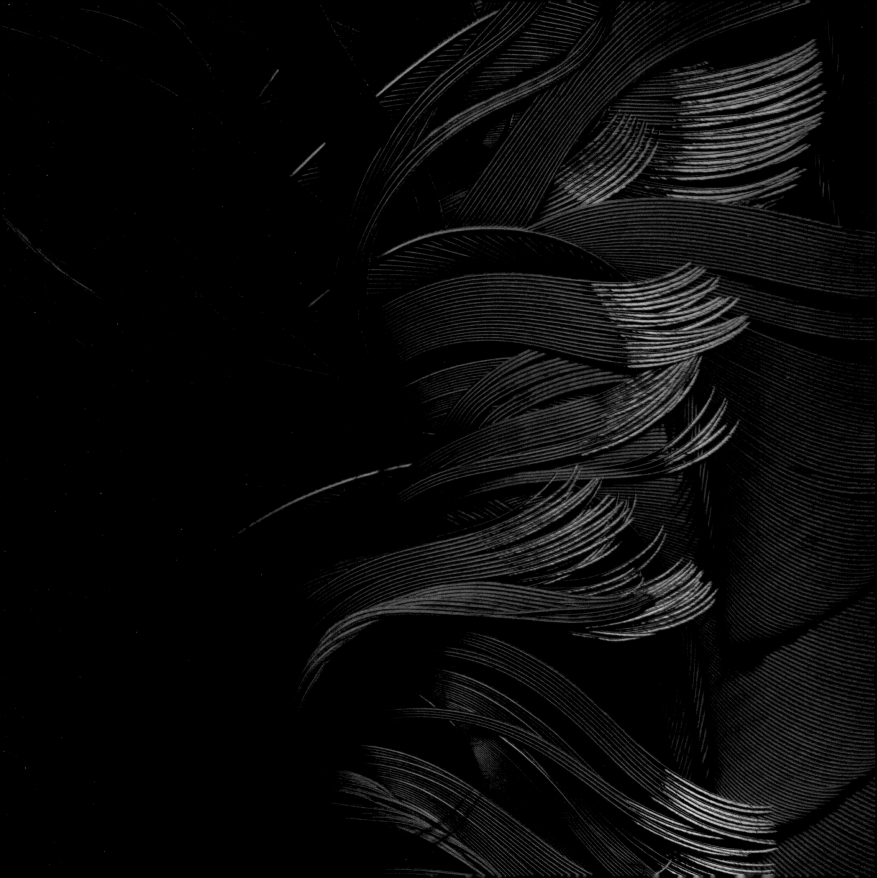

Scarlet Ibis

Apart from its curved bill, wingtips and eyes, which are all
black, the Scarlet Ibis is brilliant red all over. It is the carotenoid
pigments in its diet of crustaceans and invertebrates that produce
this intense scarlet-red colour. The Scarlet Ibis is closely related
to the White Ibis, and it has recently been proposed that the two
should be merged into a single species. Birds raised in captivity
rarely show the same vibrant colour.

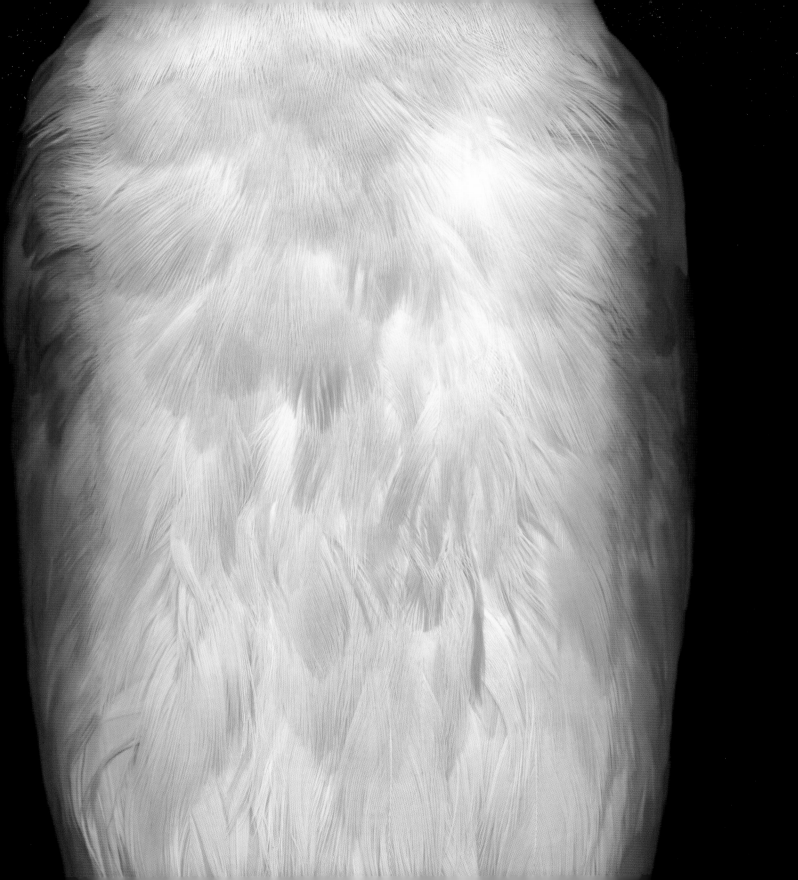

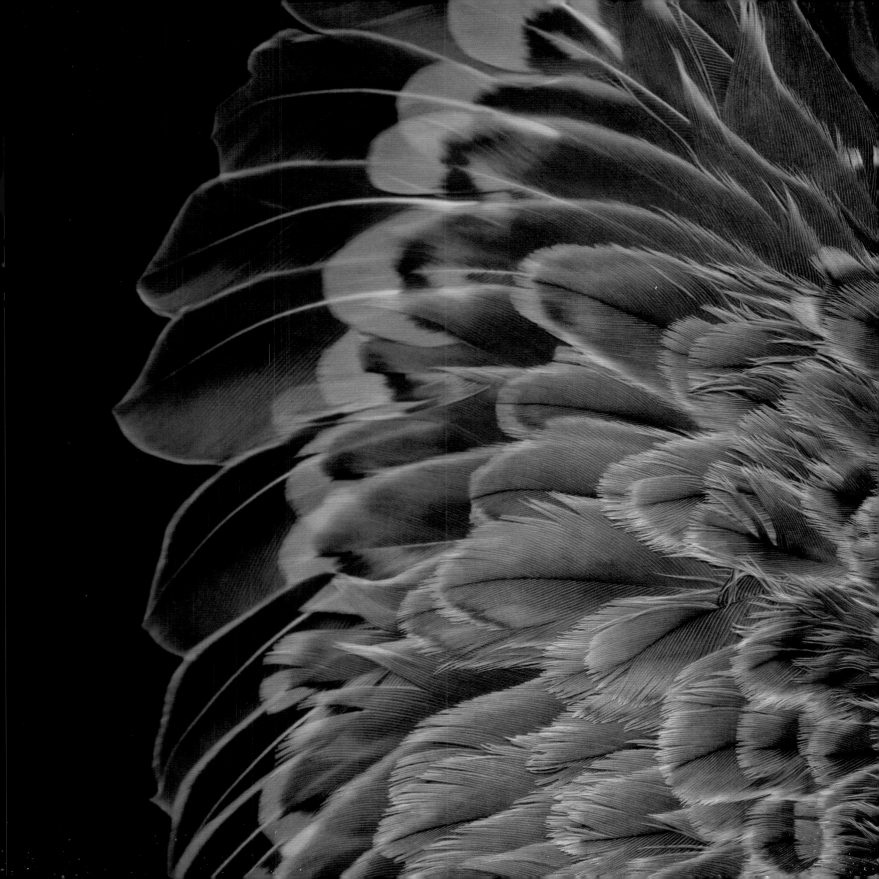

Red Knot

During a single calendar year, a Red Knot travels a distance of over 30,000 km / 18,600 miles, leaving the wintering grounds in Tierra del Fuego in March, flying to the Canadian Arctic to breed and then returning to southern South America to spend the winter. Only when the Knots have reached their wintering grounds will they begin their wing moult, replacing all their flight feathers in preparation for next year's migration. It takes approximately two months to gradually replace all the wing feathers.

New Zealand Scaup Egg

The Papango, as it is commonly known in Maori, is a diving
duck endemic to New Zealand. The species is non-migratory and
is often seen together with the Australian Coot in the deeper lakes
and ponds of the North and South Islands. Scaups nest in the
austral summer from October to March. Their nest is well hidden
in grasses or thick brushy cover, often close to the water edge.
Five to eight pearly white eggs are incubated by the female for
twenty-eight days before hatching.

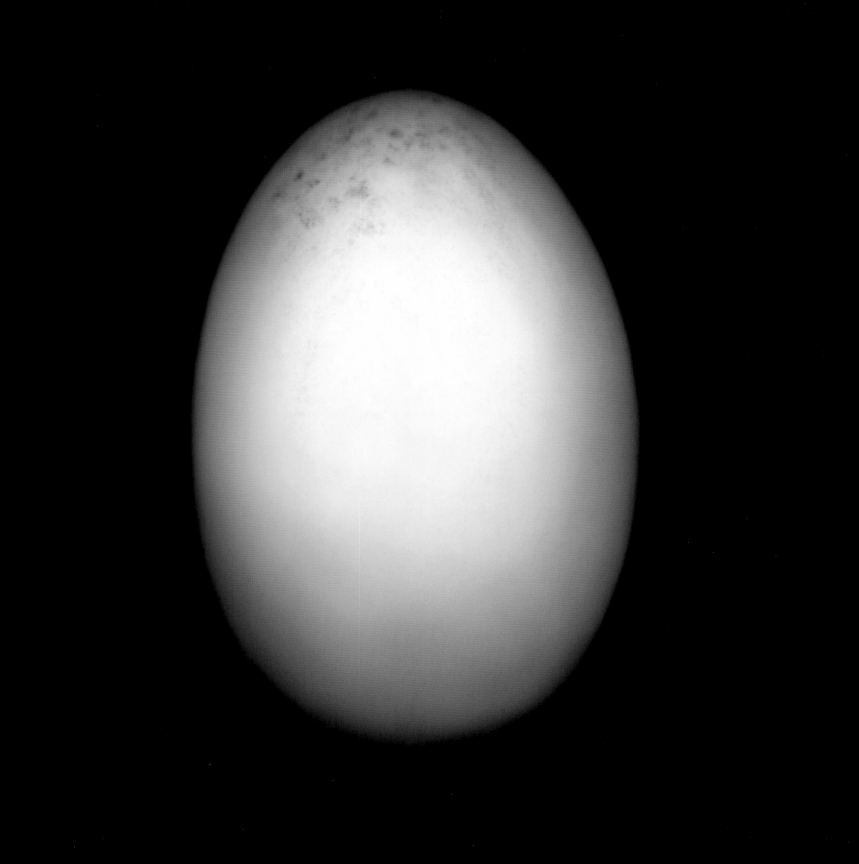

Cedar Waxwing

Cedar Waxwings always seem to have a silkier, slightly glossier
appearance than other songbirds, whether in the wild or
in a museum collection drawer. The feathers covering the
Cedar Waxwing's body (on the left) are grey to brown. They are
softer and smoother than the flight feathers. The feather on
the right here is a flight feather.

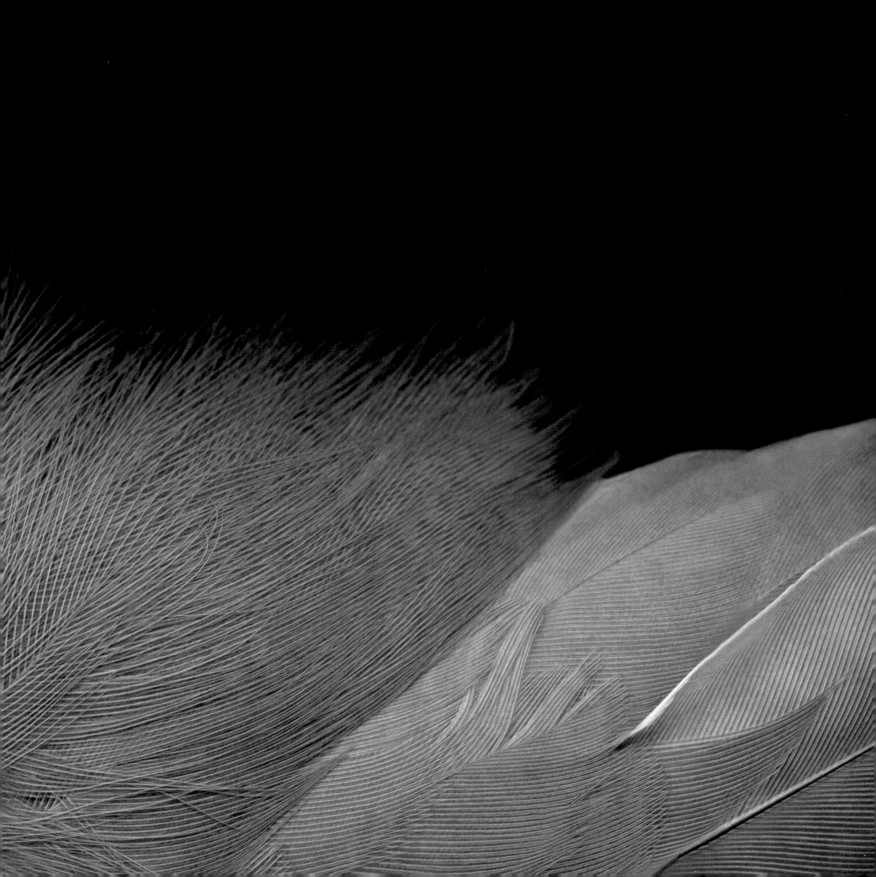

Common Murre Egg/Razorbill Egg

OPPOSITE, NEXT SPREAD AND FOLLOWING PAGE

The simple beauty of an egg is undeniable. Murre eggs have some
of the greatest variation in colour and pattern within a species in
the bird world. Common Murres breed on ocean cliff ledges and scree
slopes in high-density colonies, where they lay a single egg. Individual
females almost always lay eggs of a similar colour and streaking.
It is suspected that the high degree of variation between individuals
may help parents to recognise their own nest. Razorbills, another type
of auk, tend to nest individually in sheltered crevices, and their eggs
show far less variation. Like murres, they usually only lay one egg
in a season. Incubation is by both sexes.

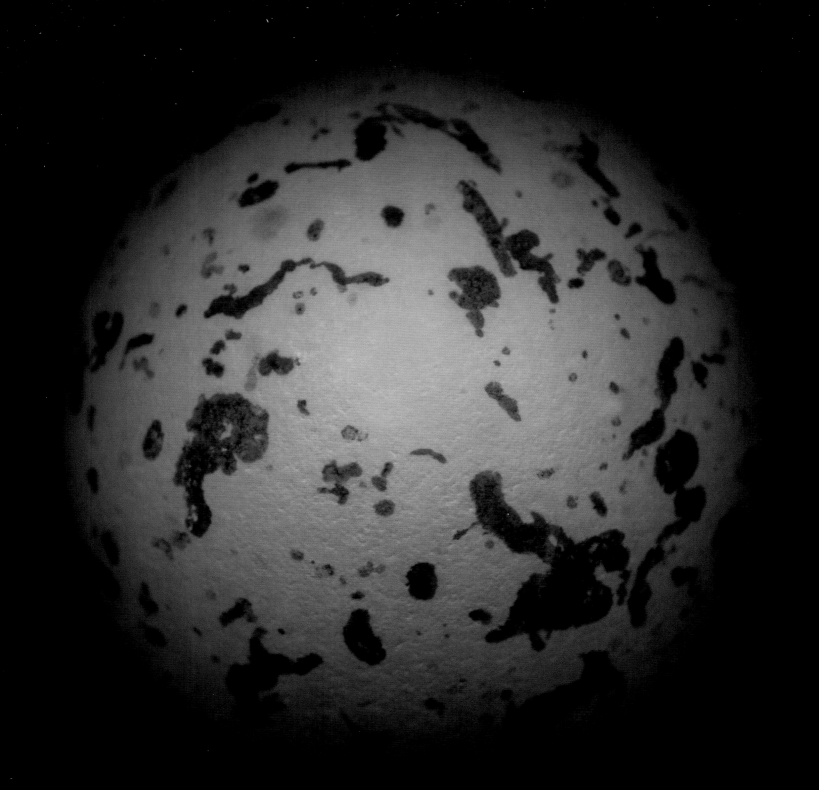

Cooper's Hawk

NEXT SPREAD

With its broad wings and long tail, the Cooper's Hawk is well adapted
to hunting in various types of forests and woodlands, which are
its original habitat. But now it is moving into the cities. The urban
landscape partially mimics the complexity of its woodland habitat,
and the pigeons, doves and starlings of city parks, along with
garden bird feeders, provide an abundance of food. Although this
hawk is usually thought of as a migrant, many individuals are now
overwintering close to bird feeders. Young birds are identified by
their yellow iris and streaked breast. Adults have reddish barring
on the breast and a red iris.

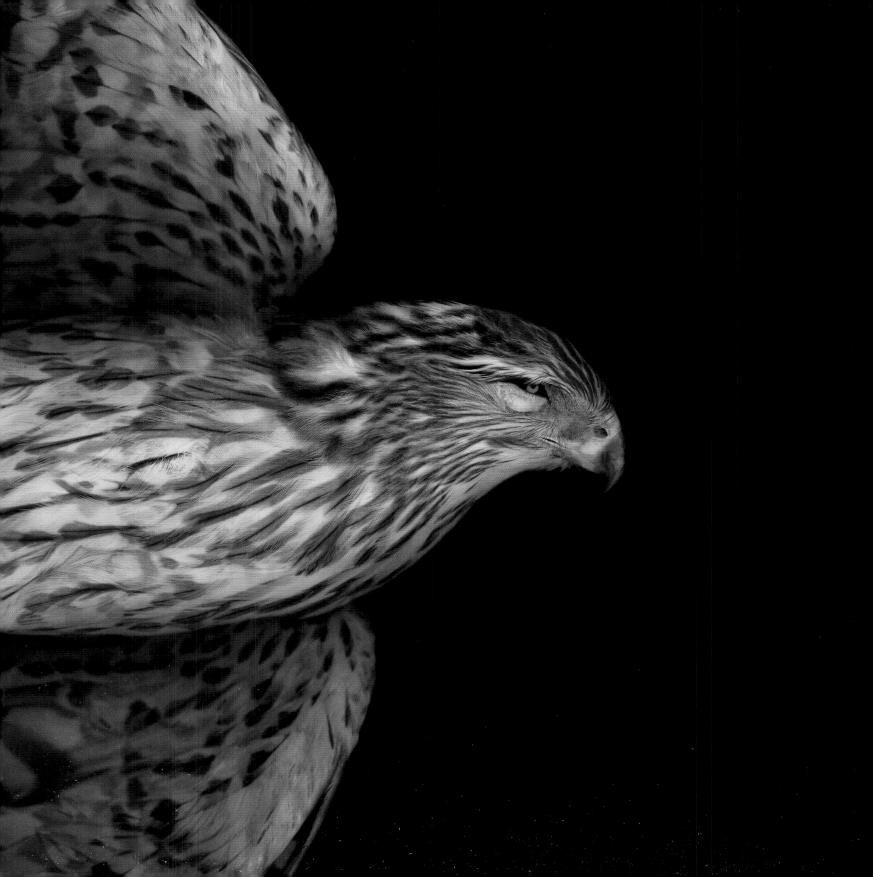

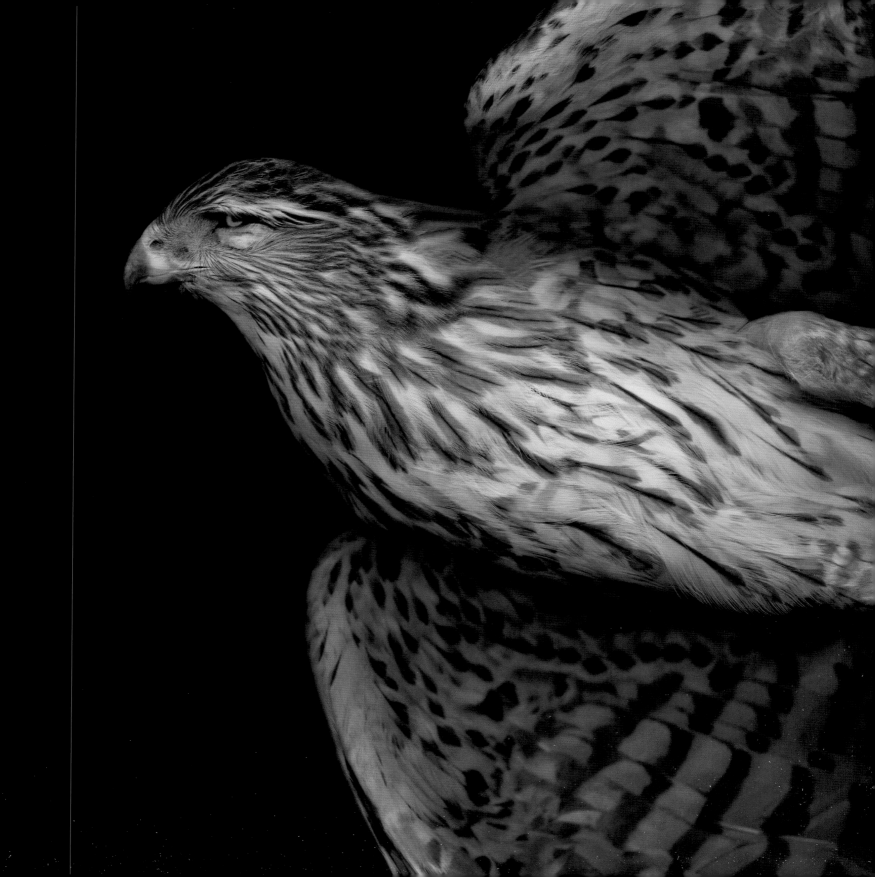

American Woodcock

Woodcocks are beautifully camouflaged, plump, long-billed shorebirds. They live in moist woodlands or marshland, where they can be found probing their long bills deep into the mud in the search for food. With eyes set well back on the head, the woodcock has binocular vision, which helps it to spot predators while searching for worms and invertebrates. Some of the colloquial names for woodcock include bogsucker, timberdoodle, mud bat and Labrador twister. Woodcocks are among the few shorebirds still legally hunted in North America.

Superb Bird-of-paradise
NEXT SPREAD

The Superb Bird-of-paradise, the only member of the genus Lophorina, is the avian kingdom's world champion in competition dancing. During courtship displays, the male presents himself to the cryptically-coloured female by raising his black velvety cape behind his head and shoulders and expanding his iridescent blue green 'breast shield'. He then begins his bouncing, hopping dance as he snaps his tail feathers together, much like you and I would snap our fingers. Females visit several males before making their decision.

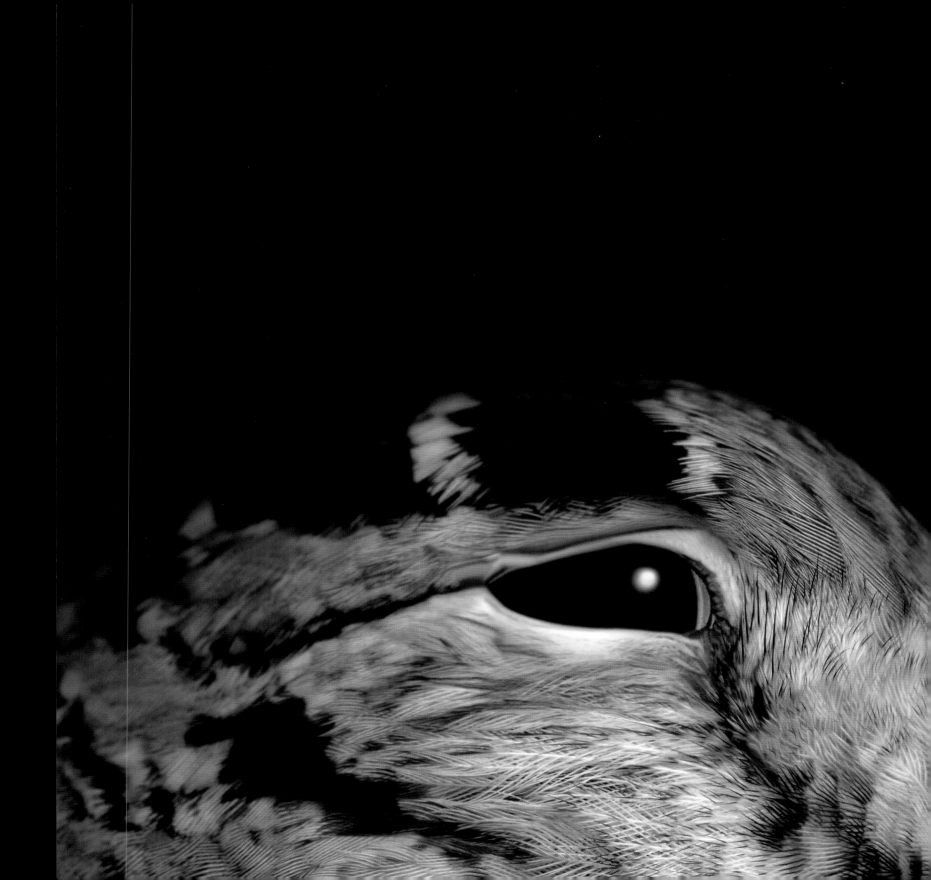

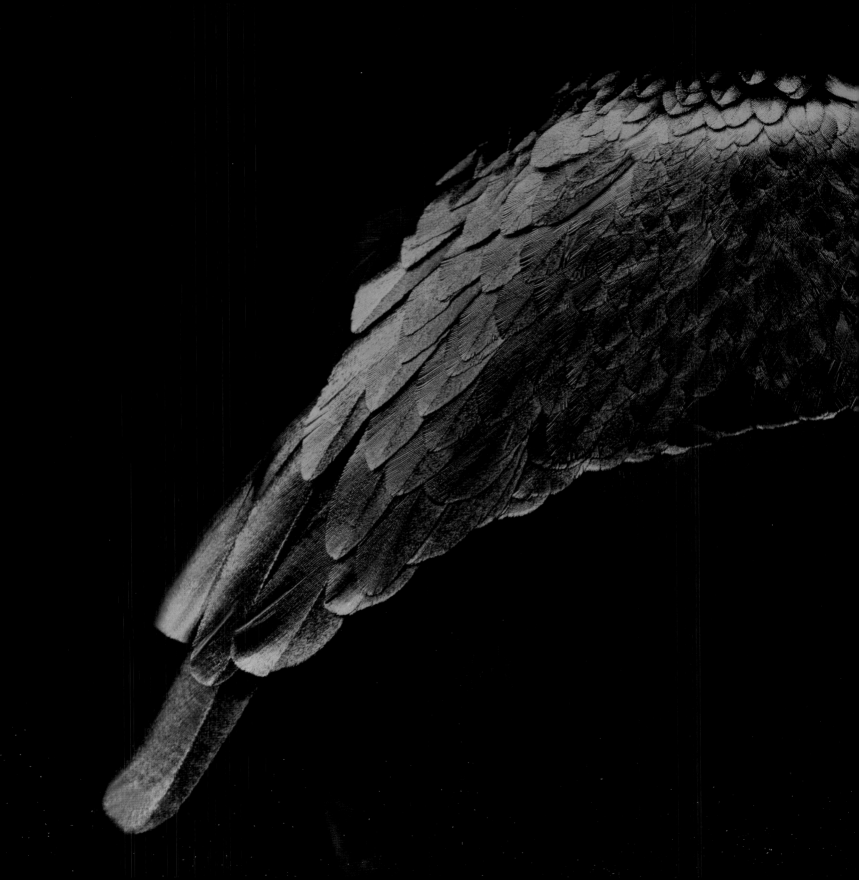

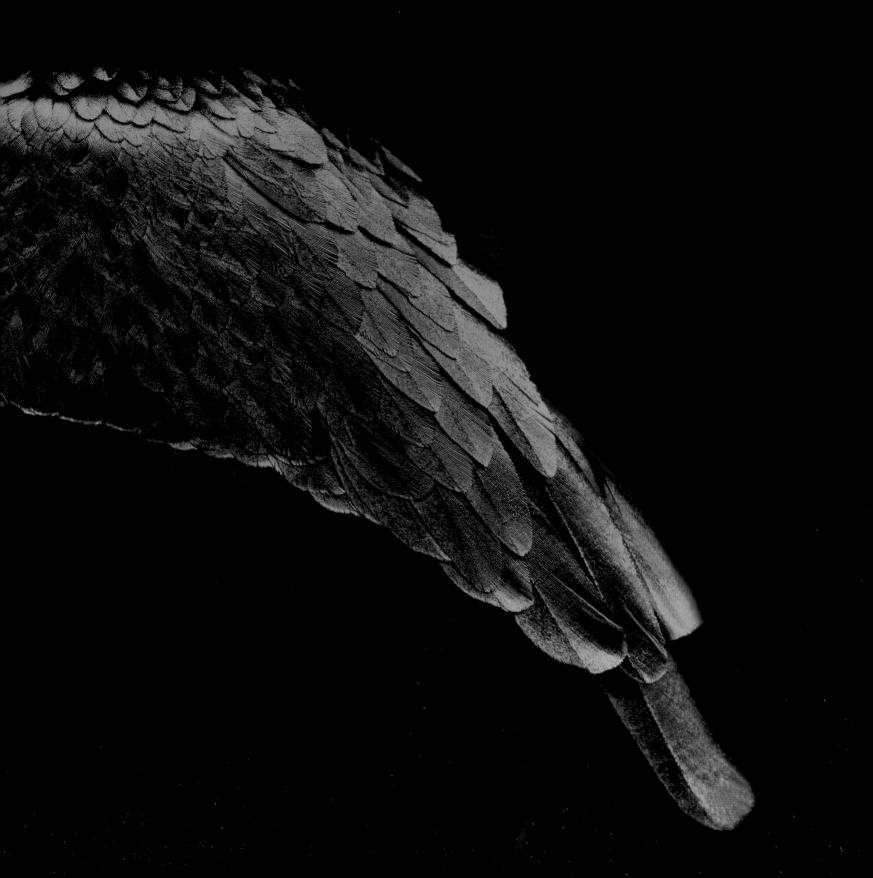

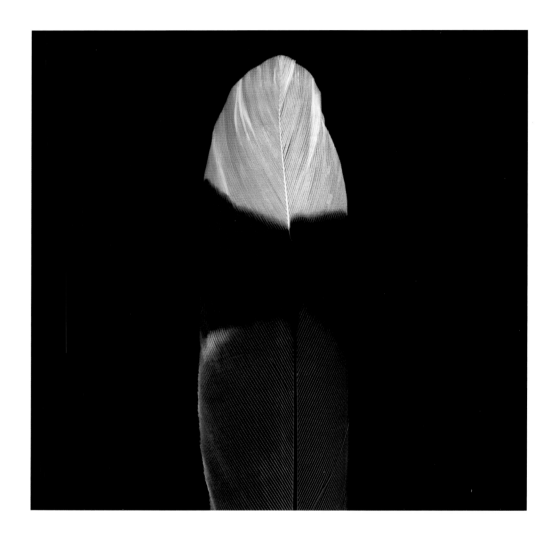

Red-billed Blue Magpie

This member of the Corvidae (crows and jays) has the longest tail
feather of any species in the family. The body of the bird is about
20 cm / 7 ¾ inches, while the tail is often longer than 40 cm /
15 ¾ inches and, in the case of the Red-billed Blue Magpie, almost
always droops at the end. Magpies and most of the other species in
the crow family are very curious and have a habit of collecting and
investigating a wide variety of foods and brightly coloured objects.
The name is now associated with people who collect small trinkets
or chatter nonsensically.

44

Greater Rhea Egg

During the breeding season, female rheas will move around and
mate with several males, laying their eggs in the males' nests. Males
will also mate with several females. Males take responsibility for
incubation and may have as many as seven females laying eggs in
their nests with an average clutch size of twenty-six eggs, although
nests have been known to contain as many as eighty. Rhea eggs are
approximately 6 inches / 15 cm in length and 3 ½ inches / 9 cm wide.
They are greenish yellow when first laid but fade to a dull cream as
incubation progresses.

Fork-tailed Flycatcher

The Fork-tailed flycatcher is 'King of the Savannah', of pastureland
and other environments where trees are sparse. The male of this
species has the longest tail to body ratio of any bird on earth.
The outer two tail feathers, or remiges, may be three times longer
than the bird's body. This species is often seen perched along
fences hunting for insects but the function and value of the tail
remain largely unknown.

——

Ostrich
NEXT SPREAD

The white feathers from a male Ostrich wing have been coveted
for thousands of years. Ostriches are farmed commercially for
feathers, meat and leather. Ostrich feathers are unusual in that
they lack the 'Velcro-like' hooked barbules that give most bird
feathers their shape and strength. Their softness and beauty
have made them desirable in the fashion world and in industry,
especially for feather dusters. Ostriches use them for courtship
and insulation. Individual feathers may be as long as 76 cm /
30 inches and 30 cm / 11 ¾ inches wide.

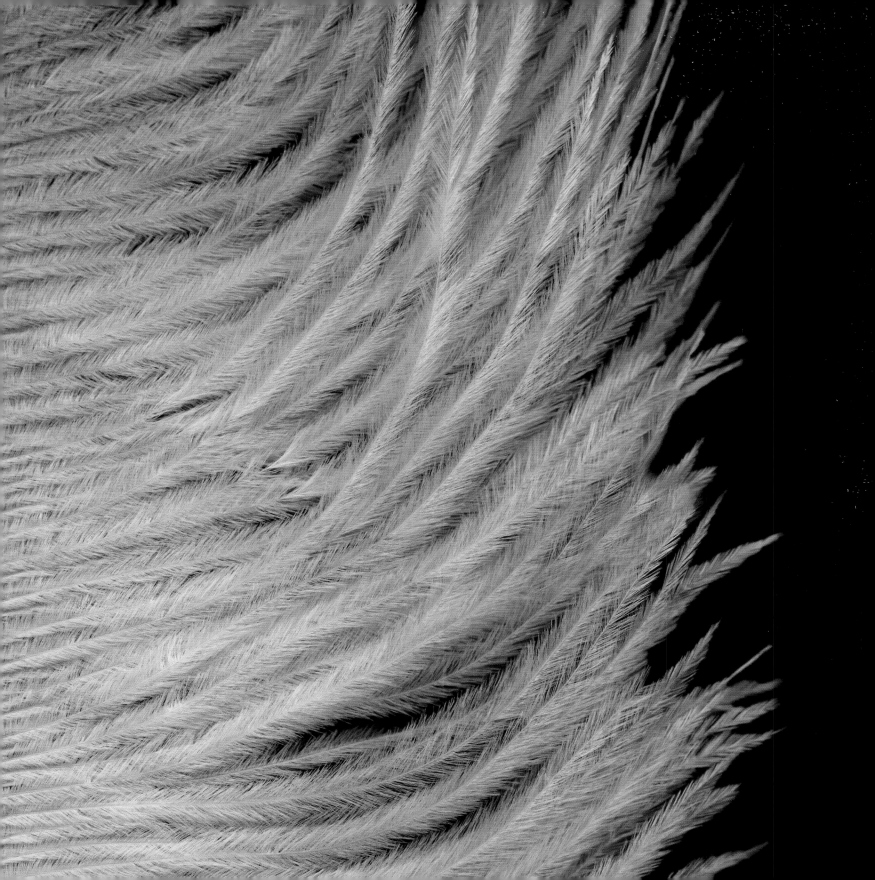

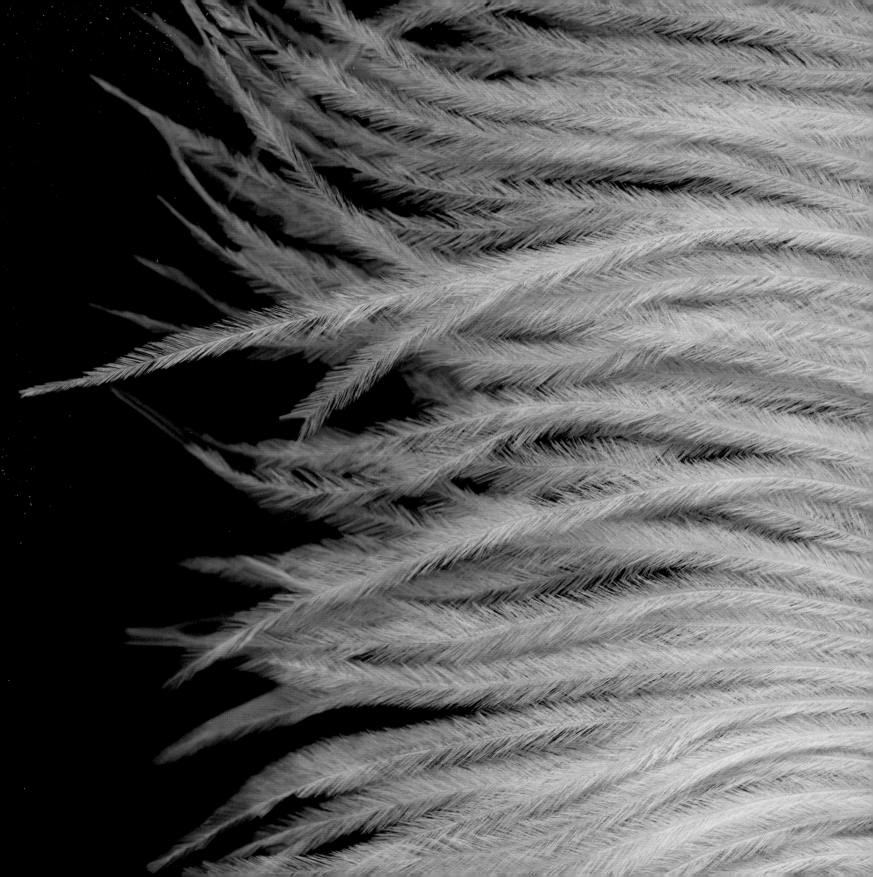

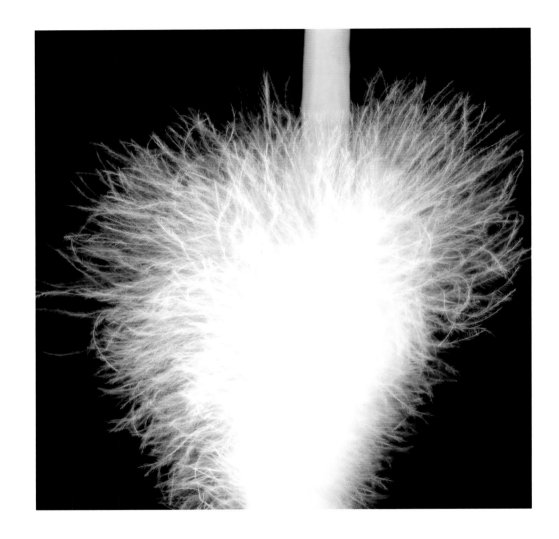

Osprey

ABOVE AND OPPOSITE

Beautiful in their design and simplicity, feathers serve many
different functions, from thermoregulation to courtship display.
They evolved from reptilian scales and, like horns, hair and nails,
are made of keratin. The typical flight feather has a strong central
shaft known as a rachis, interlocking branches of barbs and, near
the base, softer, downier barbs without hooks.

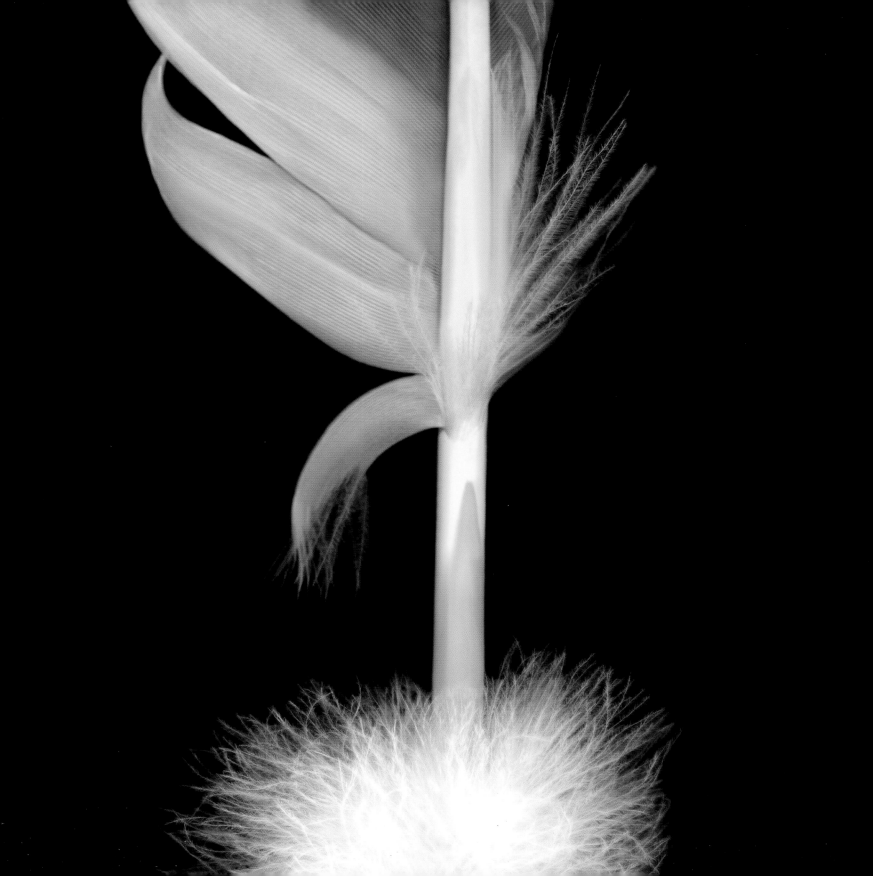

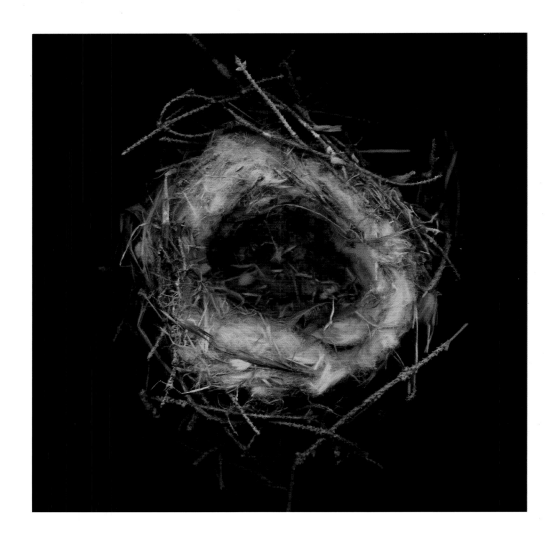

Two-barred or White-winged Crossbill Nest

The Two-barred Crossbill, known as the White-winged Crossbill in North America, can best be described as an opportunistic nomad. Foraging for conifer seeds, the species is distributed across North America and northern and central Europe. The nest is built by the female but males often assist by bringing material. Solid and warm, it is built of twigs, grasses, plant down and insect cocoons. Nests built in winter are more solid and substantial than those in summer.

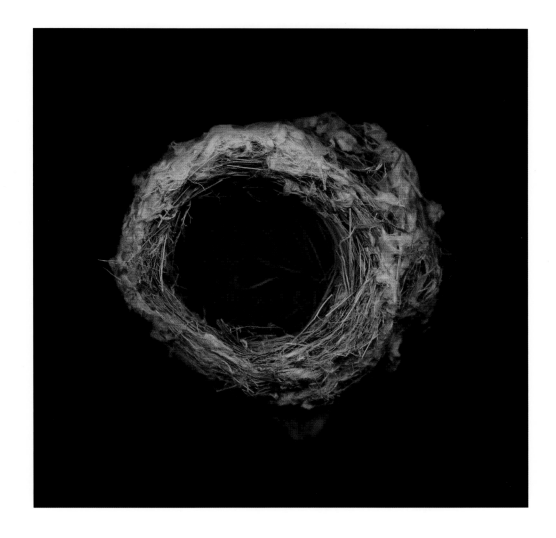

Willow Flycatcher Nest

Willow flycatchers commonly nest low in bushes and shrubs in
wet areas or near water. Nests tend to be flocculent, compact cups
made from grasses, plant down, plant fibres and bark strips, lined
with grasses and other plant material. They commonly take about
a week to build and will often remain empty for a day or two before
laying begins. The average clutch size is four white eggs, lightly
speckled at the large end, which require twelve days to hatch.

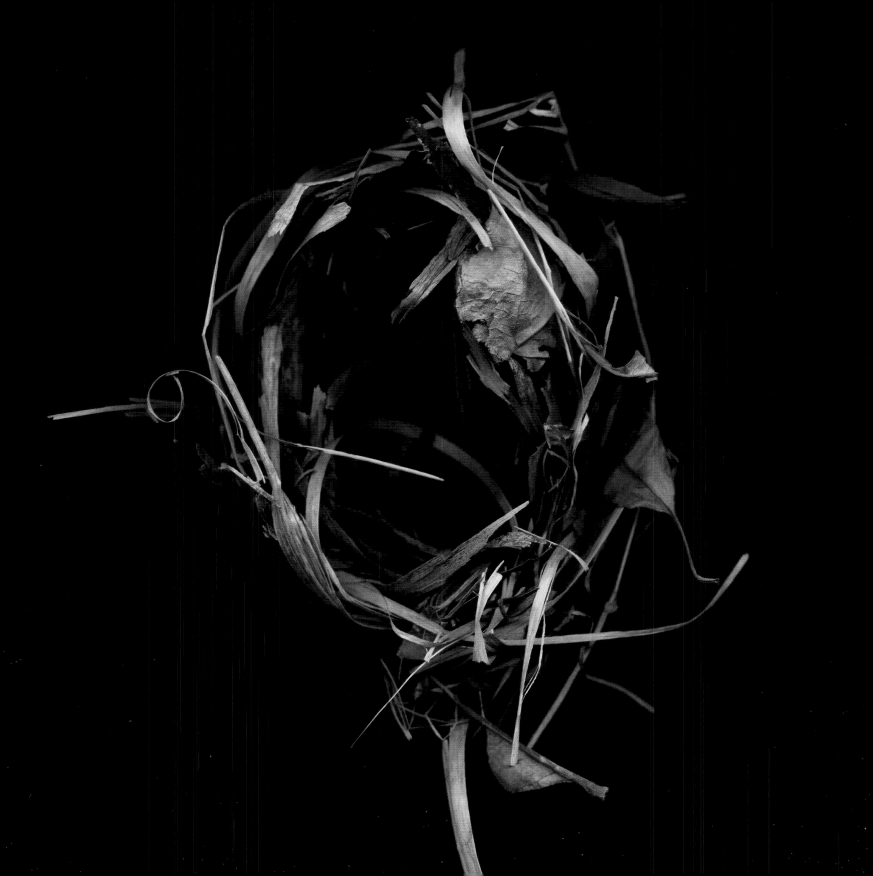

Golden-winged Warbler Nest

The nest of the Golden-winged Warbler is built by the female
alone in one to three days. While the exterior of the loosely built
cup nest is most often made up entirely of dead deciduous leaves,
the interior frequently contains strips of coarse plant material
such as bark and grasses and is lined with finer plant material
and animal hair. Usually situated on or near the ground in wooded
areas of thick undergrowth, the nest is well hidden in a grassy
clump or at the base of a shrub.

Resplendent Quetzal

The Resplendent Quetzal is Guatemala's national bird, adorning its flag and giving its name to the currency. The iridescent green feathers that the bird is famed for are found on the head, back, breast and wing coverts as well as on the elongated tail coverts that may measure almost 1 m / 3 feet in length. The quetzal was sacred to several Mesoamerican peoples, and its feathers were worn by royalty and priests during ceremonies.

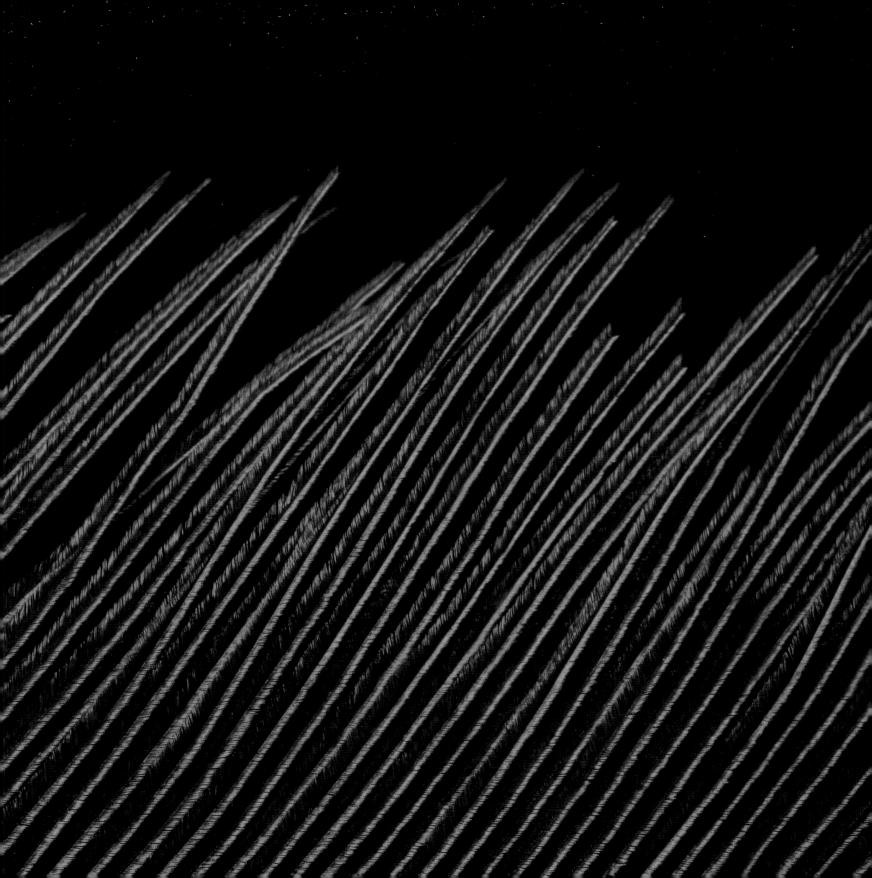

Mute Swan

Mute Swans are native to most of Europe and Asia and were introduced into many other parts of the world as beautiful additions to parks and estates. Many have escaped into the wild and have established feral populations in wetlands throughout Canada and the United States. Swans have more feathers than any other bird, with an estimated 25,000 feathers recorded for an individual of one species. The feathers on the swan's abdomen are semiplumes. They help with thermoregulation and also give the swan some of its smooth, streamlined shape.

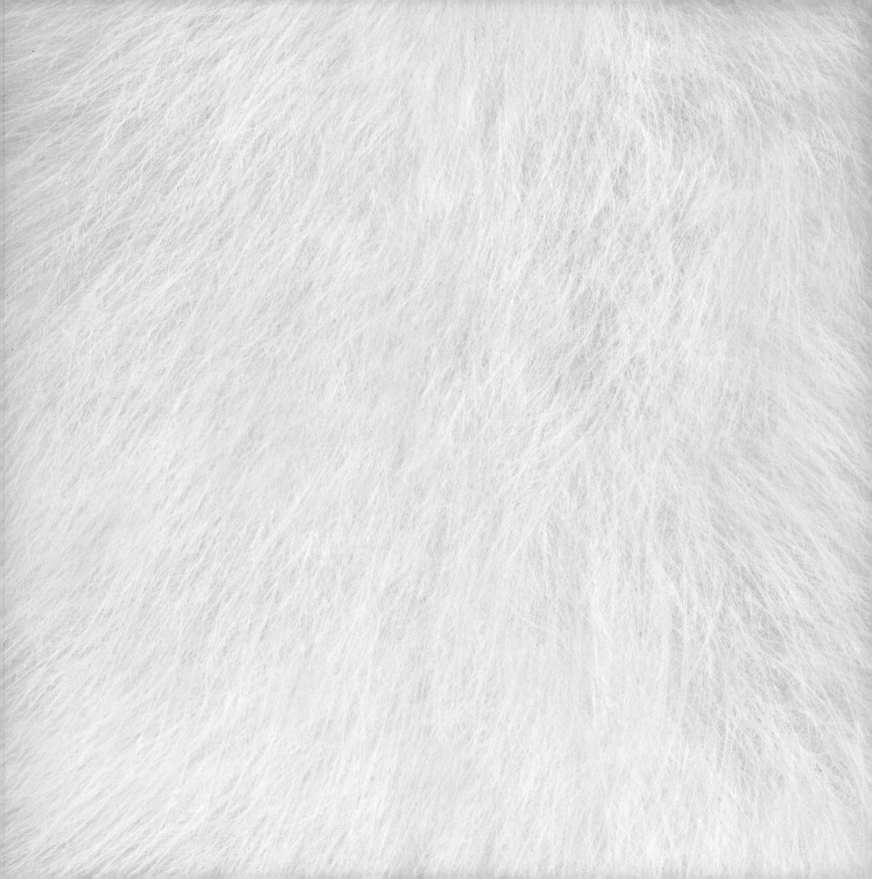

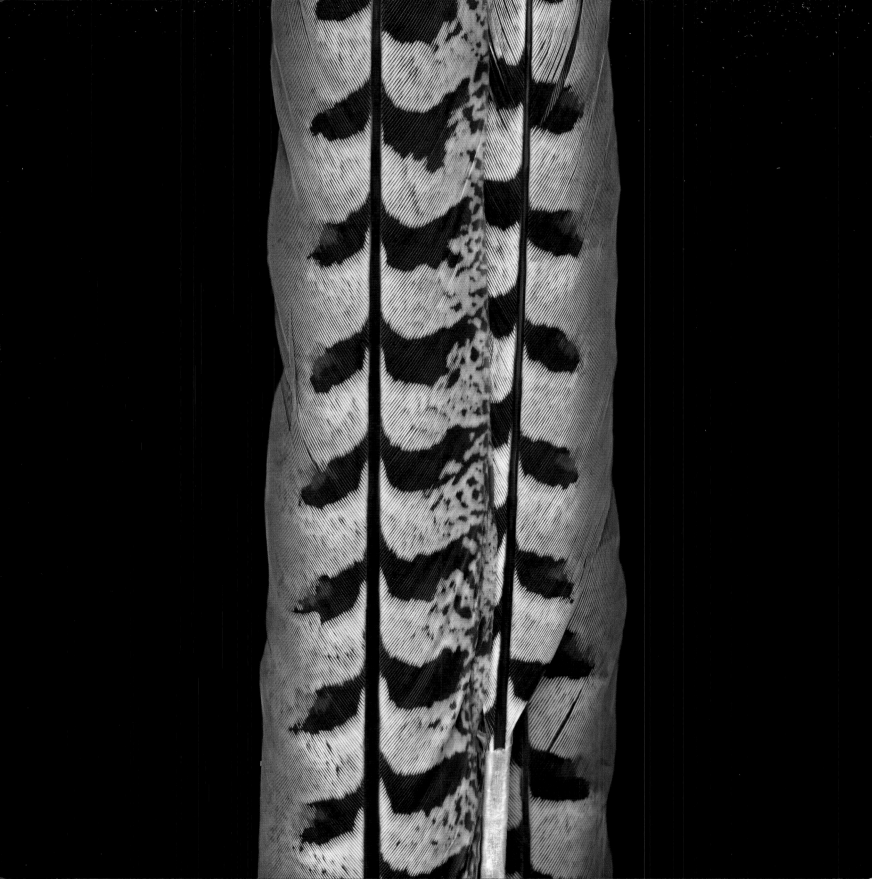

Reeve's Pheasant

The Reeve's Pheasant has the longest tail feather of any bird
species, measuring up to 2.4 m / 8 feet. The pattern of colouring
may vary depending on the sex and age of the pheasant but most
species show considerable consistency for a wild bird, at least to
the human eye. Birds are able to see in the ultraviolet wavelength,
and in many cases they may perceive patterns and colours very
differently from humans.

Indian Peafowl

The eyespots (ocelli) on the tail of the Indian Peacock are undoubtedly the most recognisable feature on any feather in the world. The peacock's tail, also known as a train, is not actually made up of tail feathers but of the elongated upper tail coverts. The tail coverts' usual function is to cover and protect the tail feathers. It has been shown that the colours of the eyespot and the angle at which they are displayed are important factors for peahens when it comes to choosing a mate.

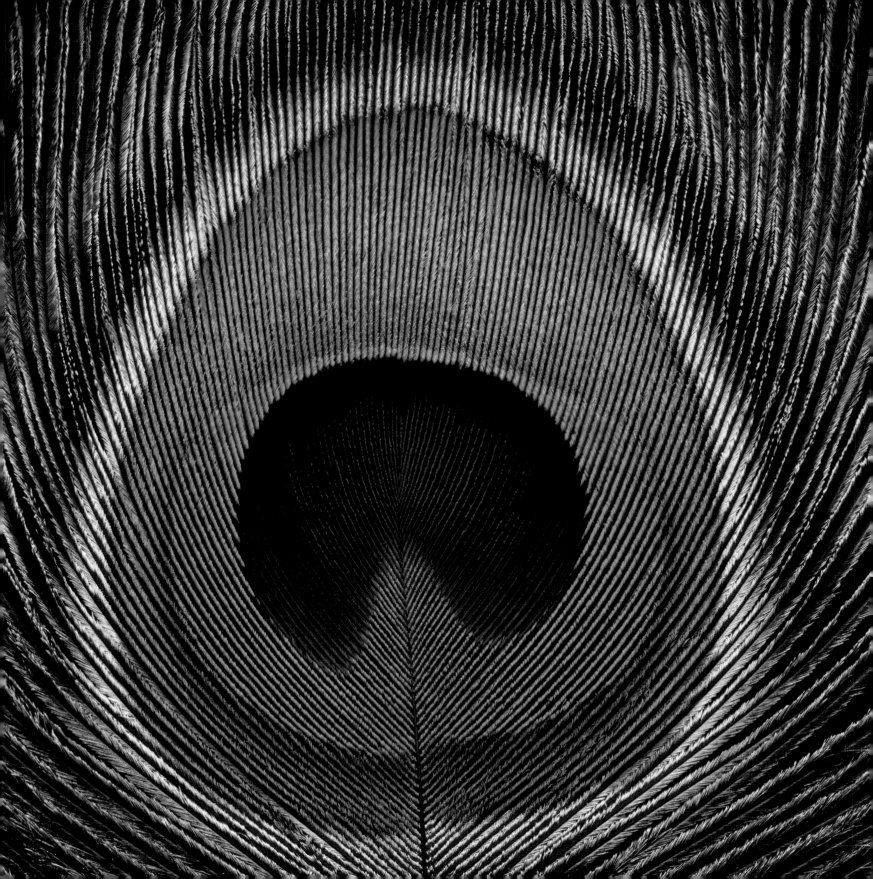

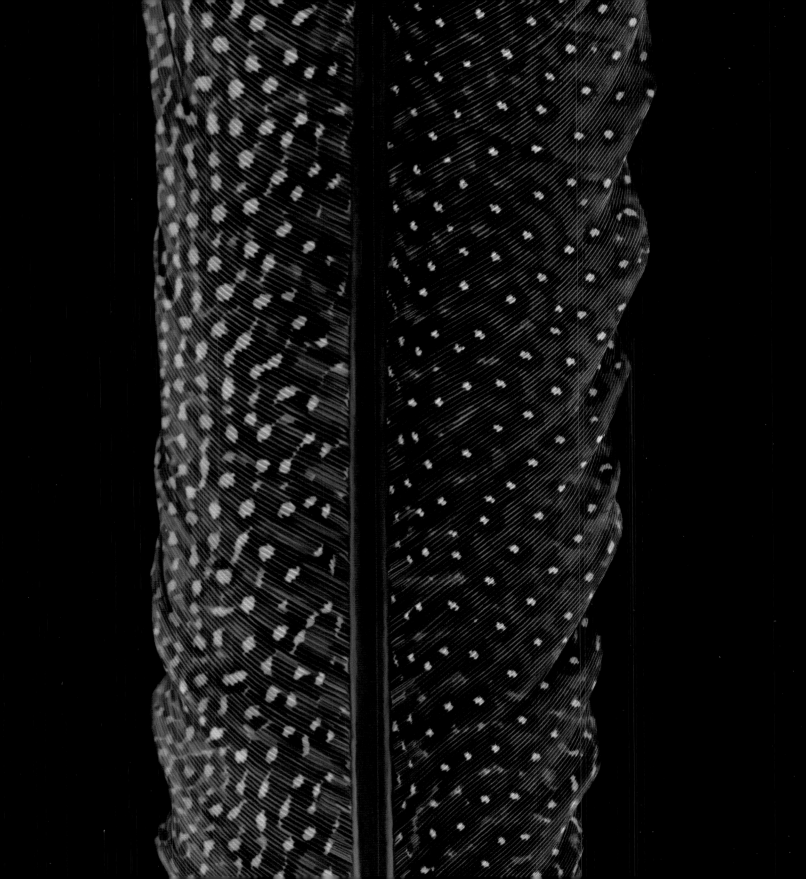

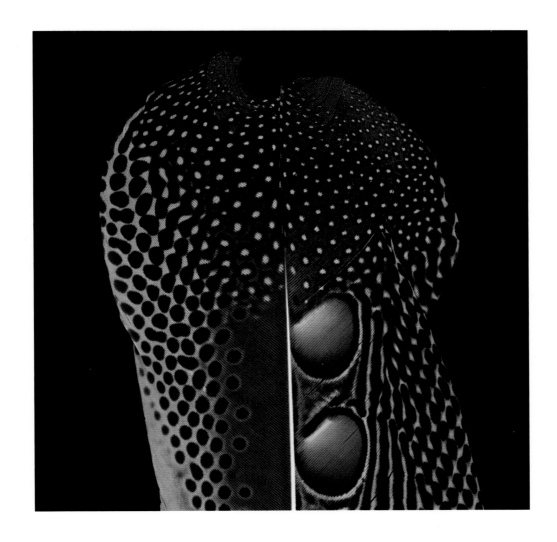

Great Argus

OPPOSITE AND ABOVE

The Great Argus was named after Argus, the hundred-eyed giant of
Greek mythology. The reason is easy to see when the bird opens its wings
during courtship. Each elongated secondary flight feather on the wing
has numerous bronze eyespots on a striped and speckled background of
white and brown. The display resembles that of a peacock but the Great
Argus uses his wings rather than his tail. Measuring as much as 200 cm /
78 ¾ inches, it is one of the largest members of the pheasant family.

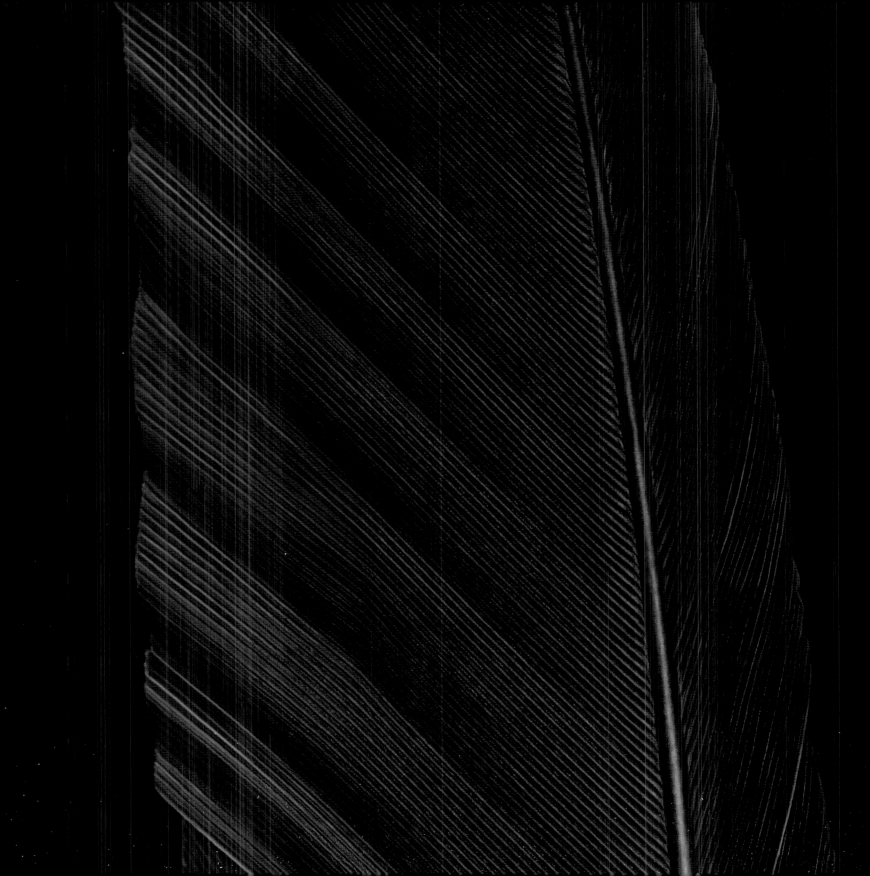

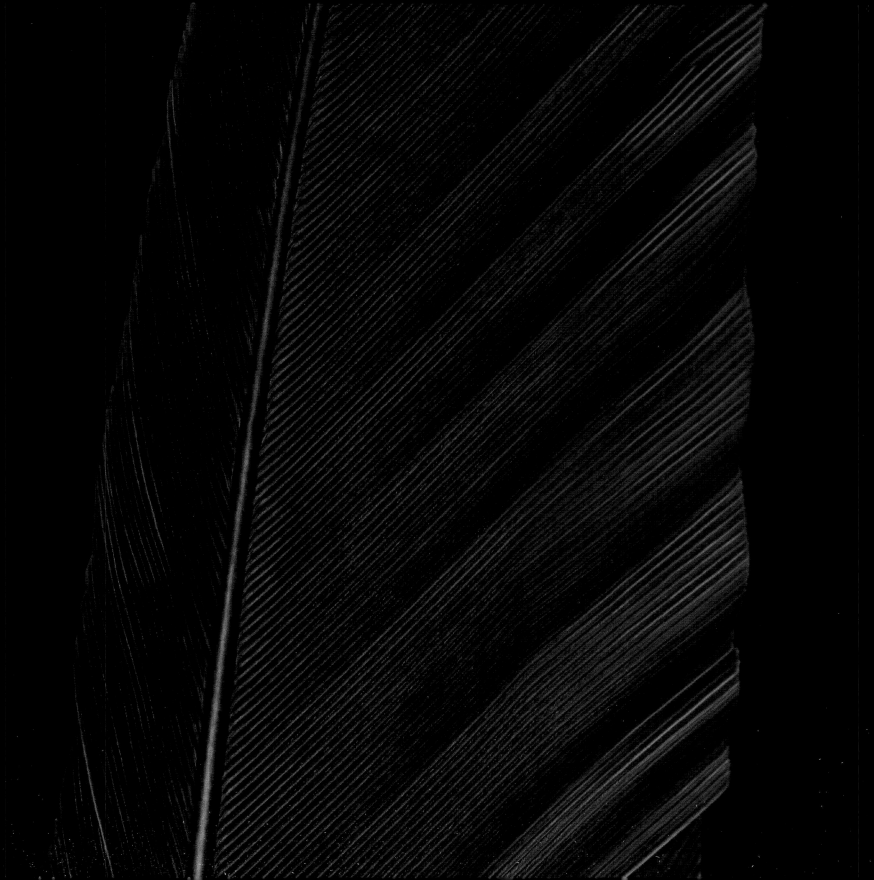

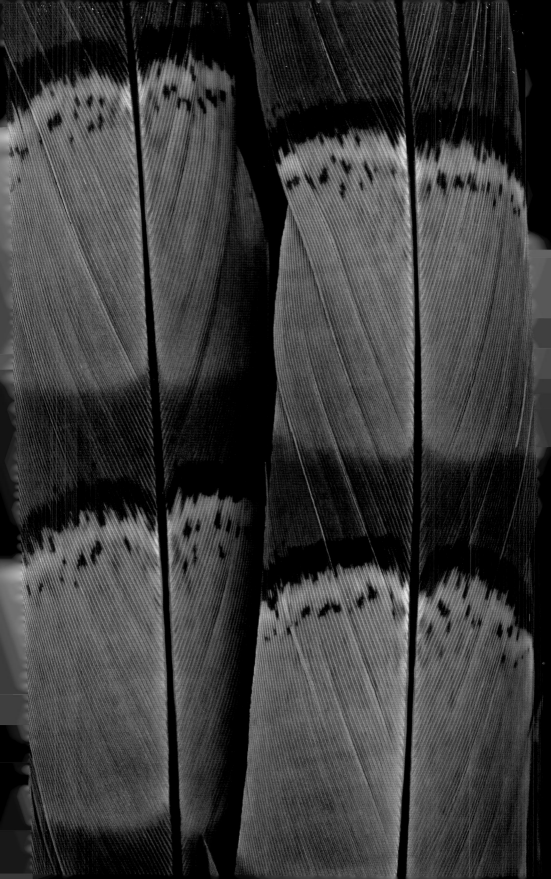

Bald Eagle

Wing feathers (remiges) on Bald Eagles and most other species
are stiff feathers evolved for flight. The solid, upper part of the
middle shaft, the rachis, has fine side branches called barbs, which
in turn branch off into barbules. Diminutive hooklets, known as
hamuli, hook on to adjacent barbules, forming a web-like structure
that makes the wing almost impervious to water and air. When pulled
apart, the web can easily be brought back together. The bird does
this by preening, a movement that you can imitate by gently sliding
your fingers along the barbs. Some Bald Eagle feathers may be close
to 50 cm / 19 ¾ inches in length.

———

Copper Pheasant

The Copper Pheasant is endemic to the islands of Japan. There
are five subspecies currently recognised, with the males of the
southernmost ones being the darkest and most richly coloured.
As in many other pheasants, the length of the male's tail far exceeds
the length of the bird's body, reaching close to 100 cm / 40 inches
in length while the female's tail is rarely longer that 20.5 cm /
8 inches. Although this species was once common, numbers have
declined because of over-hunting.

Grey Junglefowl

The Grey Junglefowl, together with the Red Junglefowl, is thought
to be one of the ancestors of the domestic chicken. The yellow
colouring on the legs of domesticated chickens is a trait inherited
from the Grey Junglefowl. The feathers in this image are from the
rump of the bird and display the grey base colouring which gives
the bird its name. Although junglefowl are forest dwellers, they
will hybridise with domestic chickens.

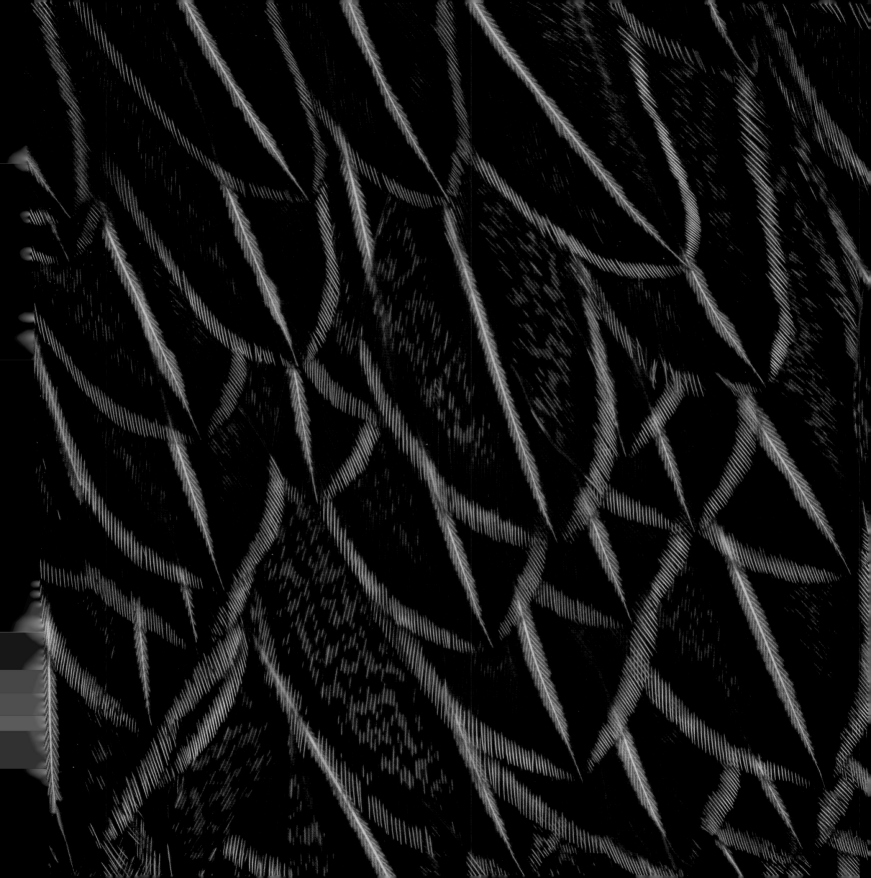

Grey Junglefowl

The Grey Junglefowl is found throughout India and in parts of
Southeast Asia. All four Junglefowl species look very similar to
domestic chickens, differing only in their plumage coloration and
facial features. The contour feathers on the breast and back of the
male Grey Junglefowl have the typical grey and brown pattern seen
in this image. Contour feathers are not as evenly distributed as
hair on the body of mammals, but grow on tracts arranged in lines
known as pterylae, with bare patches between them.

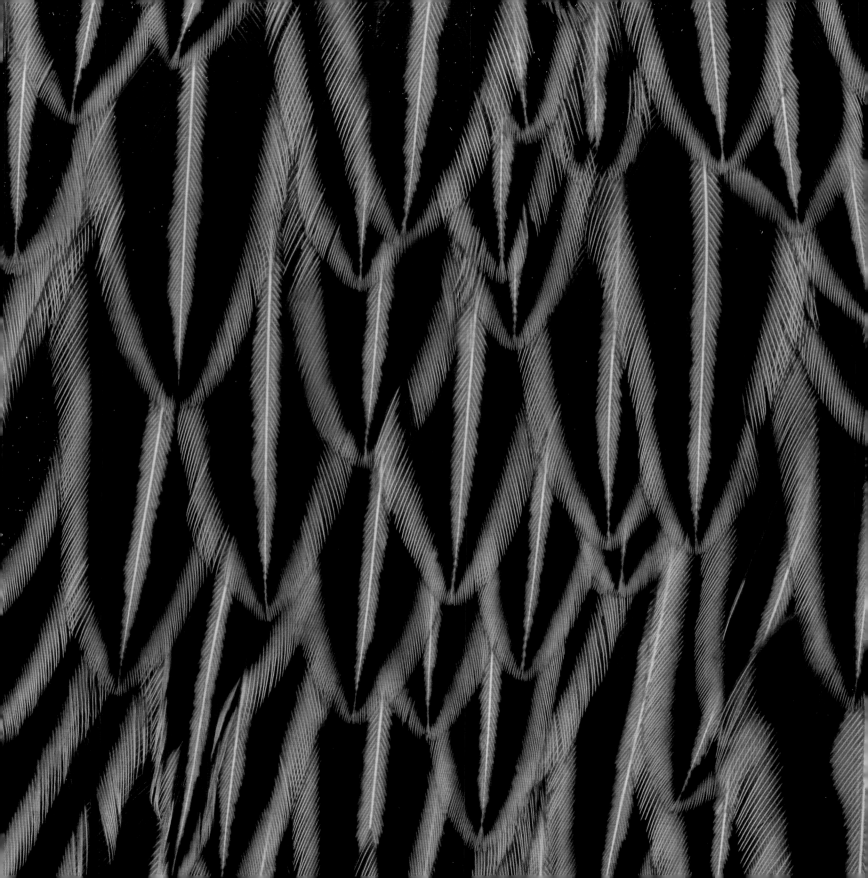

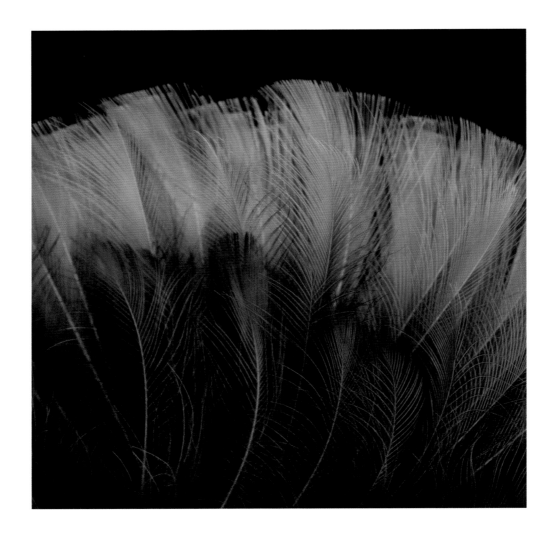

Magnificent Bird-of-paradise

The outermost feathers of a bird, contour feathers are divided
into flight feathers and those that cover the body. Flight
feathers are strong and stiff, while the feathers used for body
contouring and courtship displays are less structured and more
similar to down feathers.

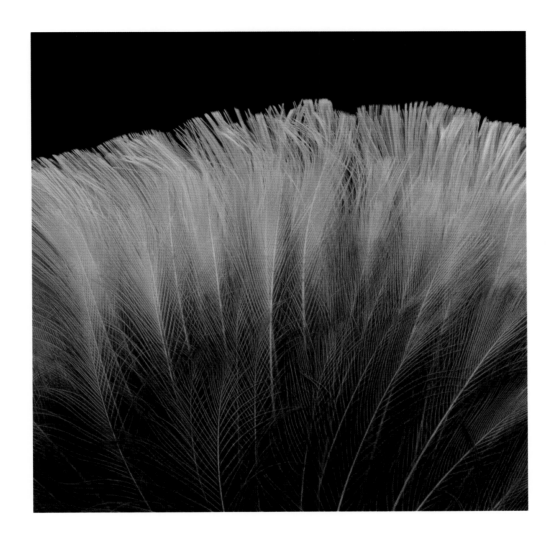

Magnificent Bird-of-paradise

The bright yellow cape on the Magnificent Bird-of-paradise sits
flat along the back of the bird until the courtship display is in
full swing. The cape is composed of contour feathers and can be
erected by the bird. Since the contour feathers overlap each other,
the cape appears fully coloured throughout. It is only when it is
erected and we observe it from behind that we see that only the
upper ends of the feathers are yellow.

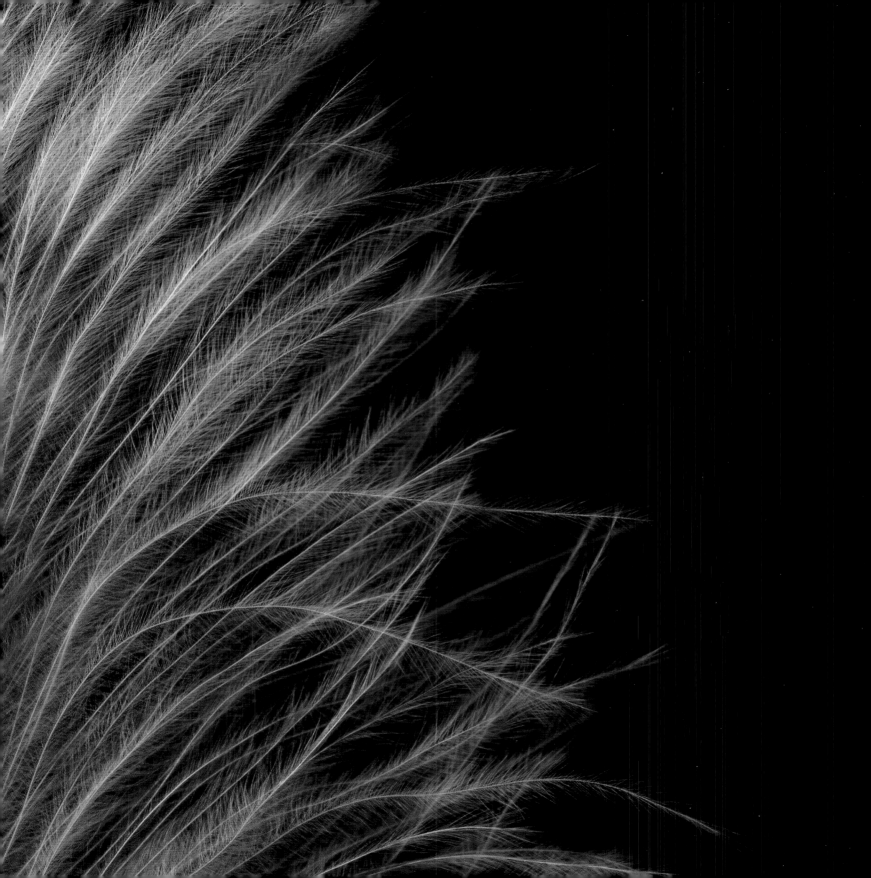

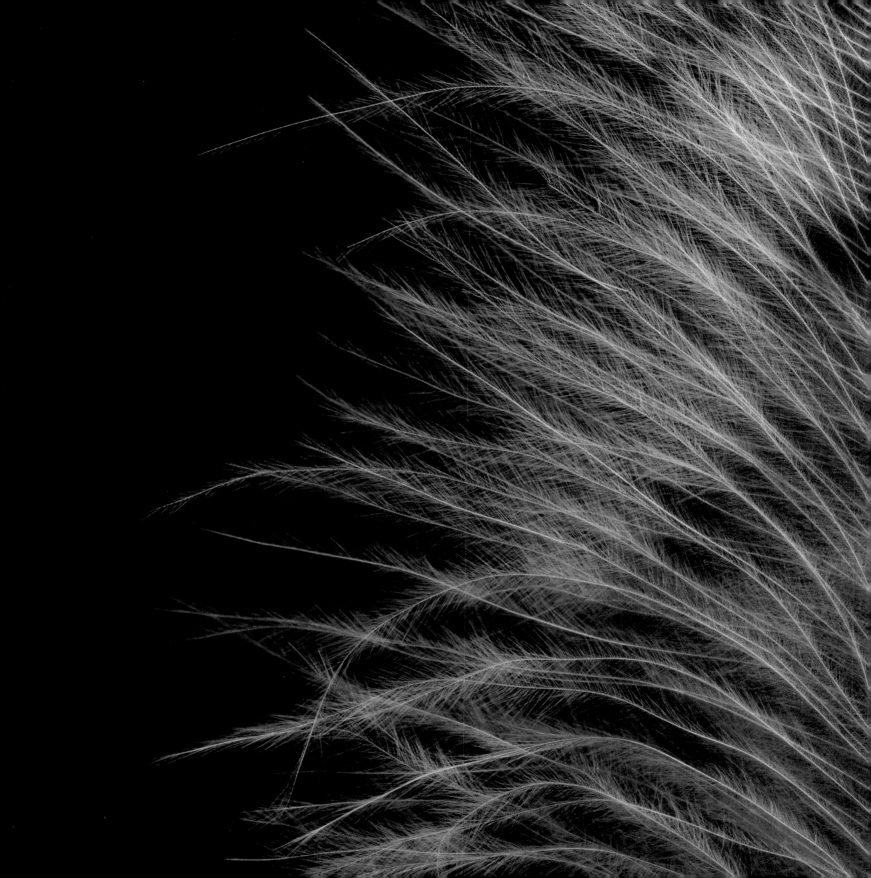

Great Horned Owl

PREVIOUS SPREAD

Feathers come in different shapes and sizes and have many uses.
Found beneath the contour feathers, semiplumes help to create
insulating air pockets, but they may also play a role in aerodynamics
and courtship displays. They have a central shaft like contour
feathers but their barbs are not hooked together, which makes them
soft and plumaceous like down feathers.

———

Ostrich Egg

Ostriches lay the largest eggs in the bird world today. Equivalent
in volume to about twenty chicken eggs and weighing up to 2 kg /
4 ½ pounds, ostrich eggs are also thick, enabling them to withstand
the weight of the adult bird. They have a glossy, porcelain-like shell,
pockmarked with hundreds of pores. The pores allow moisture,
oxygen, and carbon dioxide to pass through but keep harmful
bacteria from entering the egg.

Superb Lyrebird

This image is a close-up of the two lyrate feathers of a Superb
Lyrebird. The two outside tail feathers on the male may be as long
as 60 cm / 24 inches and have a similar structure to ordinary tail
feathers except for their overall shape. The rachis, with barbs
emanating from it in a symmetrical pattern, provides the main
support for the feather. The darker areas between the barbs are
the barbules and barbicels that help keep the barbs together,
giving the feather its strength.

——

Baltimore Oriole Nest and Egg
NEXT SPREAD

The nest of the Baltimore Oriole is a marvel of architecture.
Built solely by the female, the intricately woven pendulous
pouches made of grass, plant fibres, bark strips and plant down
are often suspended at the end of an outer branch in a deciduous
tree. The average clutch is four to five pale grey eggs, with brown
and lavender scrawls concentrated at the larger end. Only the
female will incubate the eggs and brood the young, but the male
will assist in feeding the nestlings.

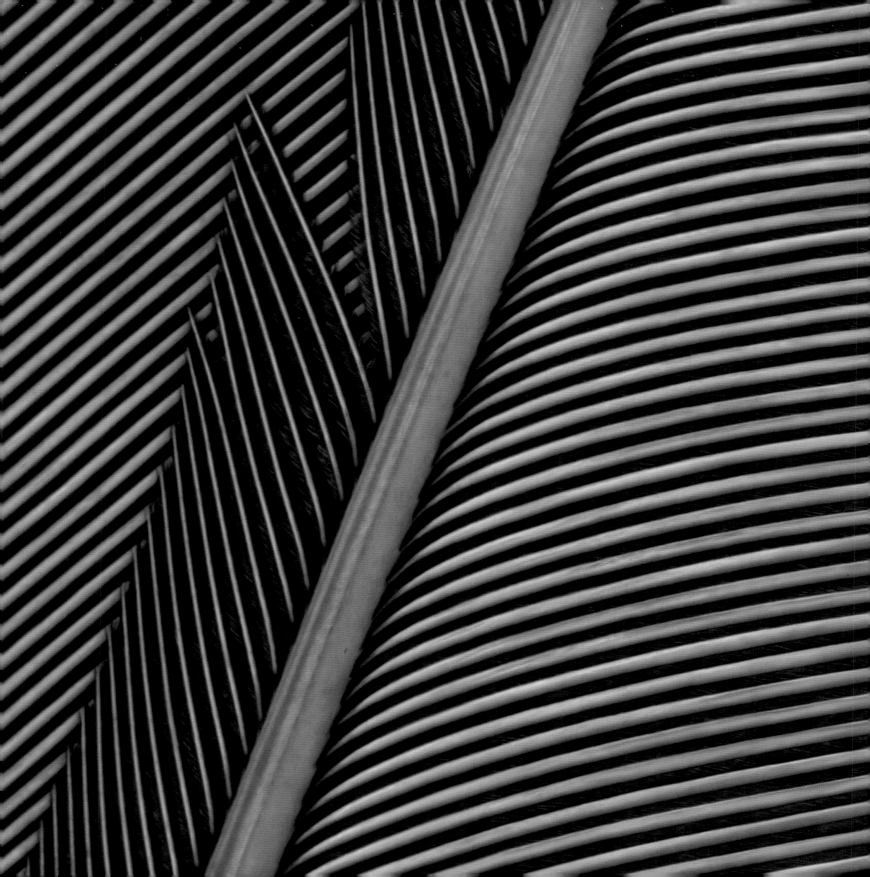

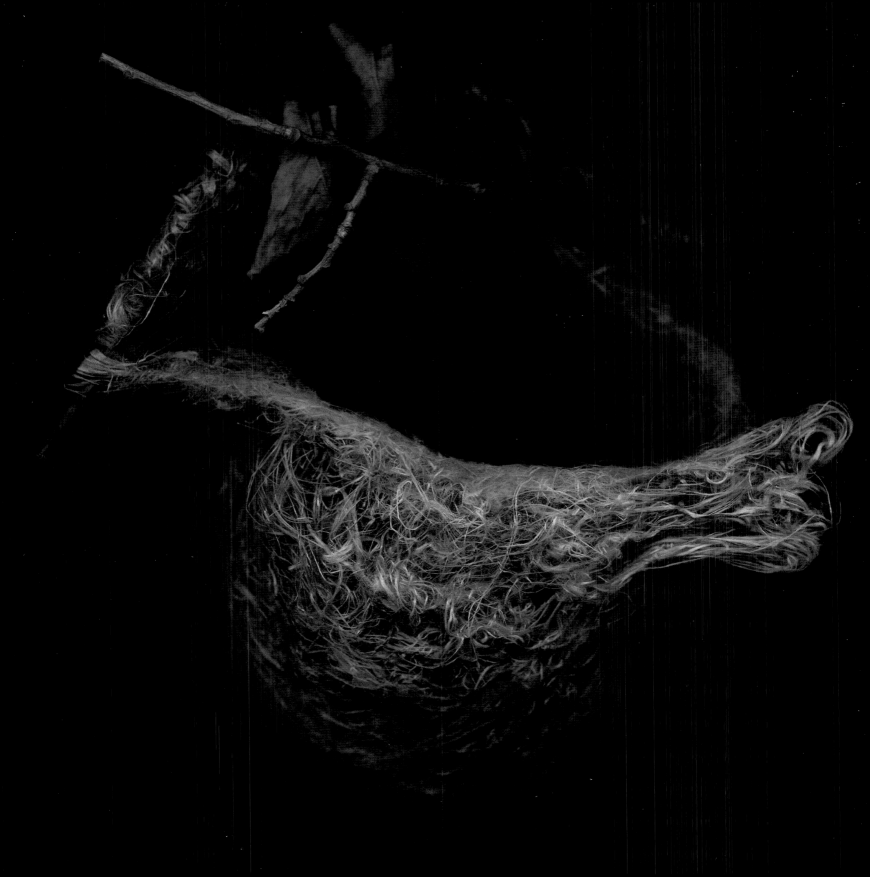

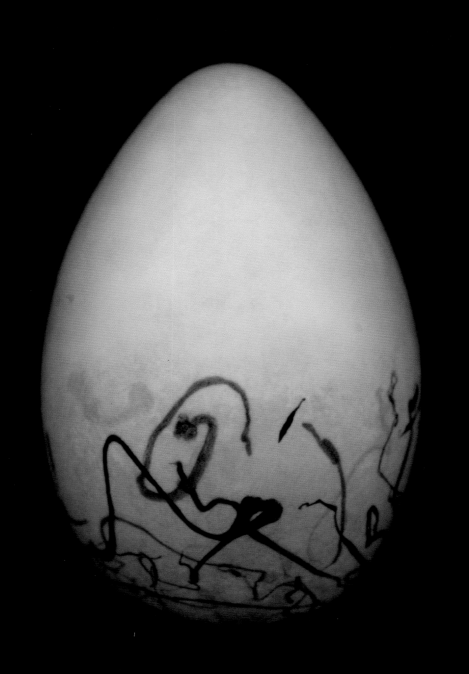

Blue Jay

Blue Jays are certainly not the most delicate and retiring avian species: they are raucous, inquisitive, intelligent and aggressive. Generalist foragers like crows, to which they are closely related, they feed on seeds in the bird feeder or snatch eggs or young out of other birds' nests. They band together to mob predators and intruders and migrate in large flocks. Males and females both take care of nest building and feeding of the young, and while the female is solely responsible for incubation, the male stays nearby and feeds the female on the nest.

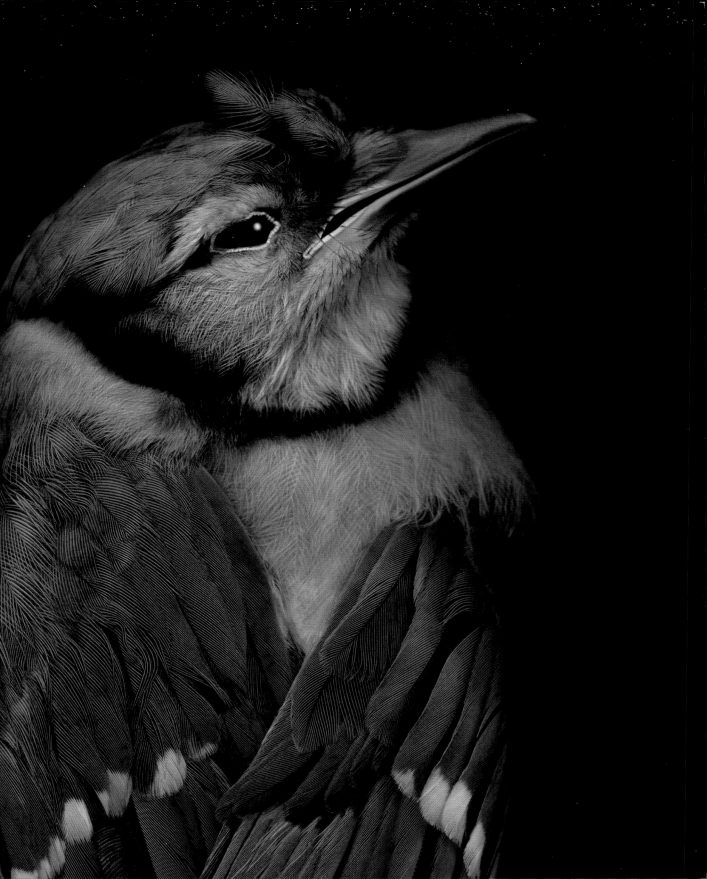

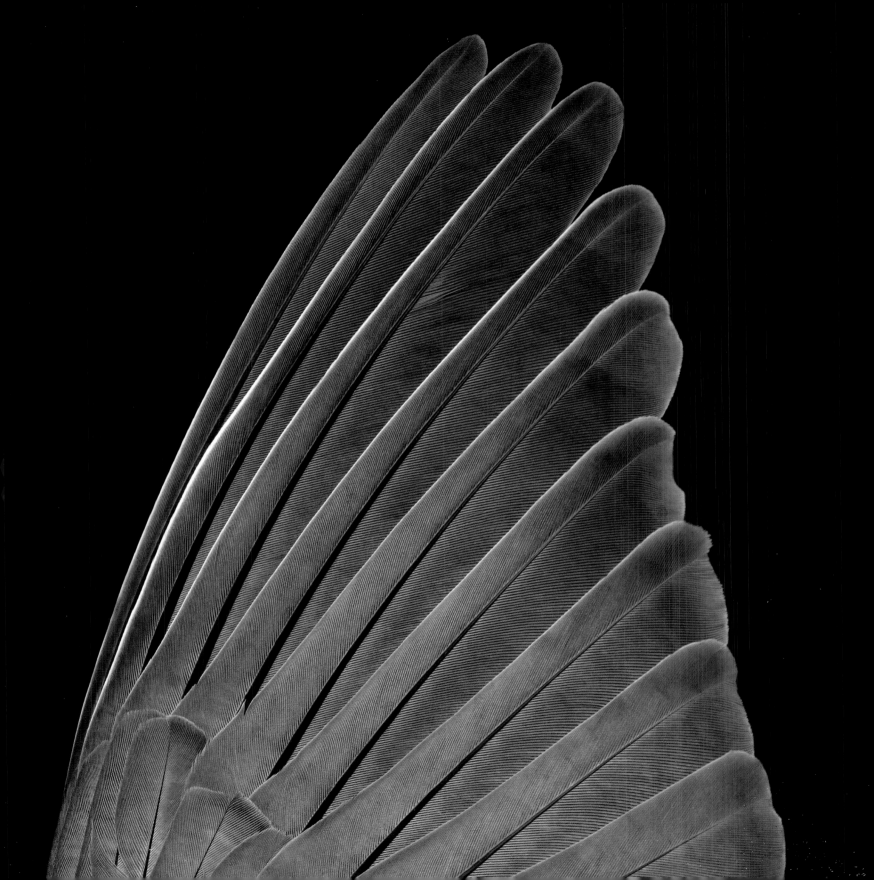

Mourning Dove

The wing of a Mourning Dove has ten primary feathers. These feathers, which are the longest on the bird's wing, are responsible for thrust. Each feather can be rotated individually and thus allows greater aerial control. Flight feathers are moulted and replaced each year, usually in September and October. The inner primaries are shed first, one or two at a time, and it takes approximately four to six weeks to replace all the feathers.

Chipping Sparrow Egg and Nest, and Brown-headed Cowbird Eggs

OPPOSITE AND NEXT SPREAD

Chipping Sparrows have adapted well to the human landscape. Their simple nests made of grasses, twigs and rootlets are found in gardens, farmyards, tree plantations, orchards and nurseries throughout much of North America. The pale bluish spotted egg is not much bigger than your little fingernail. The heavily spotted brown eggs of the Brown-headed Cowbird stand out in stark contrast. Cowbirds are nest parasites, laying their eggs in the nests of other species, relying on the 'host' parent to incubate them and raise the young. Chipping Sparrows are among the Cowbirds' favourite hosts.

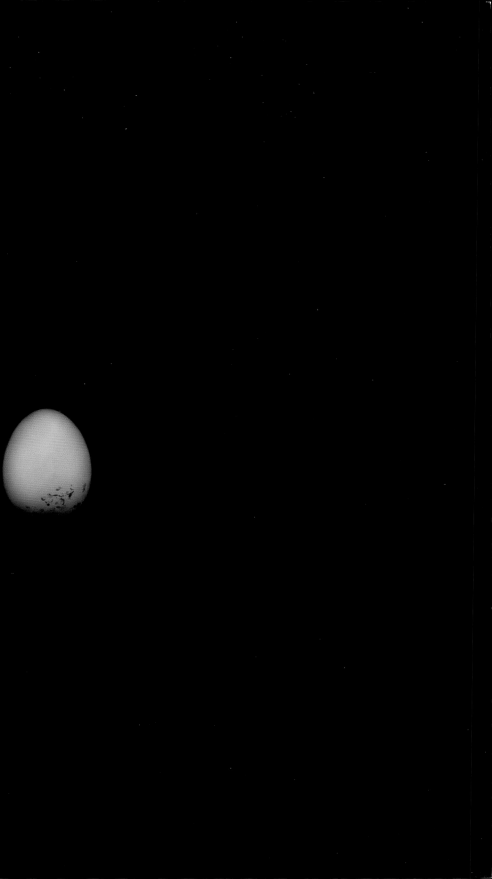

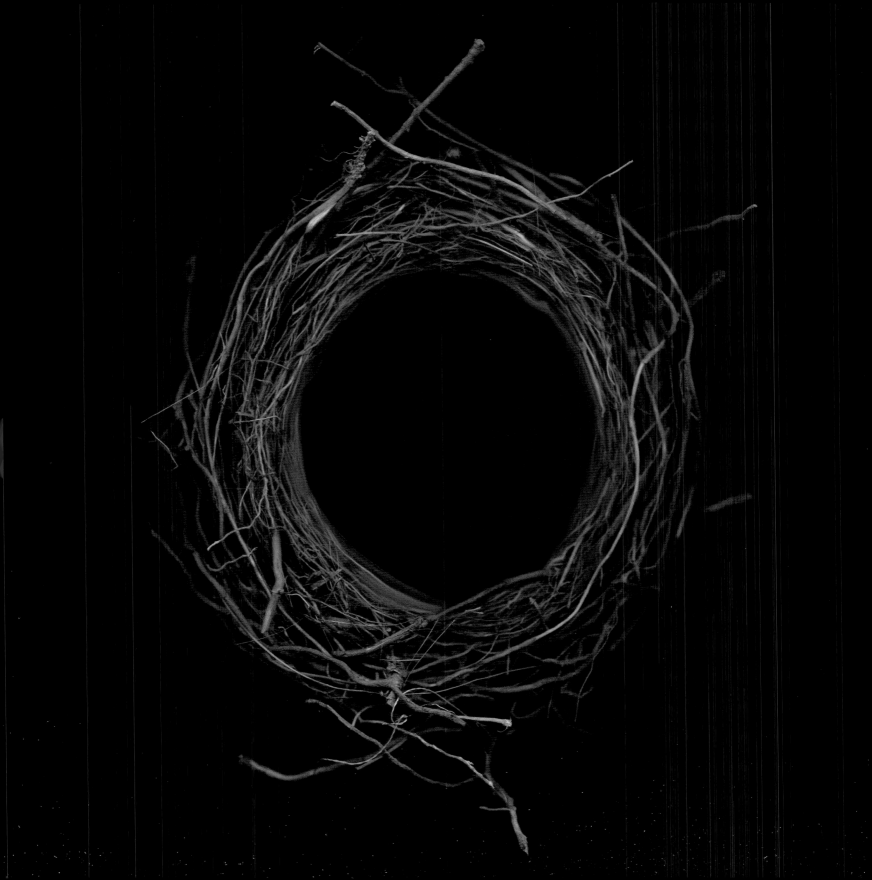

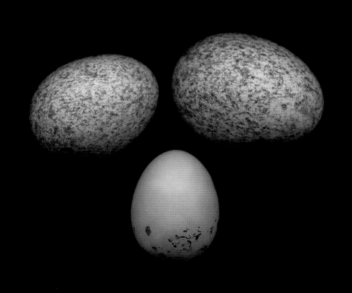

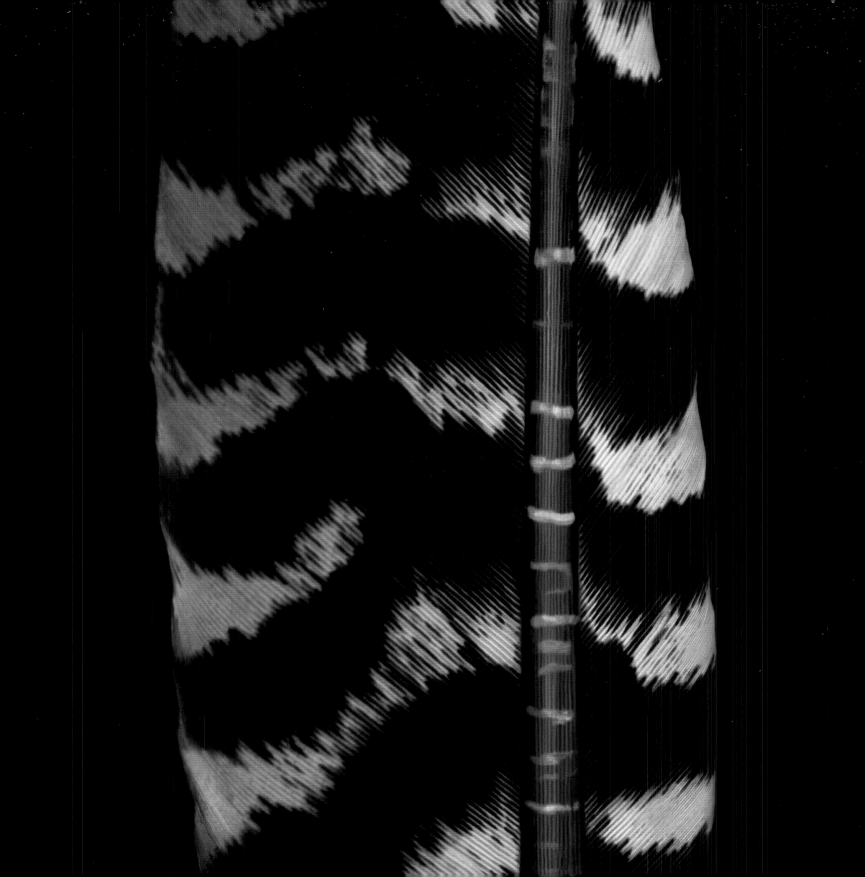

Wild Turkey

The Wild Turkey, which is the same species as the domesticated turkey, is the largest of the Galliformes (turkeys, grouse, quail and pheasants) and one of the largest and heaviest flying birds on earth today. The large, stiff wing feathers have brown and white bands, and the wings are rounded, allowing the bird a short powerful flight followed by a glide for as much as 1 kilometre / 0.6 miles. Adult turkeys moult their wing feathers annually during the summer, but only shed them one or two at a time so that they will still be able to fly throughout the moulting period.

Common or Ring-necked Pheasant

The Common Pheasant, known as the Ring-necked Pheasant in North America, is native to Asia but has been introduced in many parts of the world as a gamebird. First introduced in Europe during the Roman Empire some 2,000 years ago, it has been in Britain for over 1,000 years and in North America since the 1880s. It is now one of the world's most popular and hunted gamebirds.

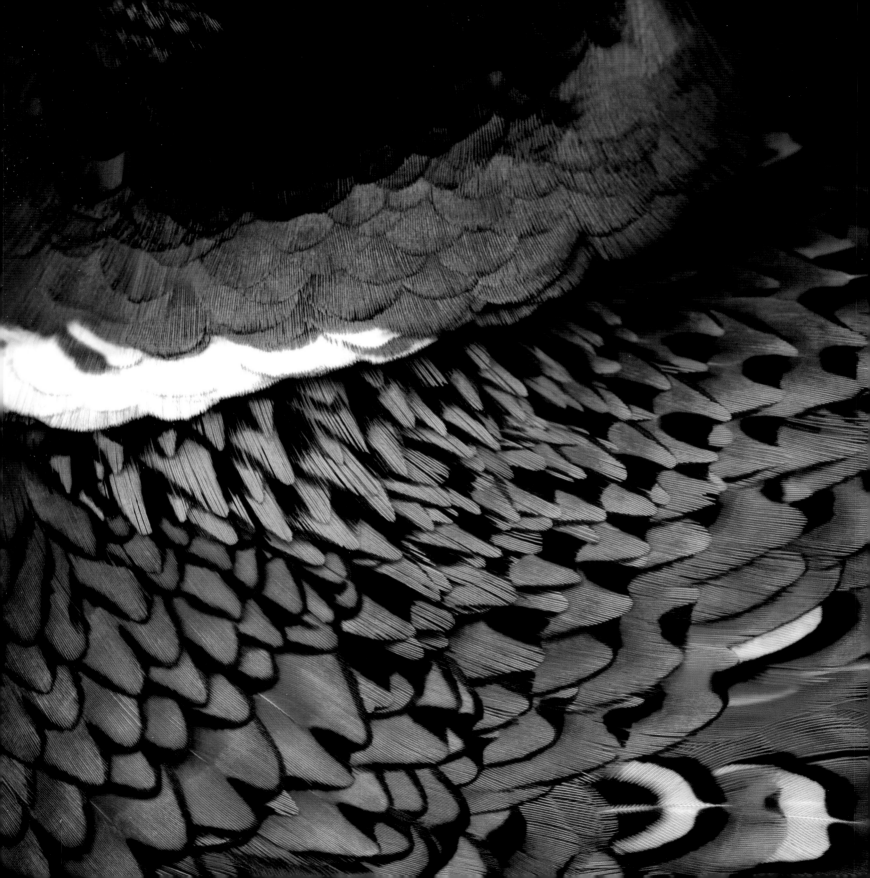

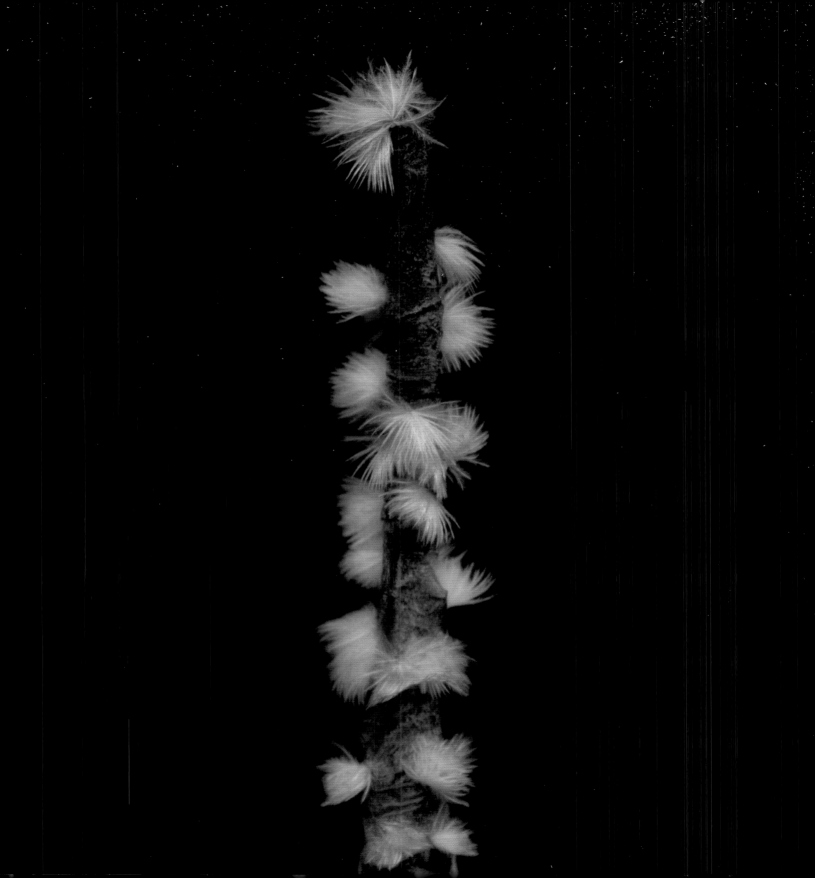

White Bellbird

The four species of bellbirds are members of the Cotinga family,
some of the loudest and most unusual birds in the Americas.
Males in all but one species have conspicuous black wattles hanging
from their head, while those in the fourth species have bluish green
faces and bare throats. The White Bellbird has a cylindrically shaped
wattle with little tussocks of white feathers hanging loosely from
just above the bill. This striking adornment may be as much as
5-7.5 cm / 2-3 inches in length.

Black-billed Magpie

The primary flight feathers of a Black-billed Magpie are mainly white, with black edges and tips. The distinctive coloration makes the bird easy to identify in flight. There is an important reason why black wingtips are common in many species of white birds, including magpies, gulls and geese. White feathers lack melanin, a pigment that provides strength as well as colour. Flight feathers wear out particularly fast, and adding a pigment-rich black border makes them much more resistant.

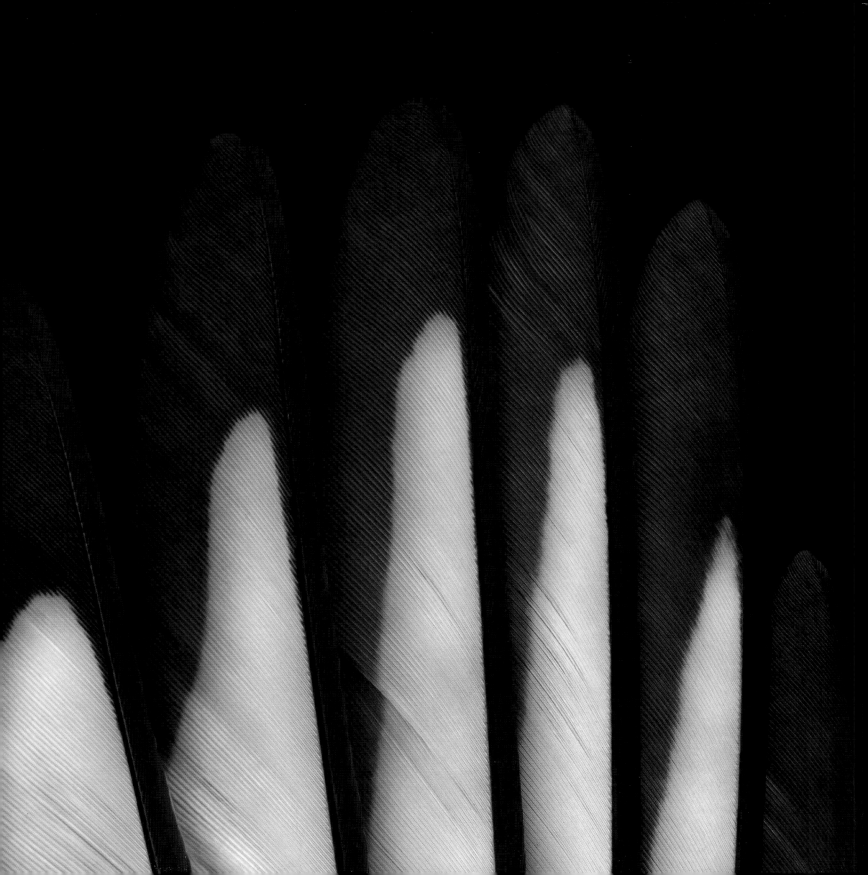

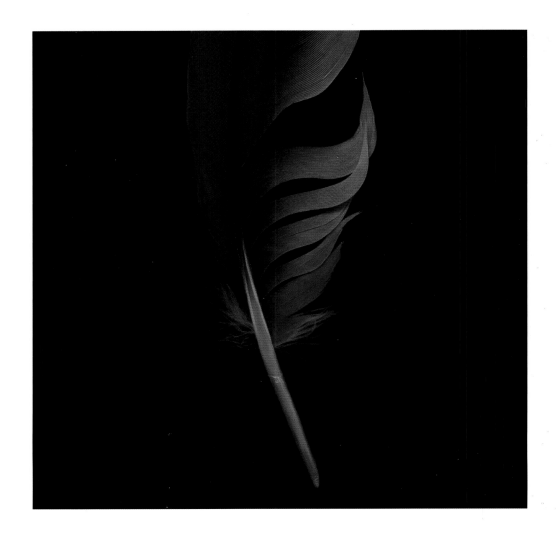

Hyacinth Macaw
ABOVE AND OPPOSITE

The Hyacinth Macaw is the longest and largest of the flying
parrots. Prized as a cage bird and for its beautiful feathers, it
is now endangered in the wild. The illegal pet trade has had a
disastrous effect on macaws and other parrot species, but the sale
of feathers for ceremonial use and feather art is now also having
a serious impact. As ecotourism moves into more remote areas,
endangered species or their plumage parts are often offered for
sale as trinkets or souvenirs.

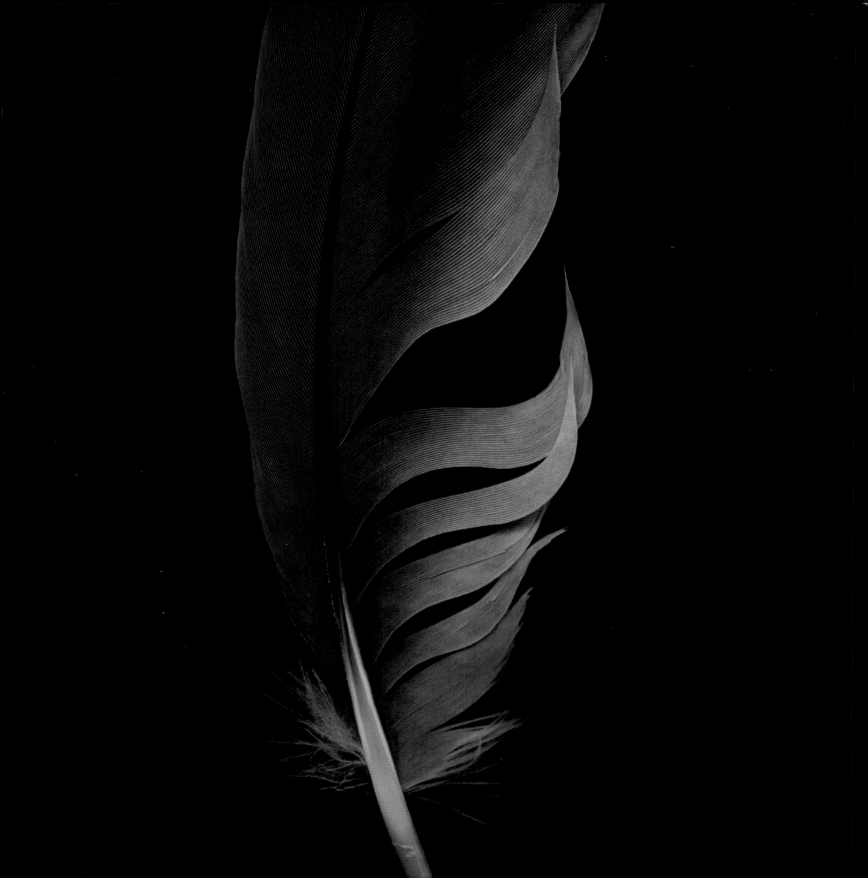

Black-billed Magpie

Black-billed Magpies are among the most eye-catching members
of the crow family. There are twelve subspecies recognised in the
Old World but only one found in North America. Magpies are found
throughout much of central western North America and coastal
Alaska. Adults have white scapulars, or shoulder feathers, and
iridescent blue and green wings and tails. The juveniles have more
white colouring on their wings than the adults but the shape of the
white patch is similar in adults and their young.

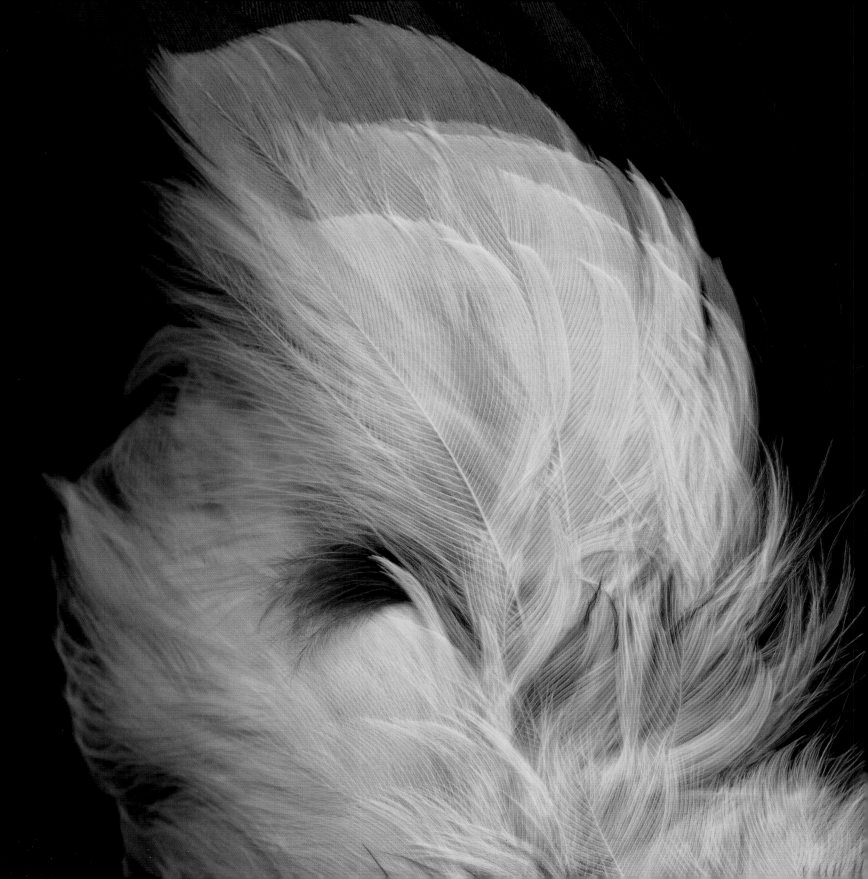

Reeve's Pheasant

Male pheasants are some of the most extravagantly coloured birds in the world. The plumage is thought to play an important role in courtship and mate selection. As a general rule, the more gaudily coloured the male, the less likely he is to help in raising the young. The beautifully patterned feathers in this image are from the back of the bird. In addition to its striking body plumage, the Reeve's Pheasant also has the longest tail feather of any bird species, with some recordings showing measurements of up to 2.4 m / 8 feet. Reeve's Pheasants are usually monogamous although polygyny has been observed in captive birds.

———

Magnificent Bird-of-paradise
NEXT SPREAD

Male Magnificent Birds-of-paradise are both solitary and promiscuous. They clear and maintain a terrestrial 'court' several square metres in size and containing several vertical saplings. During courtship, males face females, lean horizontally and dance up and down the saplings. They flatten their iridescent green breast feathers into a shield, erect and fan their yellow shoulder cape behind their head and proceed to gently tremble, in the hope of enticing the female to copulation. This image is viewed from the back of the male, a sight the female bird-of-paradise would rarely, if ever see during courtship.

104

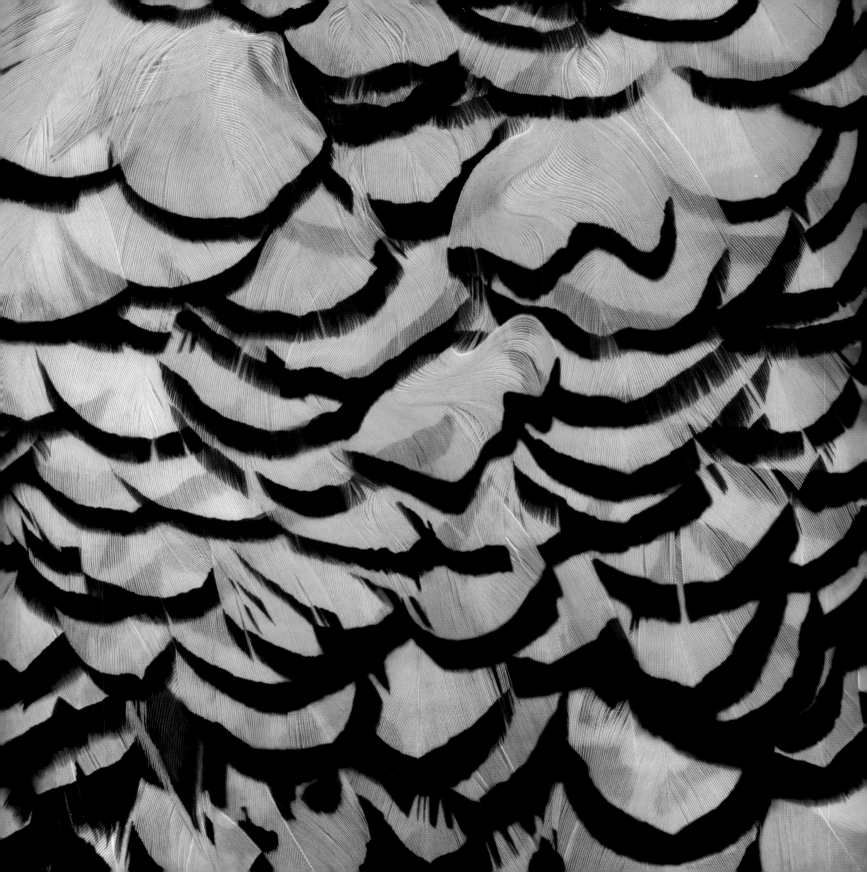

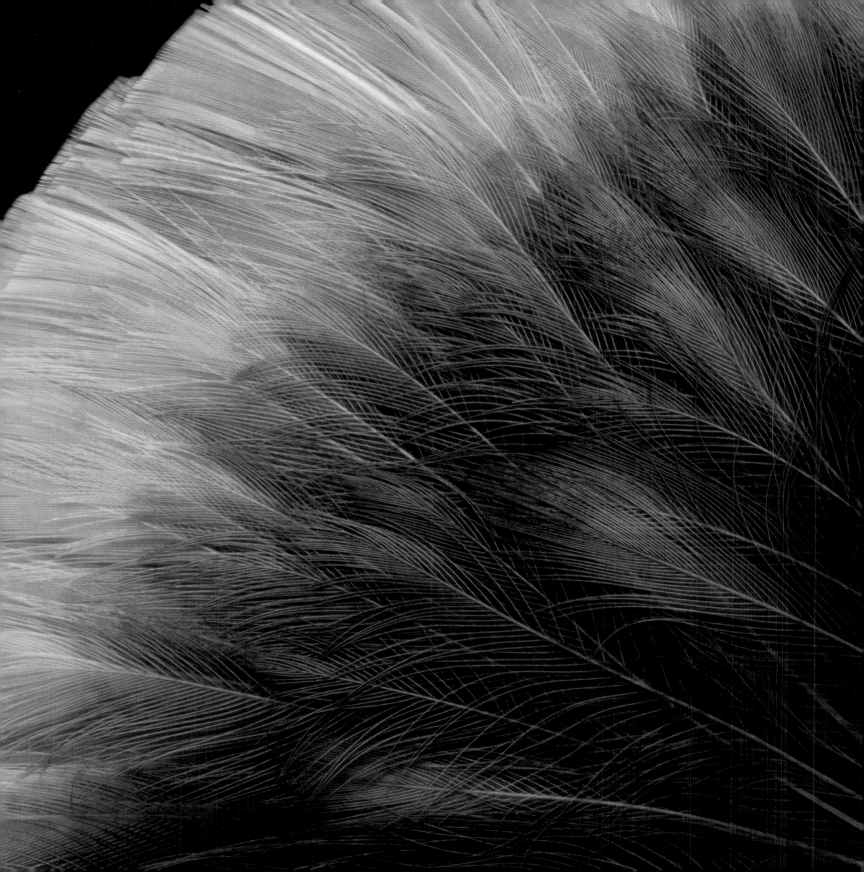

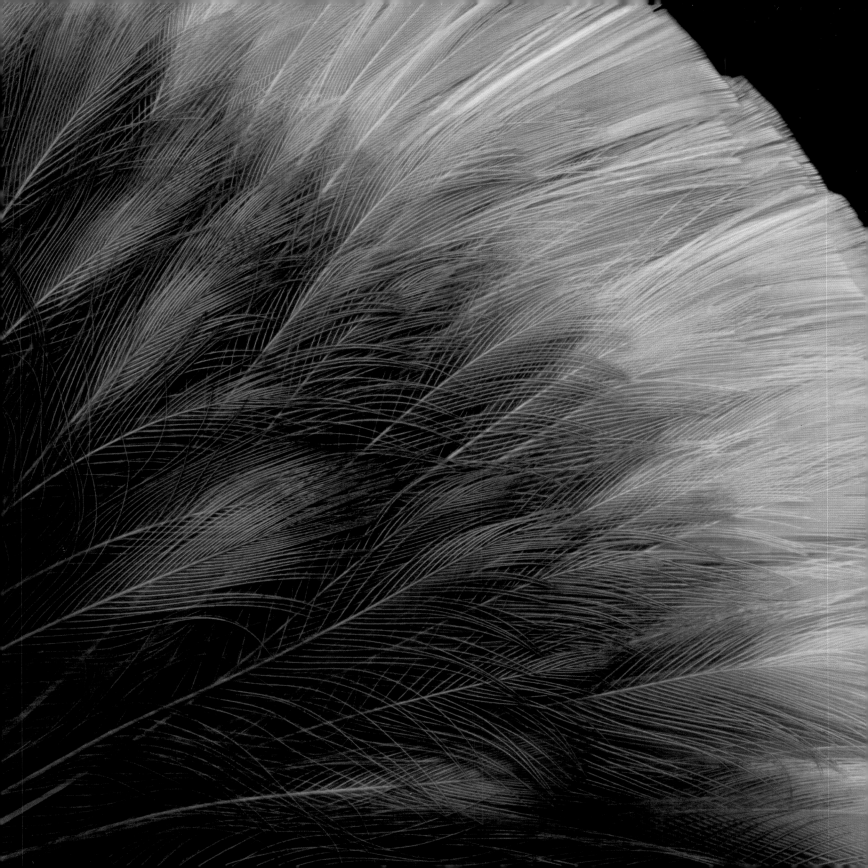

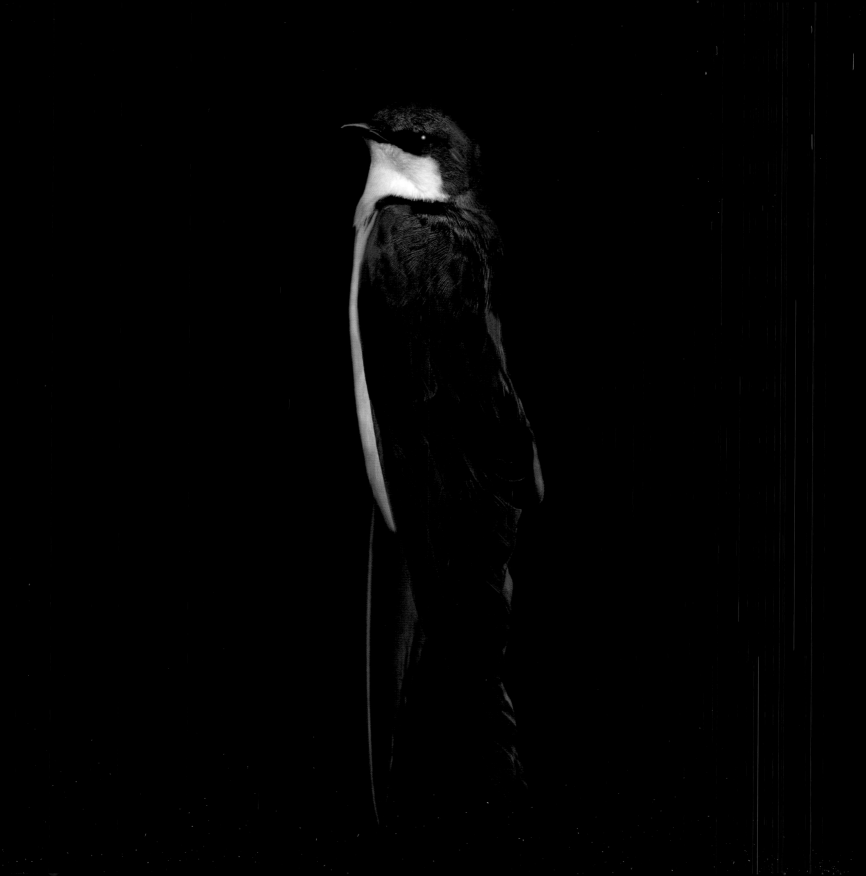

Emu Egg / Greater Rhea Egg

PREVIOUS SPREAD

Emu and Rhea eggs are among the largest in the bird world. The eggs
of both species are similar in size and may weigh close to 1 kg / 2 ¼
pounds. They hold the equivalent volume of approximately ten chicken
eggs. Egg shells are composed primarily of calcium carbonate, with a
small proportion of protein matrix. Rhea eggs have a porcelain-like shell,
pockmarked with hundreds of pores. The avocado-like emu egg, both in
appearance and size, tends to be more textured than that of the rhea but
may vary considerably between individual females. Eggs are formed in
the oviduct, and emus and rheas produce them every two to three days.

———

Tree Swallow

Swallows are found in fields and wetlands throughout much of North
America. Acrobats of the air, they have long, pointed wings and feed
on insects, which they catch in flight. Their small feet are positioned
close to the body, which makes walking difficult. They are a migratory
species, wintering in the southern United States and Mexico. During
colder weather, Tree Swallows may switch their diet to small fruit
and vegetable matter.

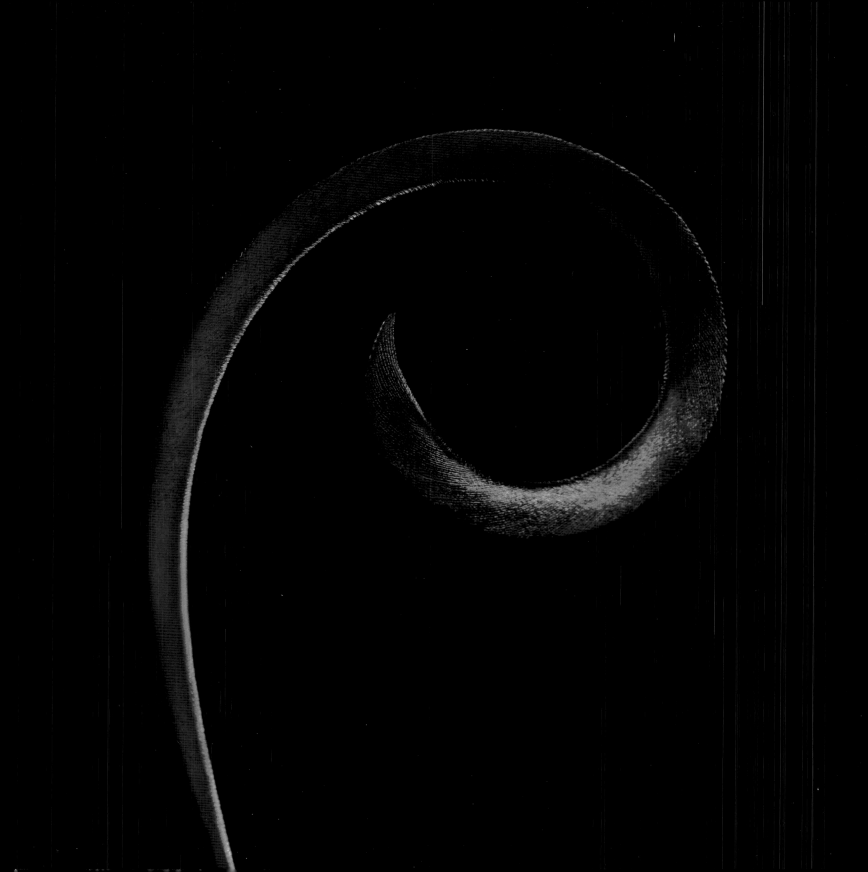

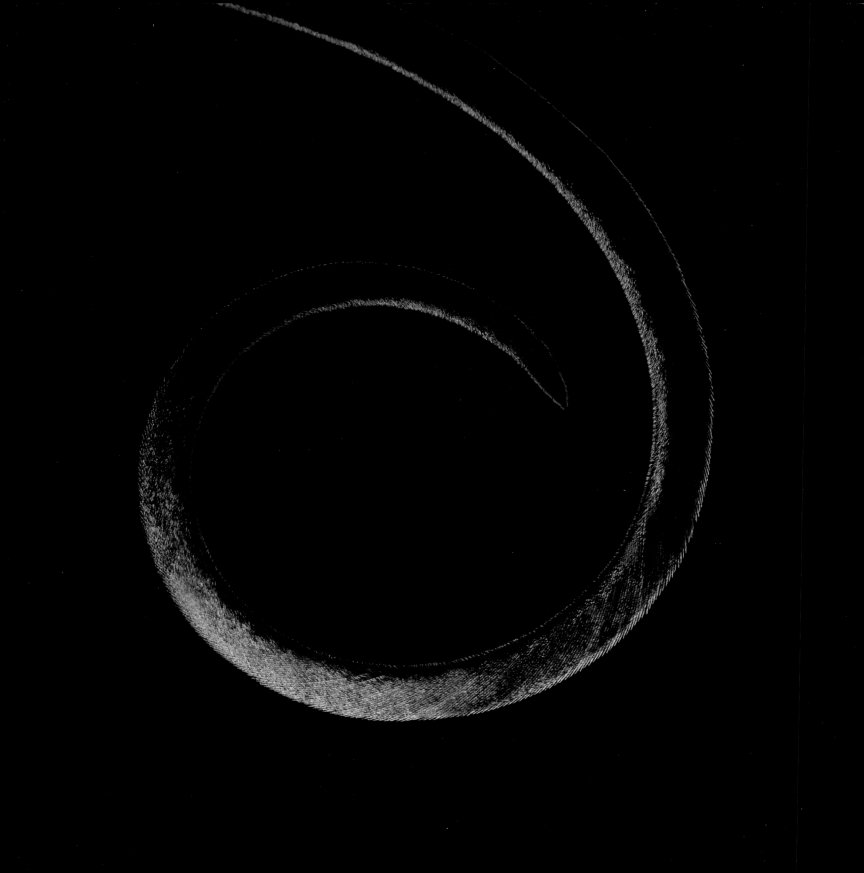

King of Holland Bird-of-paradise and Wilson's Bird-of-paradise

PREVIOUS SPREAD

The King of Holland Bird-of-paradise is a hybrid between the Magnificent and King Bird-of-paradise. Like the other two species, it has elaborate, elongated iridescent central tail feathers. The green tail feather, looking rather like Salvador Dalí's famous moustache, is similar to that of the Magnificent Bird-of-paradise. Wilson's Bird-of-paradise has a smaller but still very impressive metallic purple 'moustache'. All three of the tails play an important role during courtship and are displayed prominently to potential suitors.

———

Rusty Blackbird Nest

The Rusty Blackbird nests in the bogs, swamps and fens of northern North America. The nest is typically situated low in a tree or shrub, often close to water, and of a similar size to that of an American Robin. It is built mainly of grasses, twigs and mosses, but wet peat is often added to provide greater strength to the rim and sides. Rusty Blackbirds build new nests every year but the Solitary Sandpiper will often use their old nests.

114

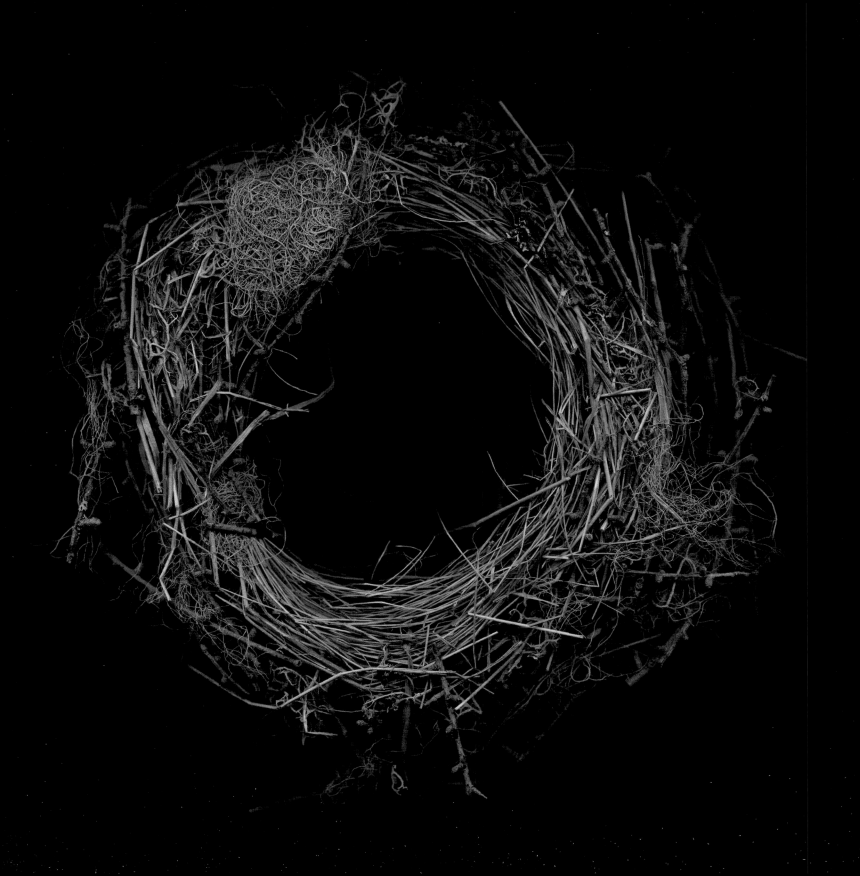

Great Horned Owl

Like hair and nails, feathers are made of keratin. Each feather grows from a follicle found in the dermal and epidermal layers of the bird's skin. It emerges encased in a sheath, with an artery running through the shaft. Finally the fully-formed pigmented feather breaks through the sheath. When the feather has reached its full size, blood is no longer needed and the artery shrivels up.

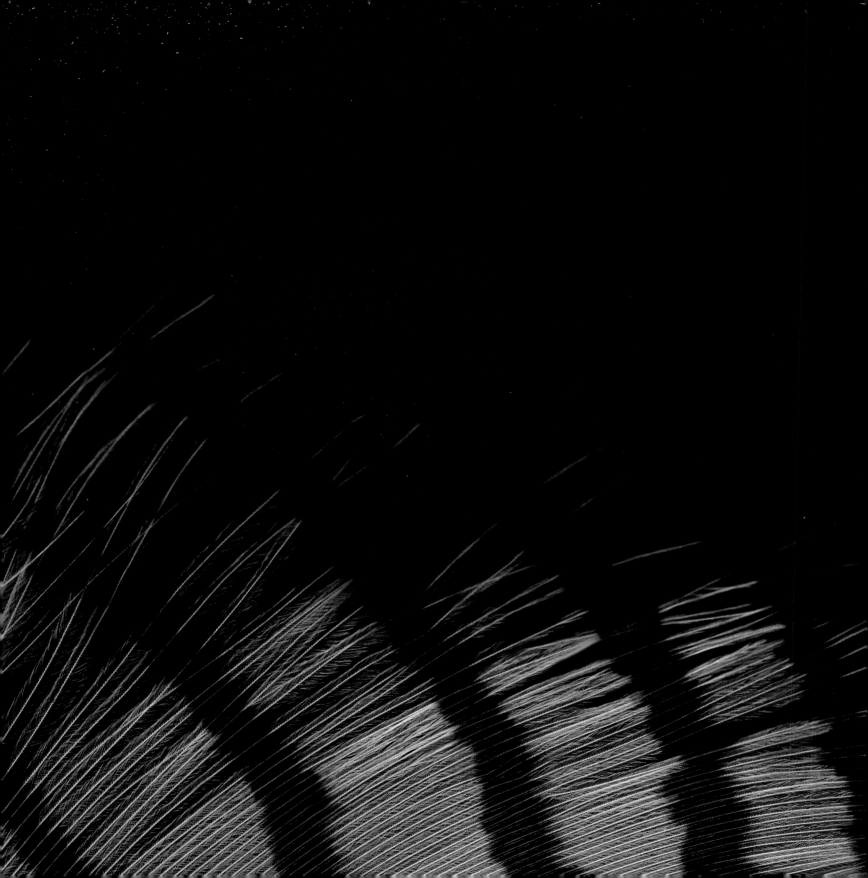

Great Horned Owl

Great Horned Owls hunt during the night and rest during the day. They can often be found sitting high up in a tree, and their cryptic plumage blends into the surroundings. The barring on the feathers breaks up the owls' outlines, allowing them to go unnoticed by other birds and humans. The plumage of Great Horned Owls is generally mottled grey-brown but there is considerable geographic variation in tone and intensity.

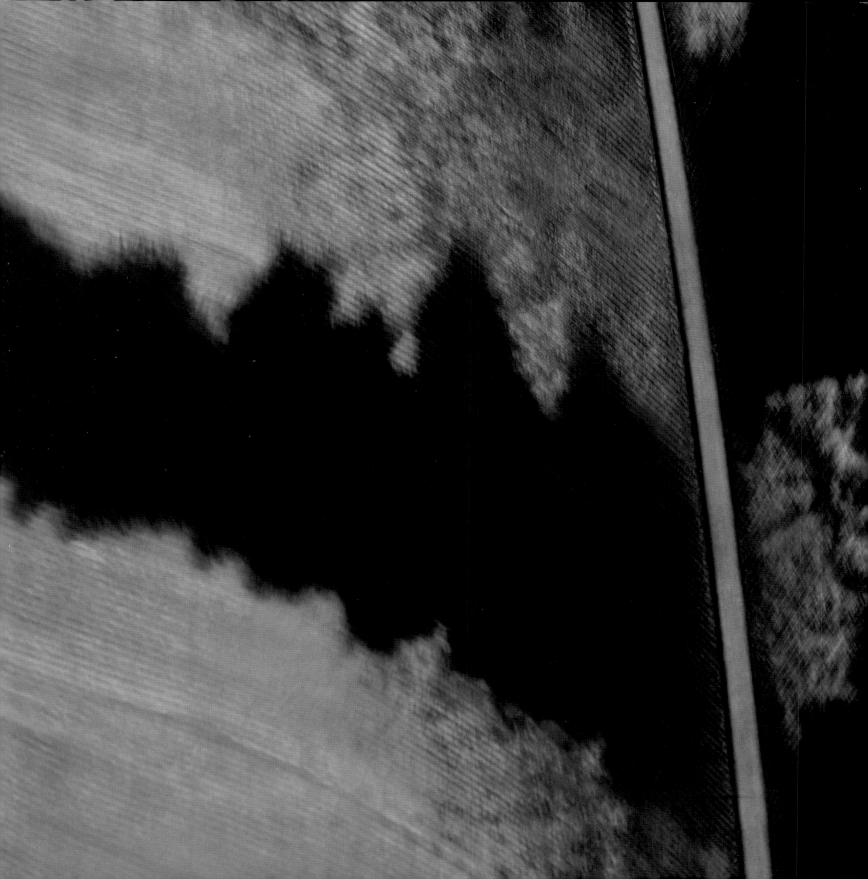

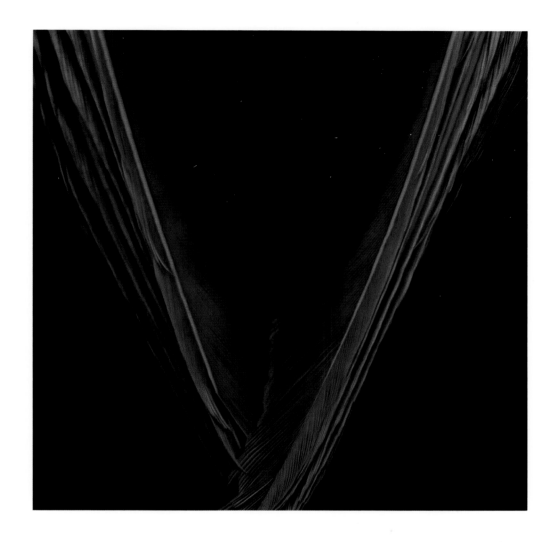

Makira Starling

Bird wings are beautiful in their design and simplicity. The largest feathers, the primaries, secondaries and tertials, are collectively known as the flight feathers. The smaller, overlapping feathers that protect the flight feathers, smoothing the airflow over the wing, are known as coverts. When the wings are folded, the primary feathers come together, overlapping each other, and are protected by the body feathers and the tertials, the innermost flight feathers.

Great Grey Owl

Most owl species are nocturnal and rely on stealth and secrecy to catch their prey. Owls are not the fastest flying predators but they are some of the quietest. Their feather and wing structure has evolved to provide them with almost silent flight. Owls have broad wings with a large surface area allowing them to stay aloft without flapping much. In addition, the anterior edge of the feather helps to disrupt airflow into smaller vortices which are then absorbed by the additional velvety, downy structure of the feather.

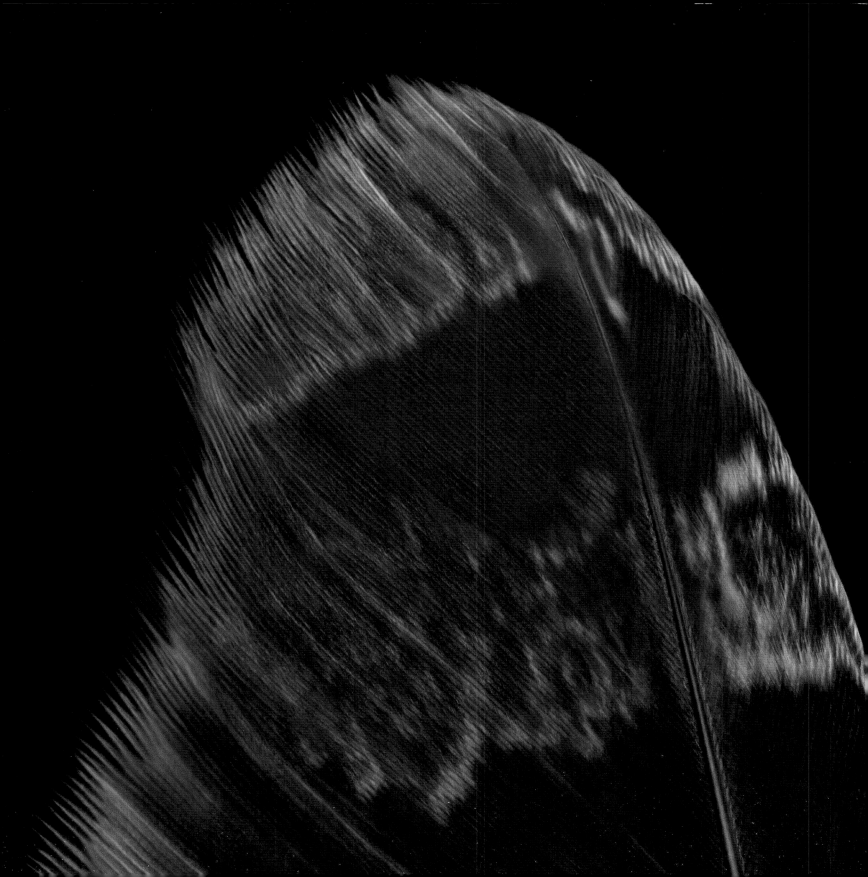

King Bird-of-paradise

The King Bird-of-paradise is one of the smallest of the group,
with the males only measuring approximately 16 cm / 6 ¼ inches
exclusive of their tail adornment. Their white breast, bright blue feet,
crimson-orange back and head, and their iridescent green-tipped
shoulder plumes are striking. However, the most arresting feathers
of all are the two elongated tail wires with iridescent emerald green
spiral tips. During the courtship dance, the tail wires are raised
behind the head and sway gently back and forth.

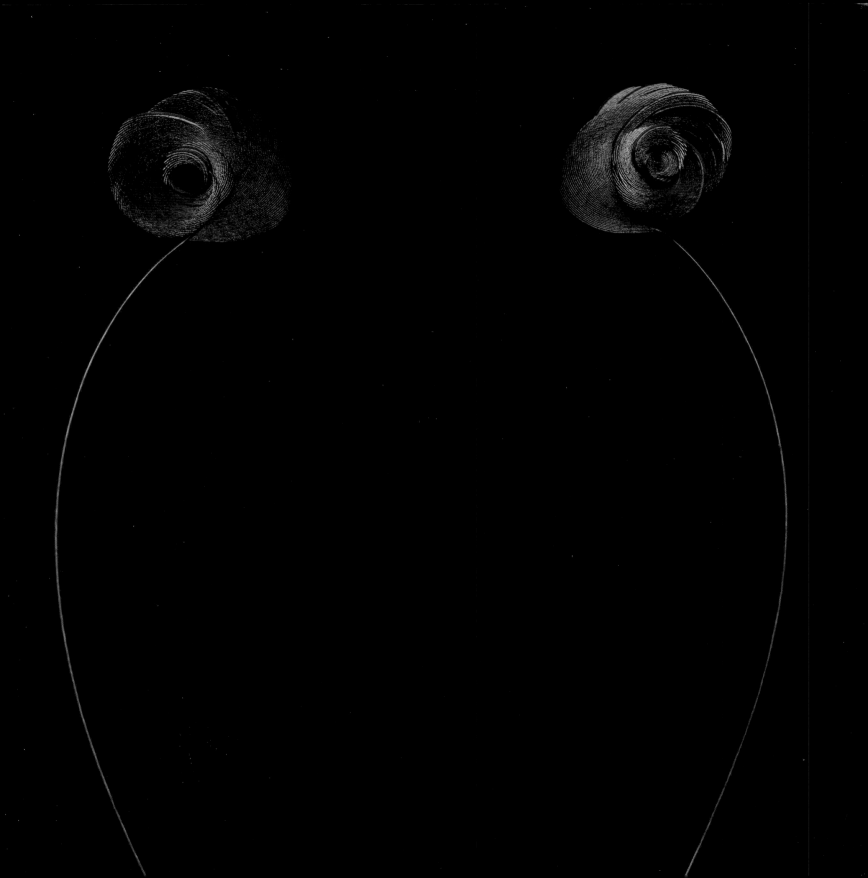

American Crow

The crow, and its close relative the raven, are thought to be some
of the cleverest birds on earth, with intelligence ratings similar to
chimpanzees. Unfortunately, crows and ravens are not generally popular
with humans. It may have something to do with them being scavengers,
or perhaps it is because in many cultures their metallic black feathering,
with hints of iridescent violet, has been associated with death, evil or
the occult. But whatever the original reason, crows and ravens have
long suffered from persecution. In the United States their winter roosts
were often dynamited in the past, and they are still hunted today.
The crow is one of the few bird species not protected in Canada.

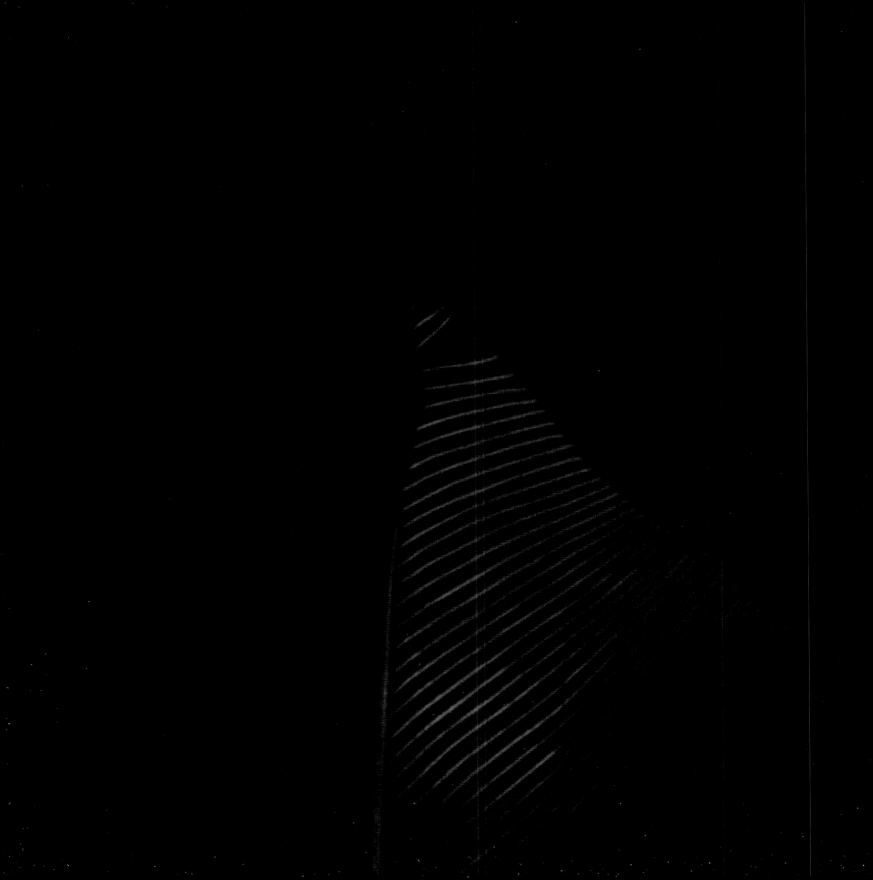

American Crow

There are over forty species of crows and ravens throughout the world, all belonging to the genus Corvus. Most are large and black with glossy wings highlighted with violet iridescence. Immature crows are less glossy, especially on the wings and tail. American Crows have rounded wings and a wingspan of approximately 36 inches or 91 cm. In northern parts of their range they migrate in murders (flocks) of between thirty and two hundred, and will often winter in huge murders of several thousand birds.

Hooded Pitta

Pittas are a terrestrial group of songbirds found throughout much of Asia and Australia. These elusive, brightly-coloured birds have large, dark eyes, a sturdy bill and a very short tail. Although they are diurnal, they are often difficult to see when they forage for worms, snails and other invertebrates in the darker areas of forests and gardens. Males and females are similar in appearance, and the species is monogamous, with both parents involved in nest building, incubation and caring for the young.

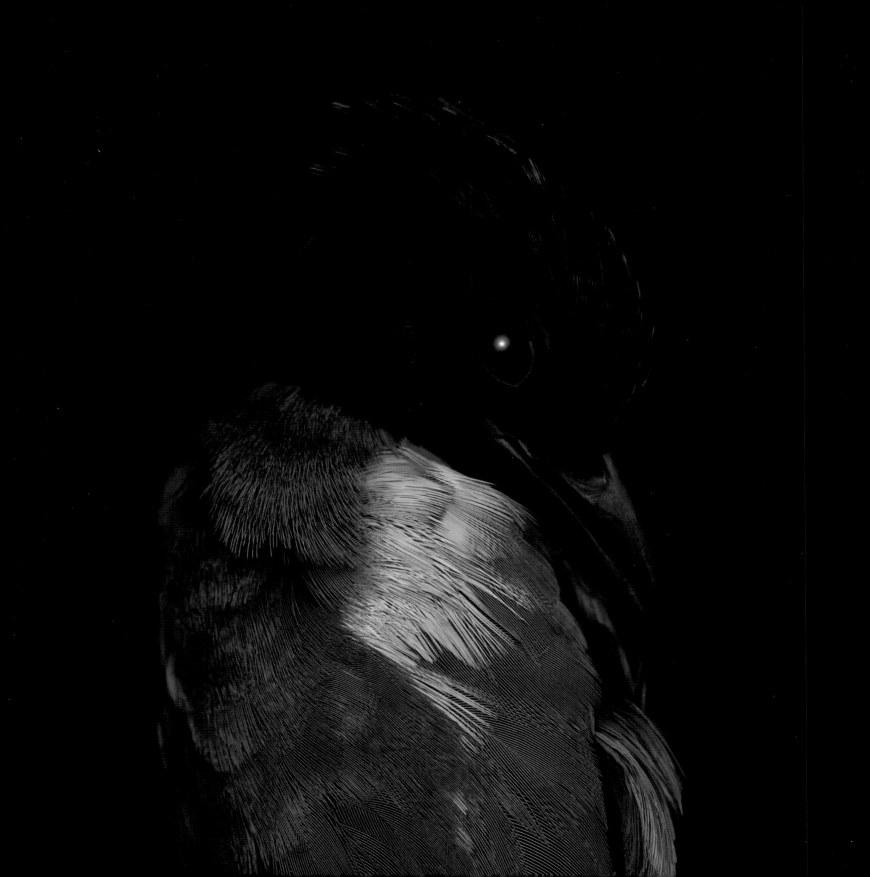

Blue and Yellow Macaw

Feathers, especially flight feathers, may have different colours on each side. The wing and tail feathers on a Blue and Yellow Macaw are a brilliant blue on the upper side and a yellowish green on the underside. The underside of a feather is generally lighter in colour since it is folded close to the body and not required for camouflage or courtship displays. The lighter coloration also requires less pigmentation and therefore less energy use.

———

Superb Lyrebird
NEXT SPREAD

One of the largest songbirds in the world, the Superb Lyrebird is endemic to Australia. Its tail is one of the most beautiful and extravagant in the bird world. The outer two tail feathers are wide and form the shape of a lyre, while the twelve inner feathers, known as filamentaries, are wispy and lacy. The tail does not reach its full maturity for seven years and is found only on the males.

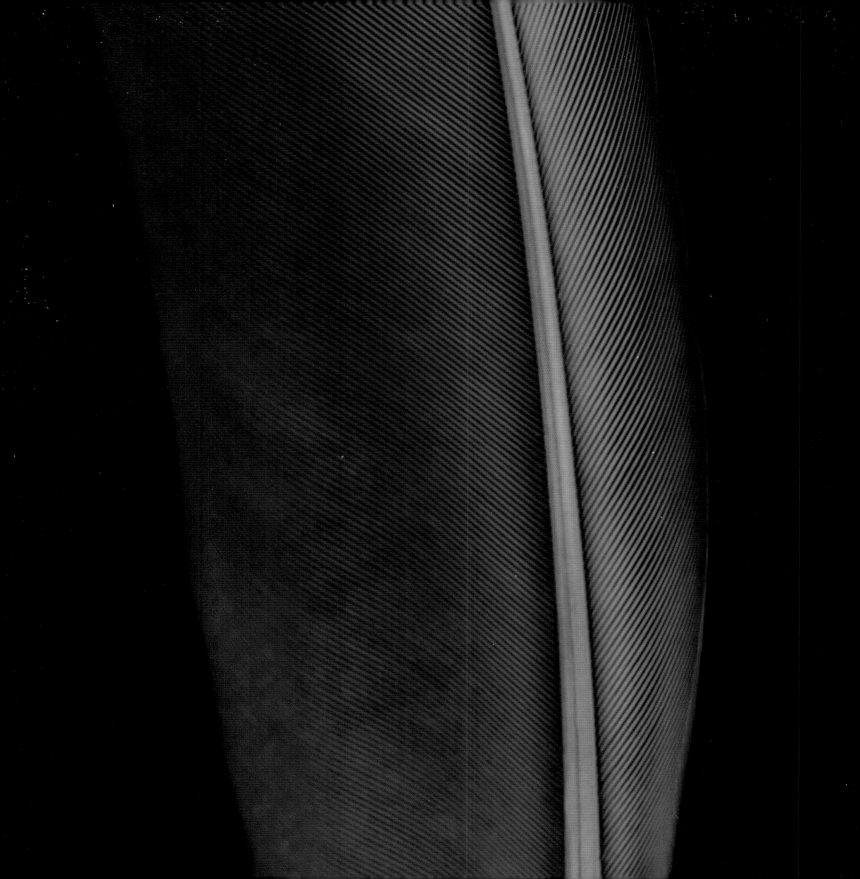

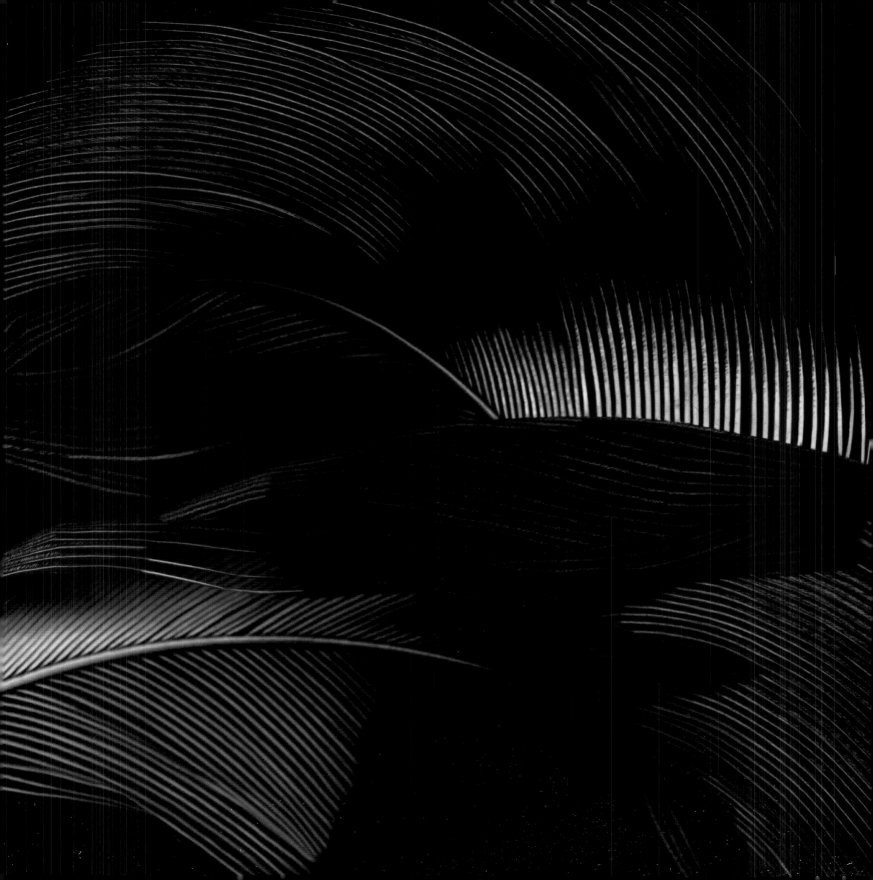

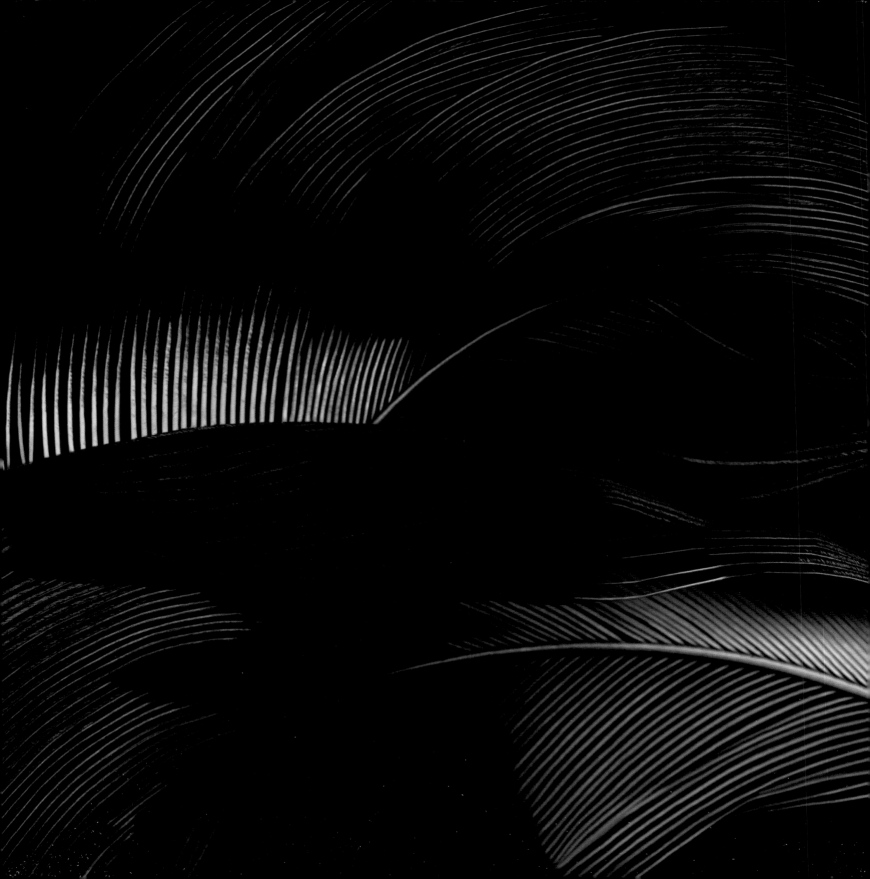

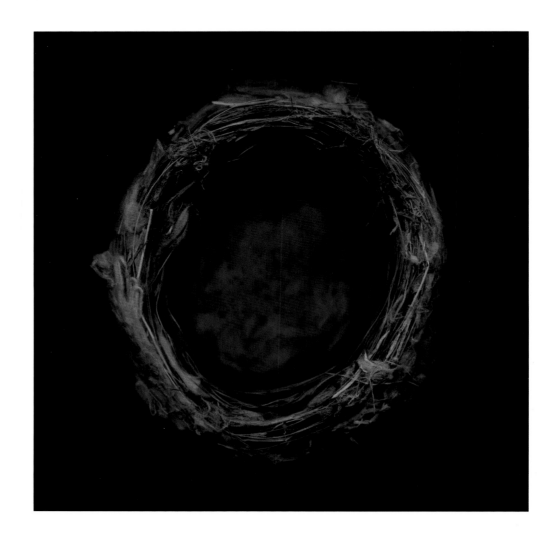

Least Flycatcher Nest

Similar in appearance to those of the American Redstart, the compact
nests of the Least Flycatcher are typically built in young deciduous
trees, often in the mid canopy. Frequently composed of bark strips,
grasses and plant down, they are held together with spider and
caterpillar webs and lined with grasses, animal hair and plant down.
Least Flycatchers will often re-use parts of last year's nest or take
material from the nests of other songbirds in the area. The nests are
built by the female alone but males assist with the care of the young.

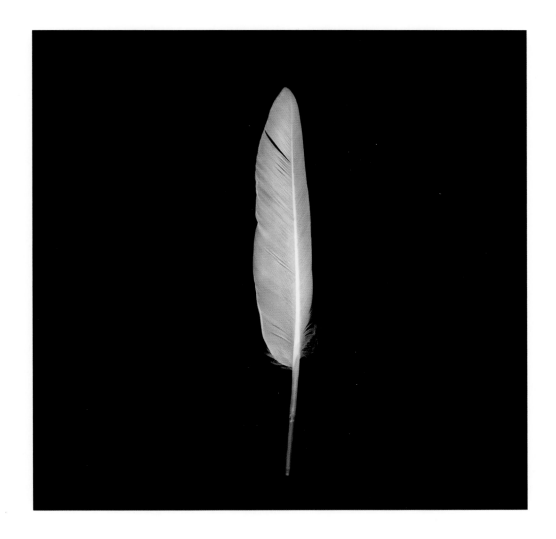

Domestic Duck

Behind the simple, exquisite beauty of a feather lies one of the most
complex integumentary structures found in vertebrates. Only birds and
a few theropod dinosaurs have ever evolved feathers. There are several
different types of feathers, from the vaneless down feathers used for
insulation to the stiffly-vaned feathers used for flight. Feathers serve
many different functions: insulation, flight, waterproofing, camouflage,
courtship, lining nests and even aiding in digestion by protecting the
bird's stomach when they are swallowed.

American Robin Eggs

OPPOSITE AND NEXT SPREAD

Robins typically lay their unmarked sky-blue eggs in the late morning or early afternoon, one egg per day until the clutch is complete. The average clutch size is three to four. Incubation usually begins after the last egg is laid, ensuring the eggs hatch at the same time. Eggs often become glossier as incubation progresses. Young that are hatched from more richly coloured eggs tend to receive more food from males. Approximately two thirds of nests contain at least one chick fathered by another male.

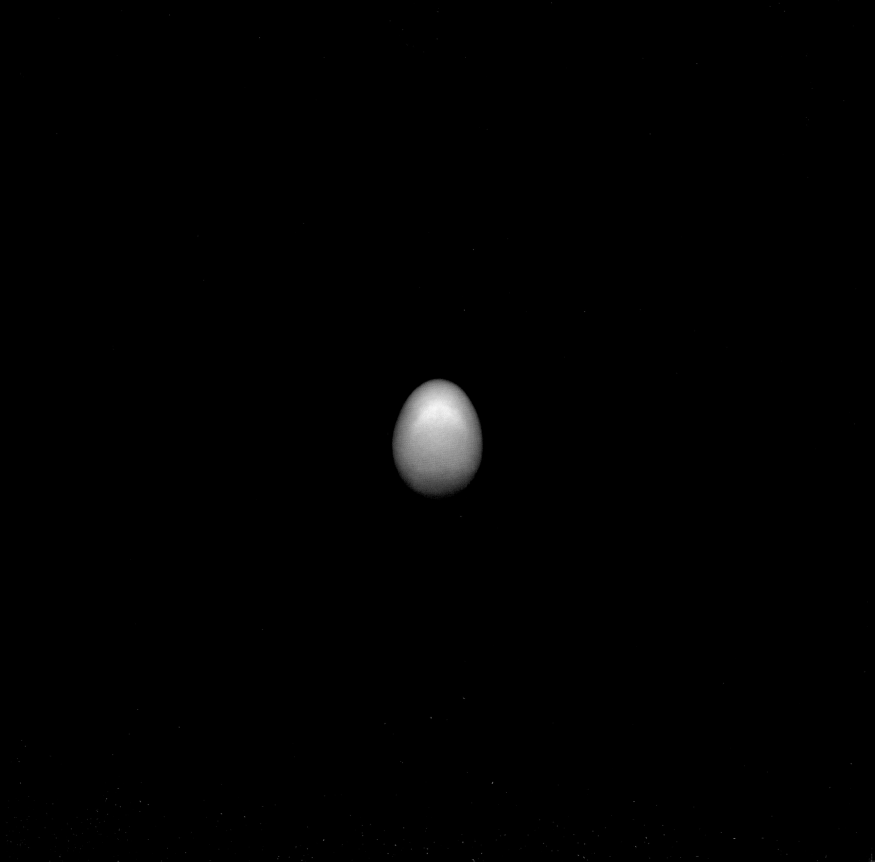

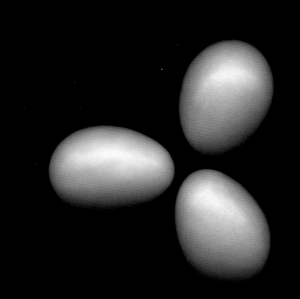

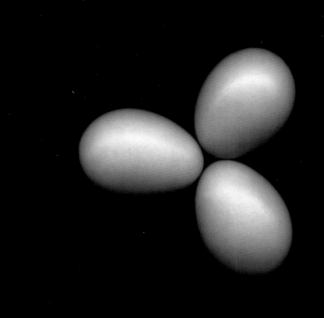

Cedar Waxwing

Waxwings are named after the small, brightly coloured droplets
produced at the end of the secondary flight feathers. These waxy tips
are found on both males and females and vary in number from one
to nine. The red colouring of the droplets comes from a carotenoid
pigment contained in some of their food. The purpose of these
decorations remains uncertain but it is suspected they may play
an important role in mate selection.

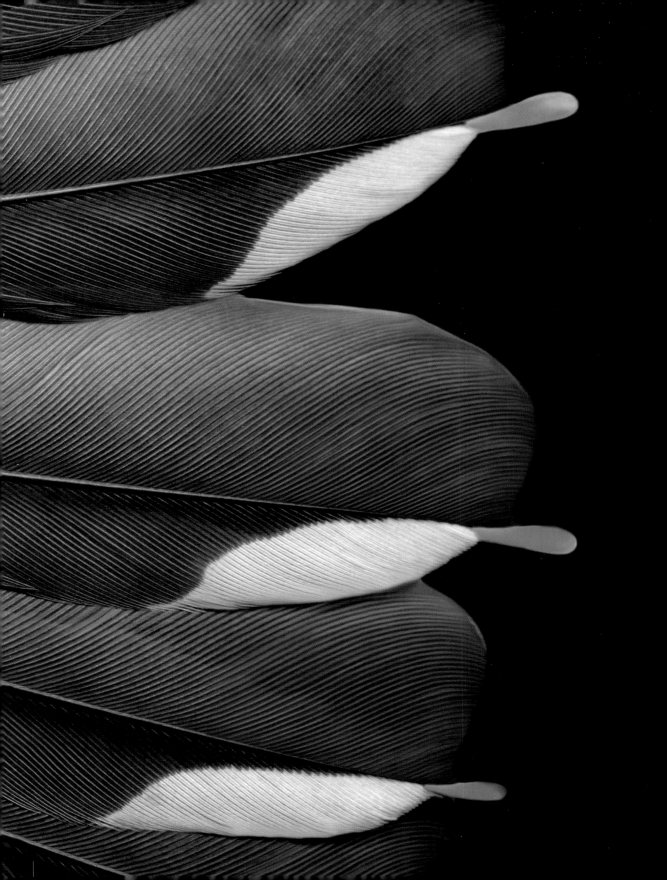

Olive-backed Sunbird Nest

Like the hummingbirds of the Americas, the sunbirds of Asia and
Australia mainly feed on nectar. They supplement their diet with
insects, especially when feeding their young. Both the male and the
female help to build the pendulous, pear-shaped nest, using grass, moss,
leaves and insect cocoons. The entrance hole is often shaded by a small
overhanging projection. The female lays two eggs and incubates them
for about fourteen days. Both parents look after the young.

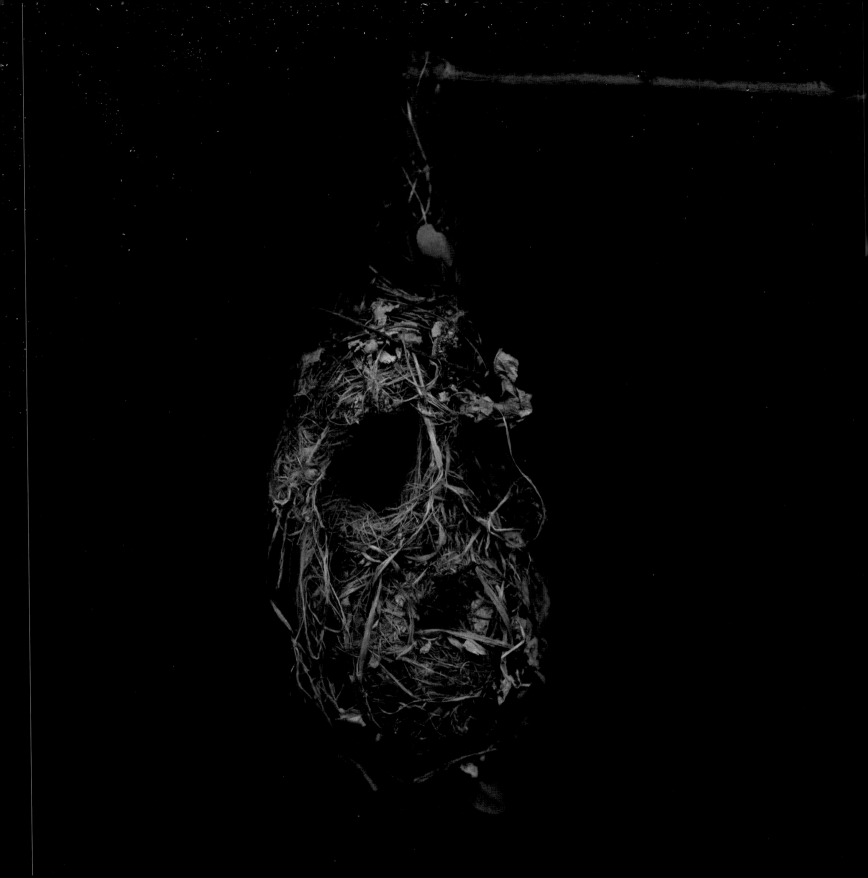

Crimson Topaz

Hummingbirds are frequently referred to as tiny jewels, and their
names reflect this. The family of hummingbirds includes the
Ruby-throated Hummingbird, Amethyst Woodstar, Andean Emerald,
Great Saphirewing, Horned Sungem, Ruby-topaz Hummingbird,
Rufous-throated Saphire, Saphire-spangled Emerald, White-throated
Mountaingem and Crimson Topaz, to name but a few. The Crimson Topaz
is second in size only to the Giant Hummingbird. It has an iridescent
green throat, red belly, crimson back and elongated tail feathers.

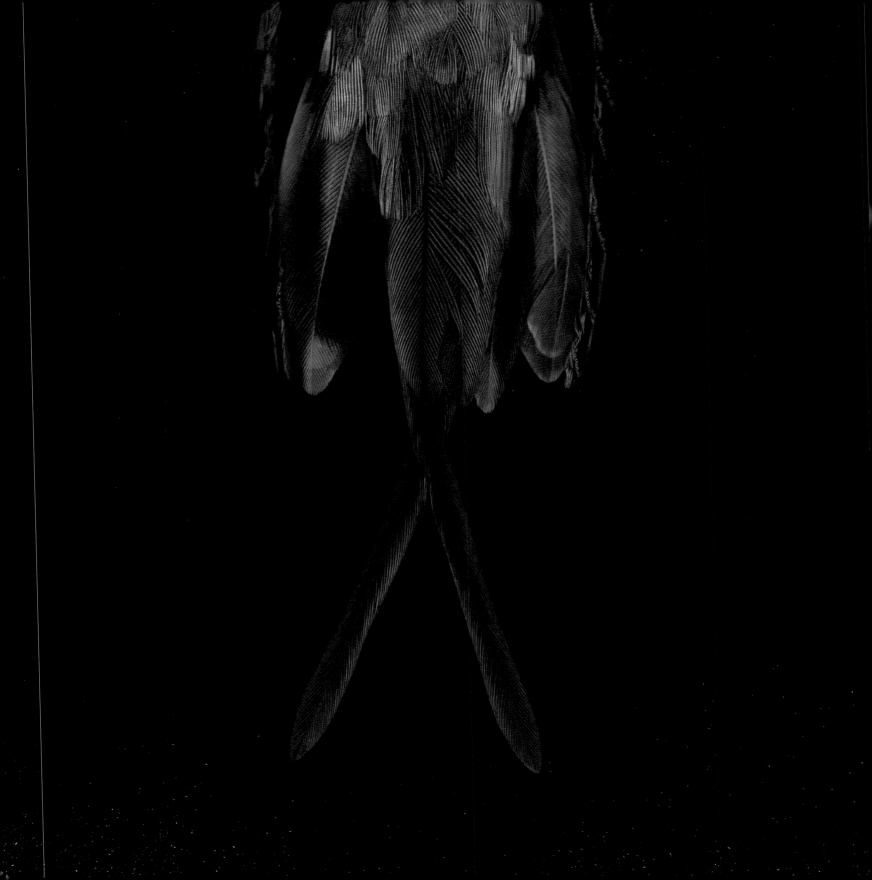

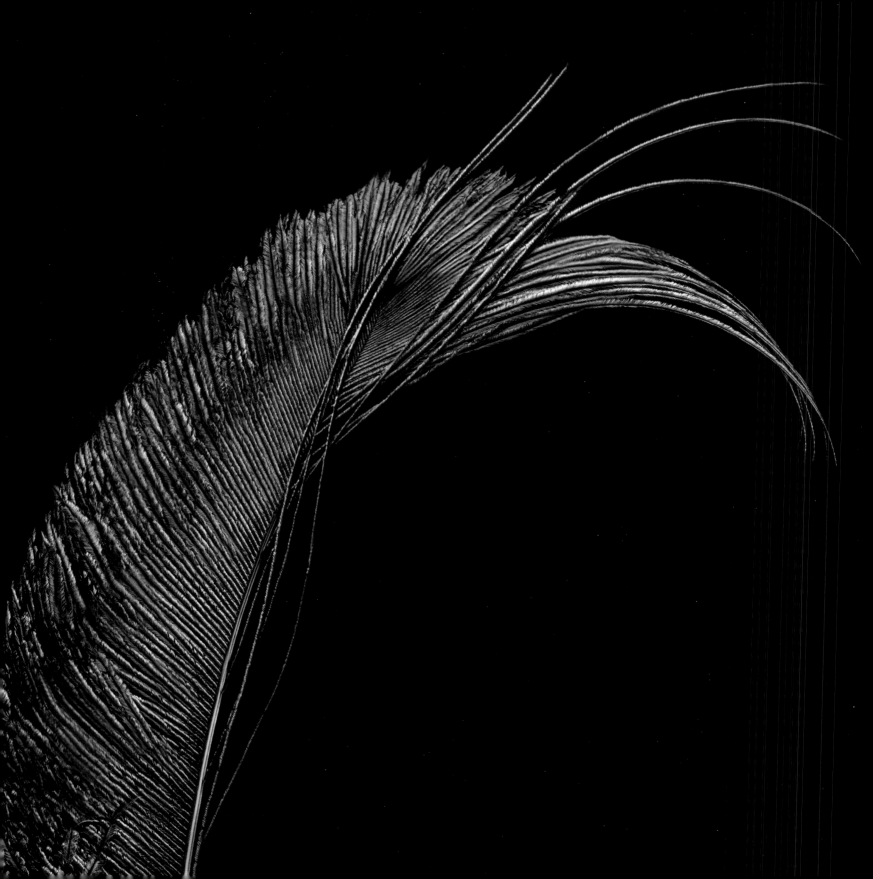

Indian Peafowl

The coloration of a bird's feather is produced either through light absorption and reflection by pigments or an optical effect known as structural coloration. The pigments in the peacock's tail are actually brown, but the beautiful iridescent hues of the eyespots are the result of structural colour: as light travels through the feather's microscopic structures, it is refracted at various points, and interference of different wavelengths amplifies some colours and mutes others. Unlike colours produced by pigments, structural colours change according to the viewing angle and are therefore often iridescent.

———

Red Knot
NEXT SPREAD

The Red Knot is a long-distance migrant travelling from breeding grounds in the Arctic to wintering grounds as far south as Tierra del Fuego in South America, a round trip of over 30,000 km / 18,600 miles. This feat is accomplished with the help of two beautifully simple, aerodynamic feather structures. The larger primaries are the principal source of thrust, while the smaller feathers lying on top of the primaries are known as primary coverts and help to smooth airflow over the wing. The flight feathers of the Red Knot are only replaced once a year, usually on the wintering grounds prior to spring migration.

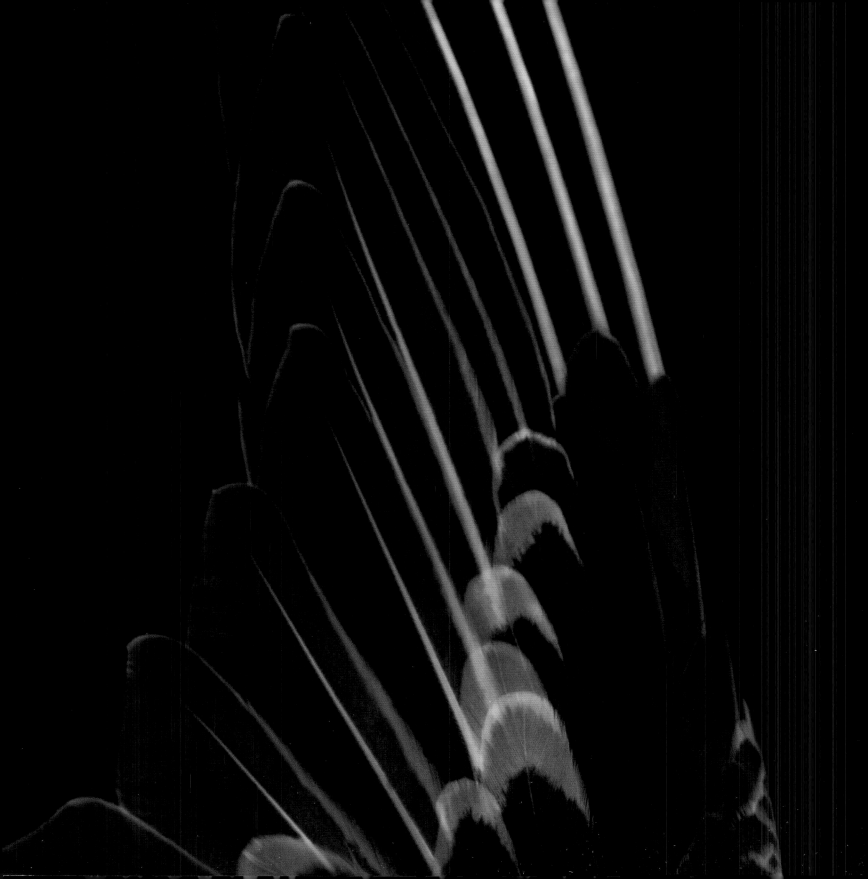

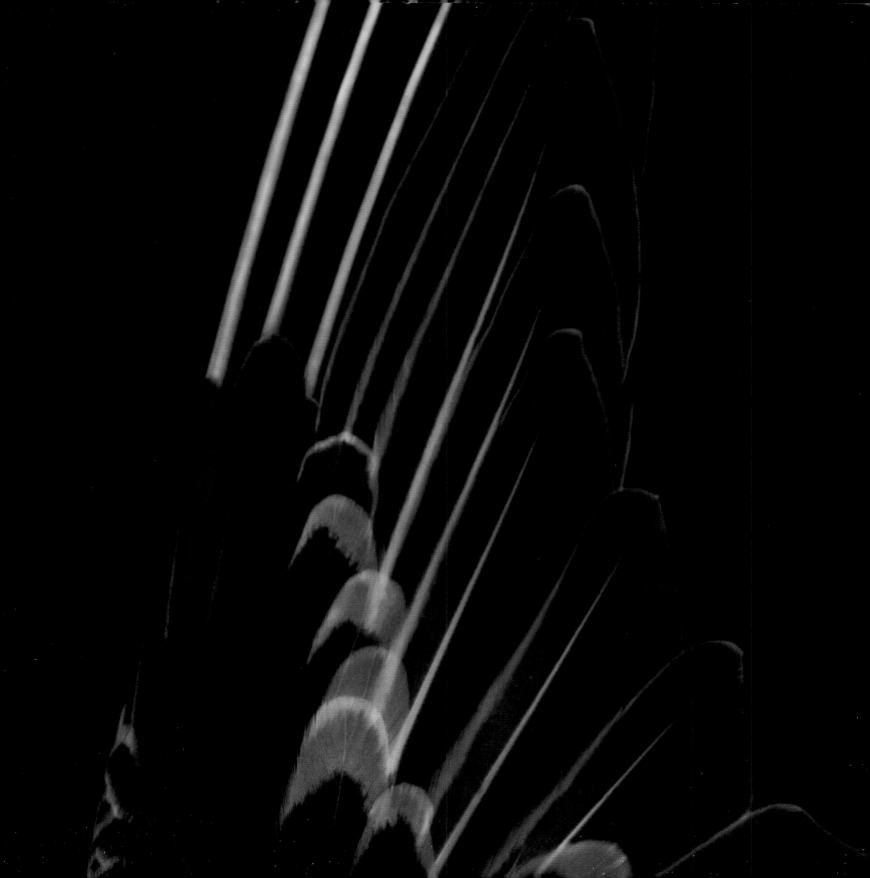

Emu Egg

The large, flightless Emu is endemic to Australia and is represented on the country's coat of arms along with the kangaroo. The Emu egg is the size and shape of a very large avocado. When the egg is first laid the surface is granular and pale green but during incubation it becomes darker in colour. During the breeding season females may mate several times and lay several clutches with different males. Incubation is left to the males, who will stay on the nest for about fifty-six days without eating or drinking. During this time they will lose up to a third of their body weight.

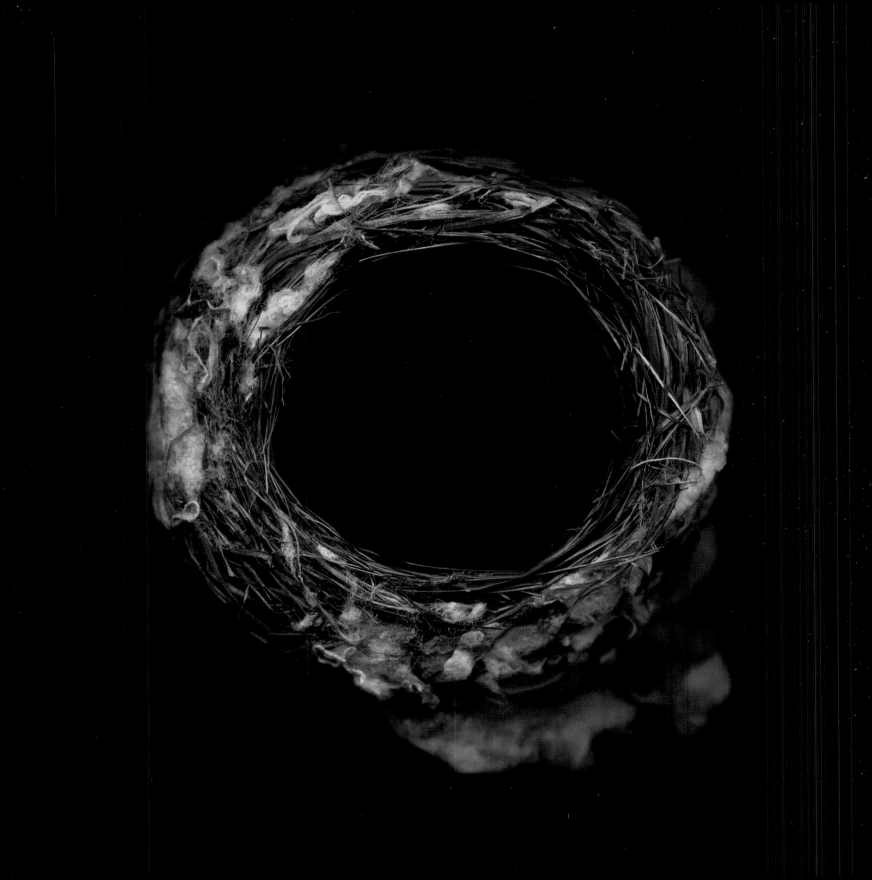

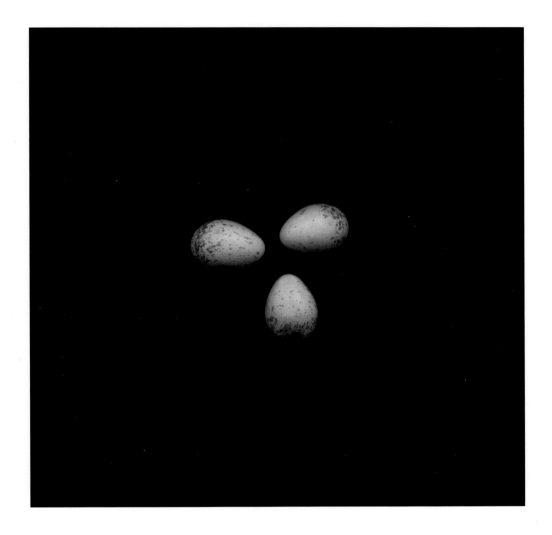

American Redstart Nest and Eggs

OPPOSITE AND ABOVE

The redstart most often places its nest in the upright crotch of a
deciduous sapling. The small compact nest is composed of bark strips,
grasses, plant fibres and plant down, and held together with insect
silk and spider down. It is lined with grasses, rootlets and pine
needles. The average clutch size is three to four white eggs, with
a concentration of brown speckling at the large end. The eggs are
incubated by the female for ten to thirteen days. The young
are fed by both the male and the female.

Golden Pheasant

The tail of the Golden Pheasant may be twice as long as the body, extending to almost 60 cm / 23 ½ inches. The longest two central tail feathers are mottled while the outer tail feathers are smaller and burnt orange in colour. Almost all of the feathers found on the Golden Pheasant are popular for salmon fly-tying. Pheasant feathers are still popular in fashion, costume and millinery design and captive birds are still bred for that purpose.

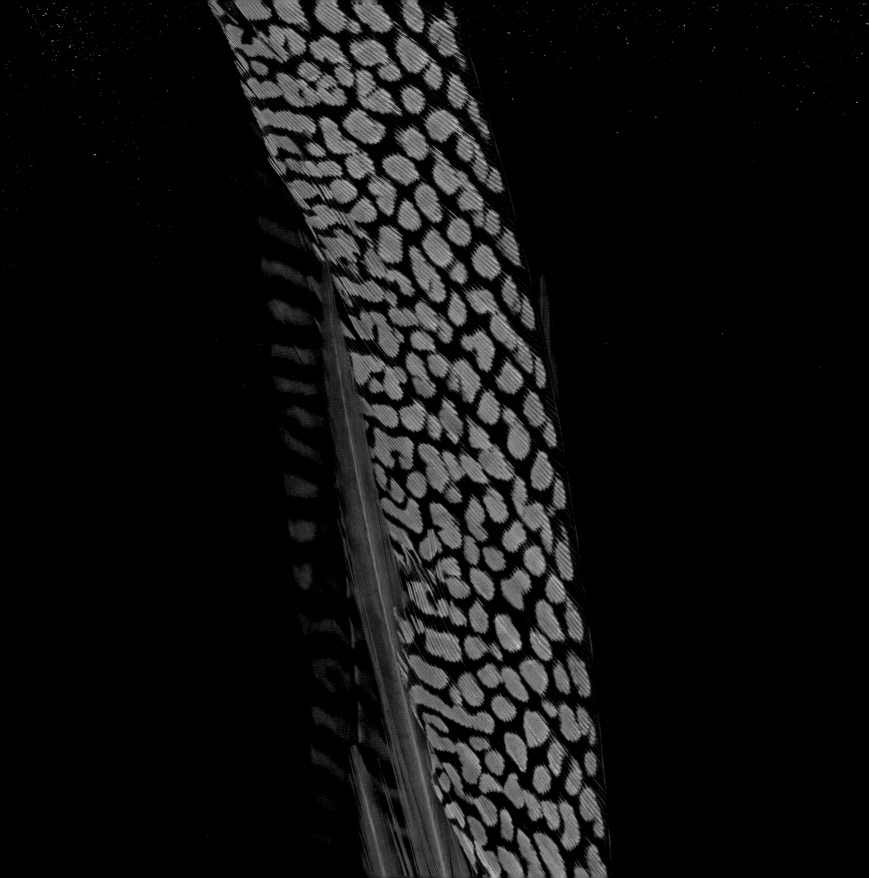

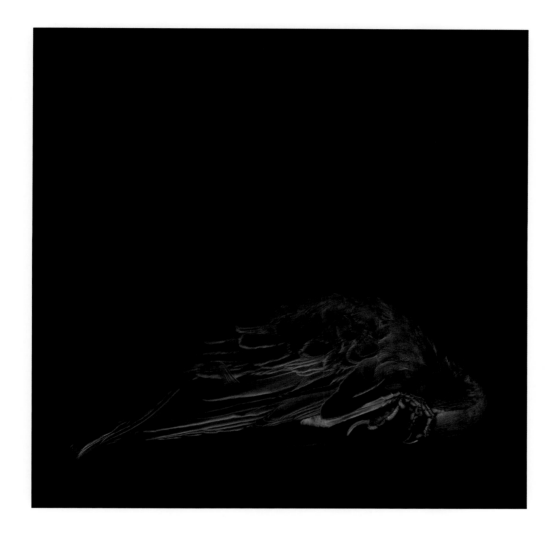

Common or
European Starling

Each year, museums receive thousands of birds that have died as
a result of collisions with windows in cities and suburbs. The deaths
occur mainly in the spring and autumn during migration. Young
birds migrating for the first time during the autumn are particularly
at risk since they are often not familiar with the urban landscape.
Poor weather conditions, especially wet, foggy days, lighting in
and on buildings, and reflective glass all add to the hazards for
a migrating bird.

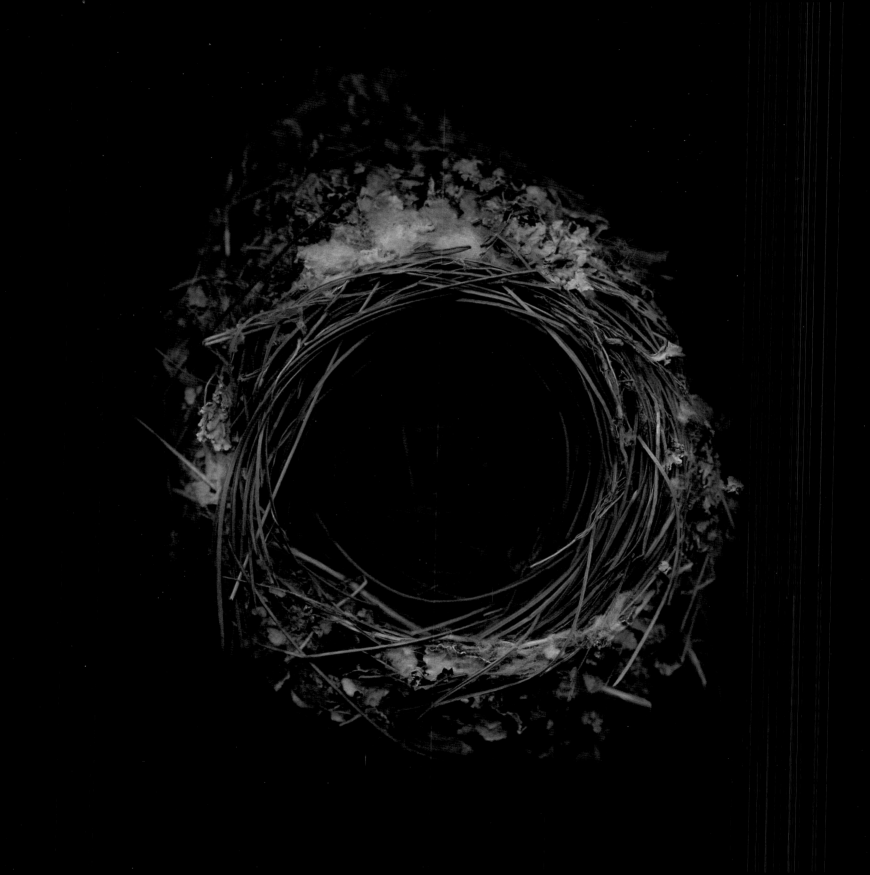

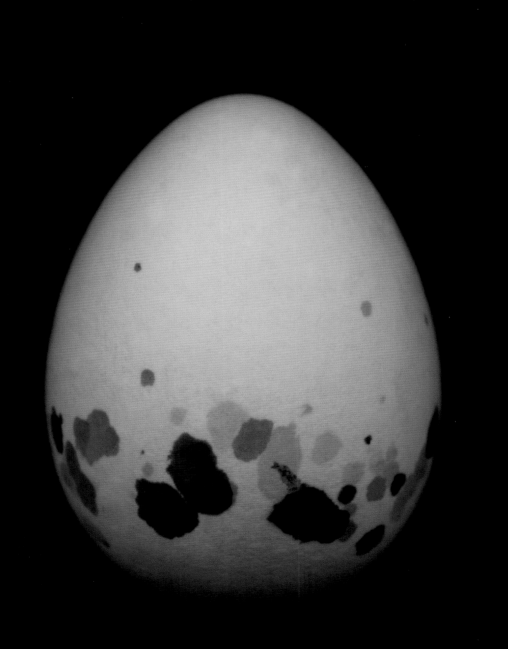

Eastern Wood-pewee
Nest and Egg

PREVIOUS SPREAD

Eggs of the Eastern Wood-pewee are pale white, wreathed with brown blotches concentrated at the larger end. The nest is often built on top of a dead horizontal branch high in the canopy of a deciduous tree. Typically located well out from the trunk and built by the female alone, the nest is a shallow bowl camouflaged on the outside with grey and green lichens. Its lining consists of grasses, needles, plant fibres and plant down. Spider webs are used to hold the material together.

———

Indian Peafowl

The term peacock refers only to the male. The female is known as a peahen and, as you might expect, young birds are known as peachicks. Only the male is brilliantly coloured but the female does show the beautiful iridescent blue green on her head and neck. The feather seen here is found on the rump of the peacock and is used in the fashion industry and for fly-tying.

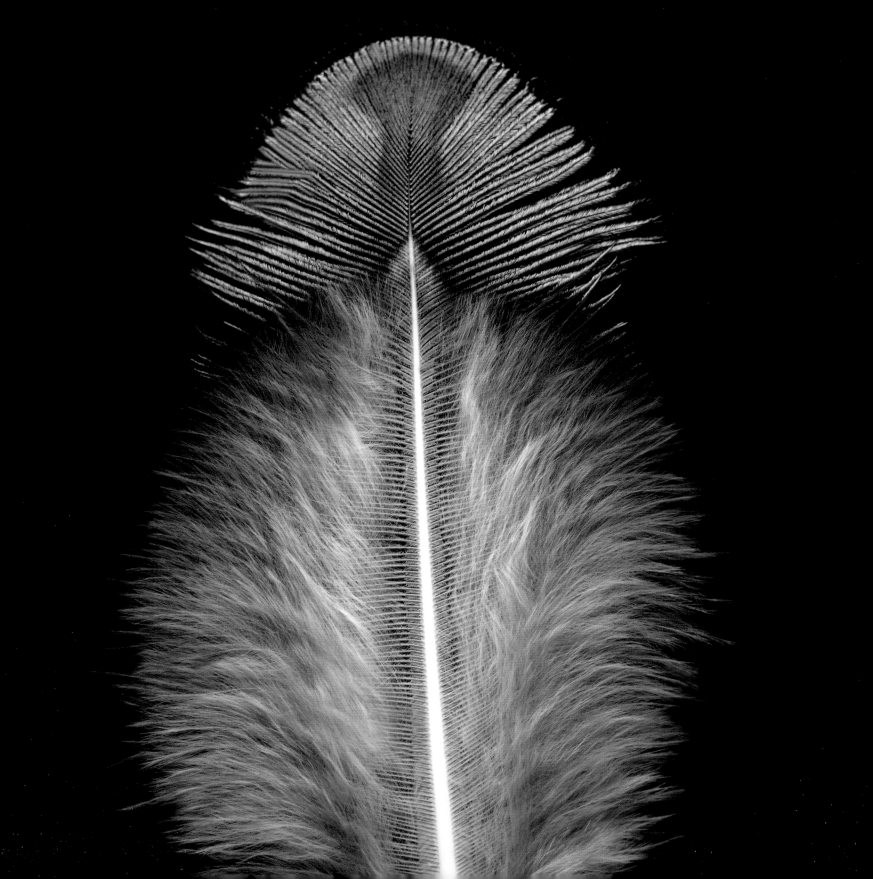

Greater Racket-tailed Drongo

Drongos are small to medium-size insectivorous songbirds restricted to the Old World. They are known to be fearlessly pugnacious when defending their territories from other species. The Greater Racket-tailed Drongo has black plumage, with a purplish green iridescence. Both males and females have two long, distinctive rackets on their outer tail feathers, always located on the inner side of the rachis.

———

Greater Bird-of-paradise
NEXT SPREAD

The spectacular flank plumes of the Greater Bird-of-paradise are only found on the males. It is evolution and female mate choice that we can thank for these beautiful adornments. Sexual selection arises through preference by one sex for certain characteristics in individuals of the other sex. In this case, females select the most beautifully adorned males. Over time, the genes controlling these traits continue to be passed down through offspring, as the most colourful and most beautiful are repeatedly selected.

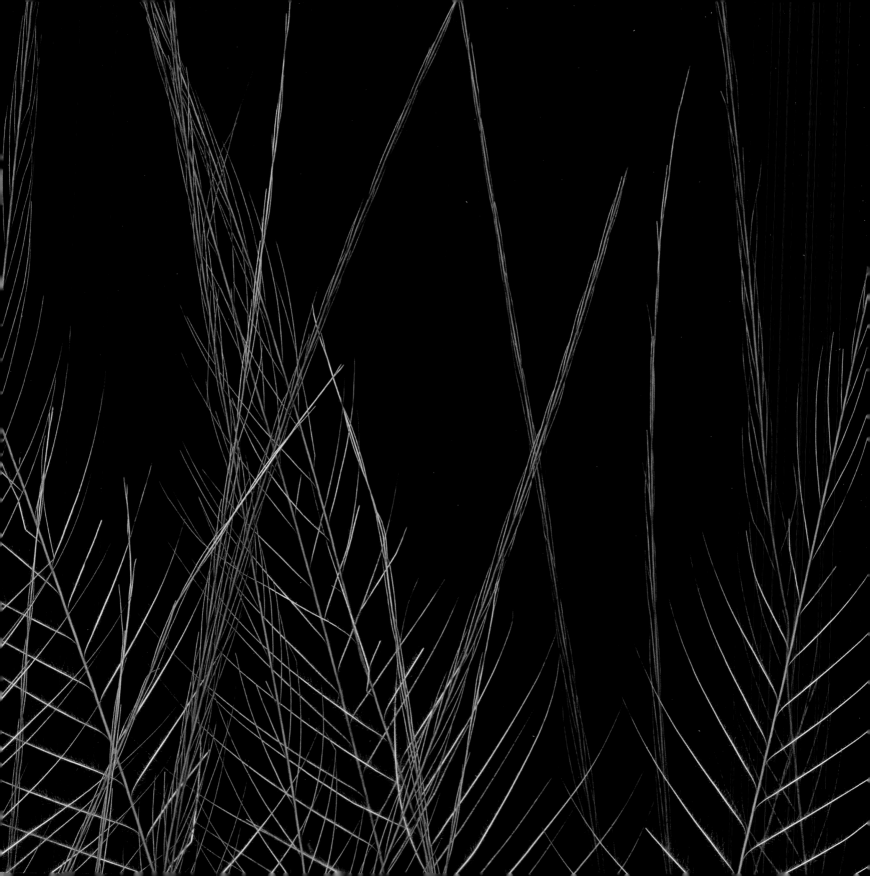

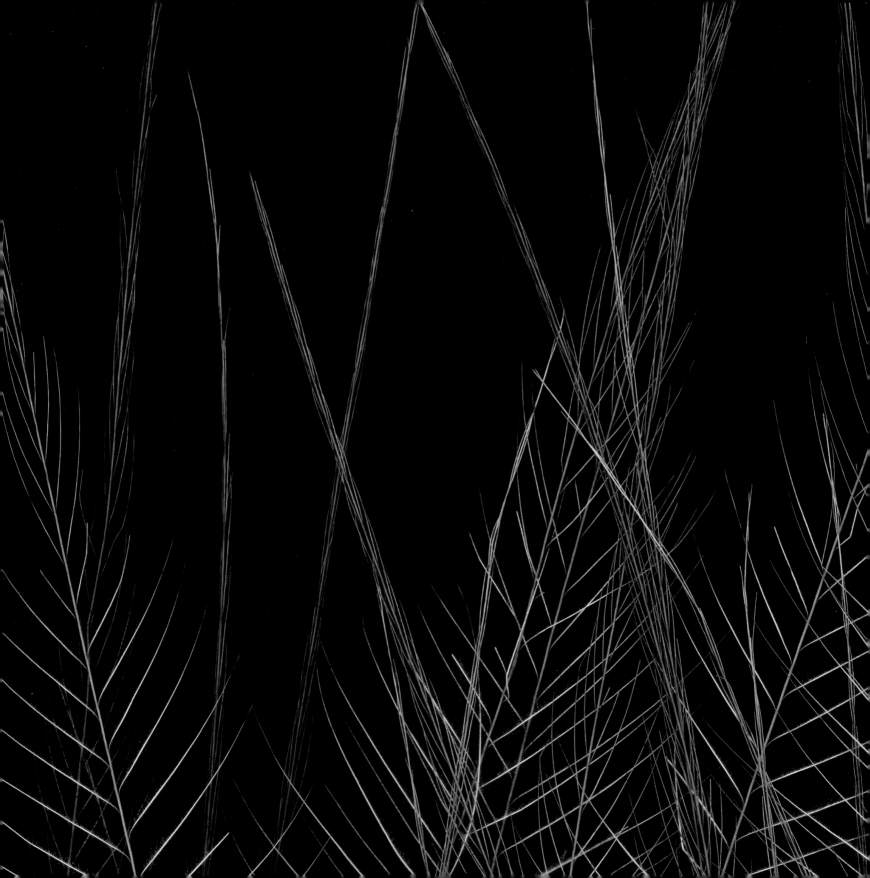

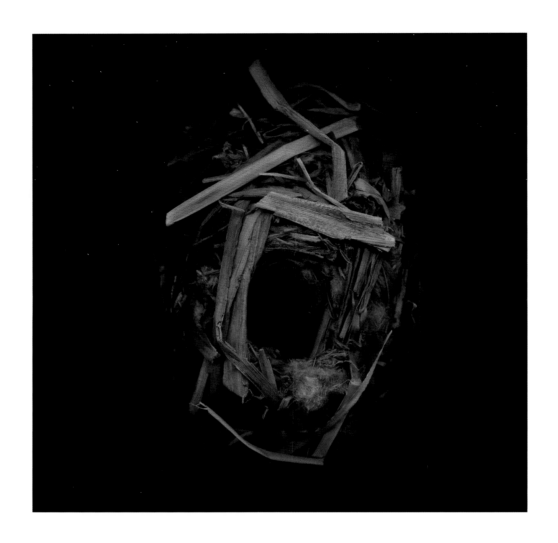

Marsh Wren Nest

Few species of North American birds are such dedicated nest builders as the Marsh Wren. The tiny songbird is polygynous, with males taking between one and three partners. Throughout the breeding season males build numerous 'dummy' nests in their territory. Their number varies but over twenty nests have been frequently recorded. Nests are woven dome structures made of cattails, bulrushes, sedges or grasses. Females may choose one of the male nests or build their own, lining it with cattail down and feathers before laying their eggs.

Black Sicklebill

During courtship display, the male raises his iridescent black pectoral plumage, shaped like a broad axe, around his head. The feathers are soft to the touch and, when not being displayed, lie close to the body, so that the metallic blue tips are hidden from view. When the display begins, the feathers move out from under the wings like large arms and slowly expand behind the head.

American Robin Nest

Robin nests are made from mud, grass and twigs, and lined with more
soft grass, and built by the female in five to seven days. Nest building
may be delayed if fresh mud is not available. Robins nest in a variety of
habitats, and although most nests are placed in trees or bushes, cliffs,
buildings and other human-made structures like bridges or picnic
shelters are also possible locations. Because of their durability, nests
may be used the following year by other species.

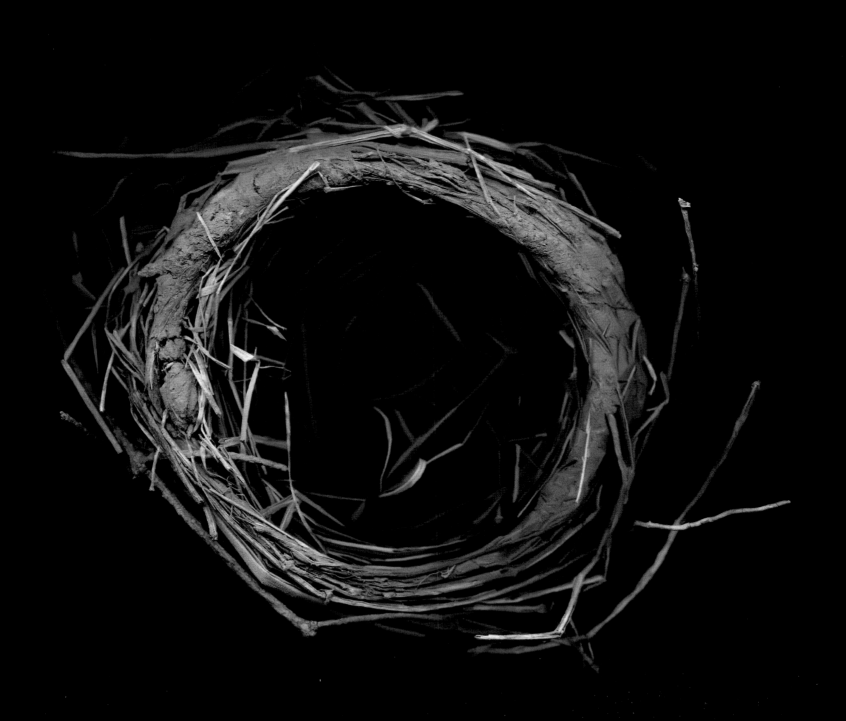

Long-tailed Duck

Long-tailed Ducks breed on the Arctic coasts of North America, Europe and Asia and winter in coastal areas and freshwater lakes further south, as far as Chesapeake Bay in the United States and the United Kingdom in Europe. During the winter, they feed on a variety of crustaceans, amphipods, fish and molluscs. In recent years, type E avian botulism, a disease caused by the ingestion of a toxic bacterium in food, has affected Long-tailed Ducks and other waterfowl in the Great Lakes region of North America and decimated local populations.

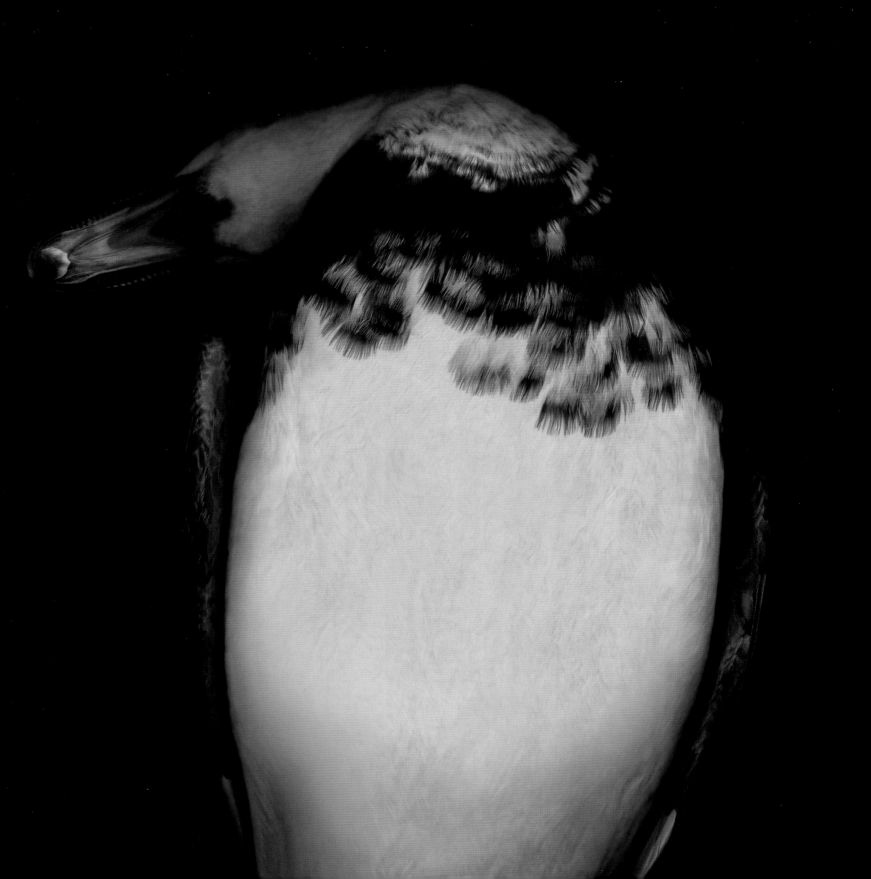

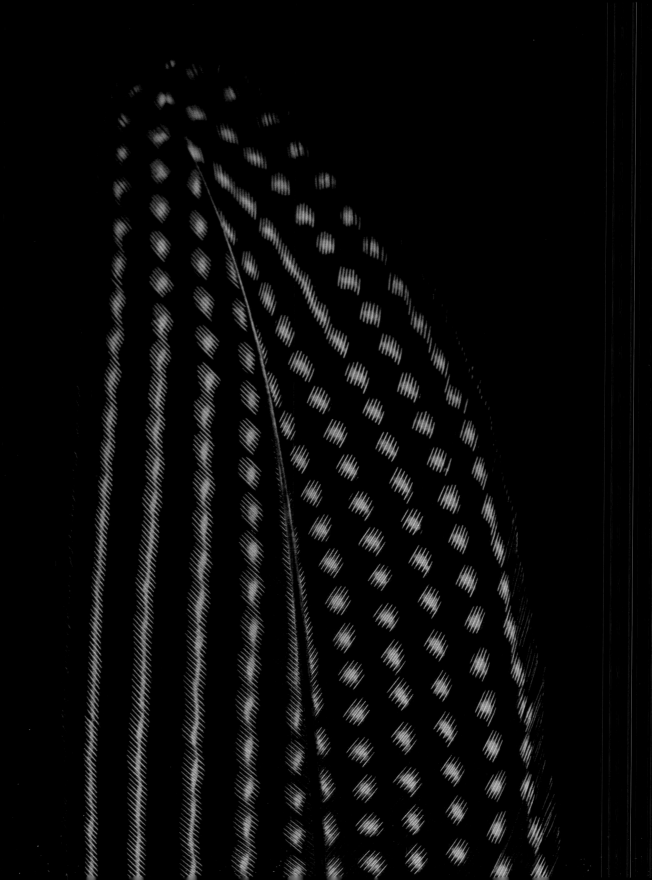

Western Crested Guineafowl

Male and female Guineafowl are similar in appearance and colouring but females tend to be a little smaller. The wing and flight feathers are designed for quick bursts of flight followed by an extended glide, as they are in turkeys. Although noisy, Western Crested Guineafowl are more reclusive than Helmeted Guineafowl and are inconspicuous in the heavily forested habitat they prefer. In North America and Europe their feathers are popular in crafts, jewellery and fly-tying.

Southern Masked Weaver Nest

ABOVE AND OPPOSITE

It is not easy being a male Southern Masked Weaver. During the breeding season, the males spend much of their time constructing as many as twenty-five nests. These intricately woven pendulous globes of reeds and grass are built in about a day. The male may have several female partners that will eventually select a suitable nest and line it with softer grass and feathers. The female is then responsible for incubating the eggs but the male does assist with the feeding of the young.

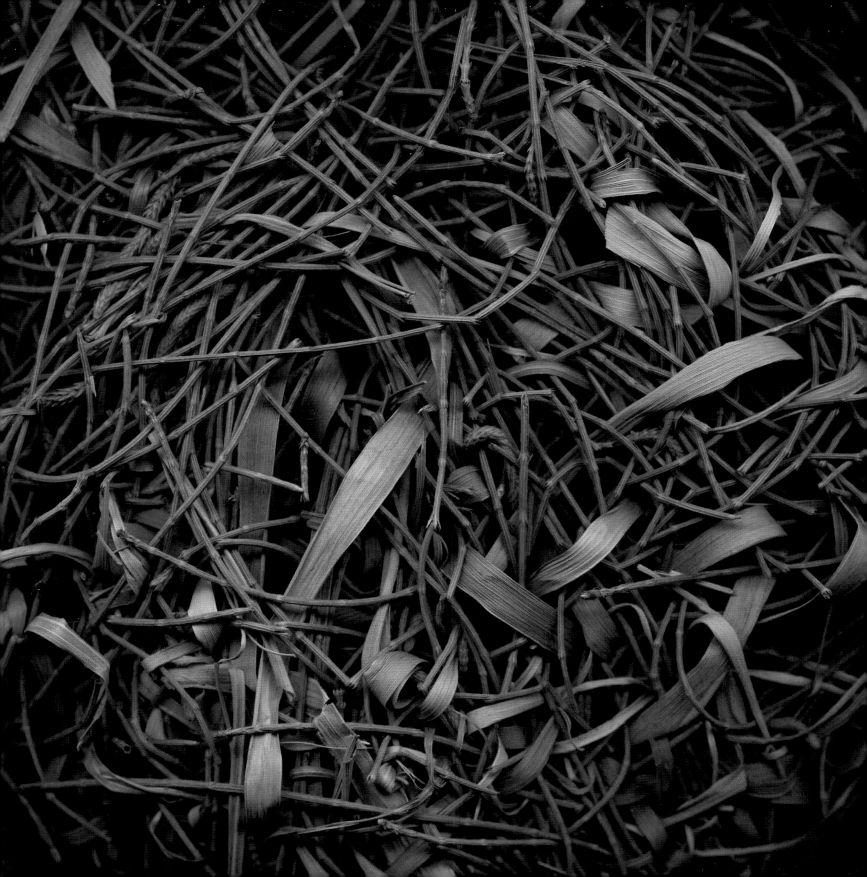

Cedar Waxwing

These wax-like droplets are located on the end of the Cedar Waxwing's secondary flight feathers. Not all individuals have these red tips, and they are not found at all on the closely related Japanese Waxwing. Depending on the birds' diet, the droplets may range from bright red to orange. The tip of the tail is frequently yellow but may also vary in colour for the same reason. Birds will sometimes appear intoxicated when they have eaten fermented fruit.

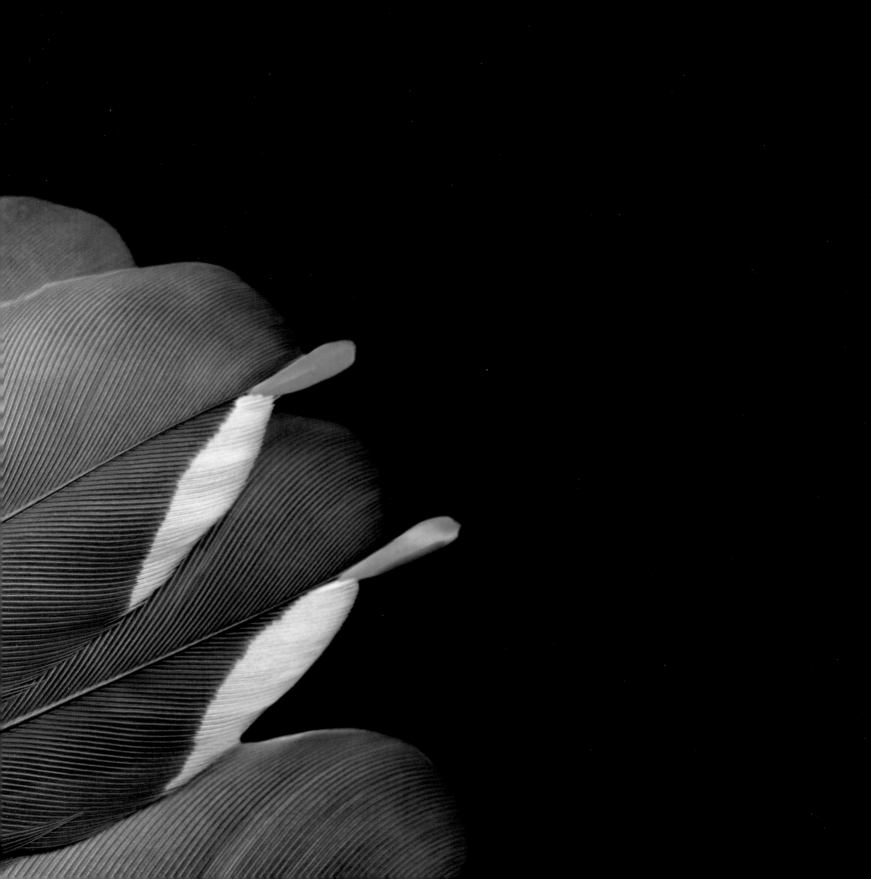

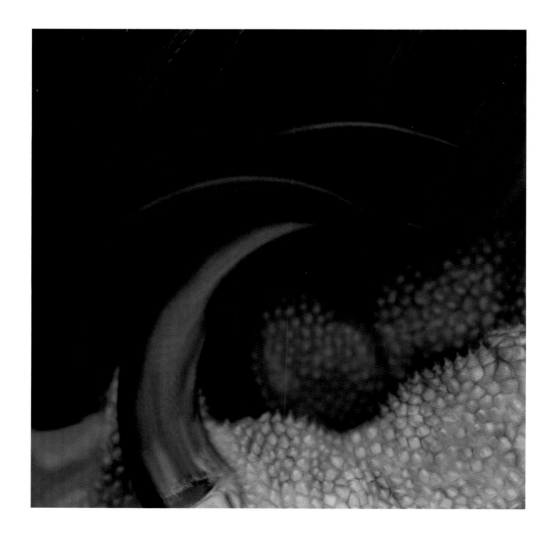

Osprey

Osprey feed almost exclusively on fish. Their talons and feet are
beautifully designed to catch their prey. Ospreys dive into the water head
and talons first and are successful at least one in every four times. Their
talons are long and curved, and their outer toe is reversible, allowing
them to grasp the fish on both sides. Backward-facing scales on the
talons act as barbs, helping to hold on to the catch. Ospreys always carry
the fish head first, in 'torpedo position', which reduces wind resistance.

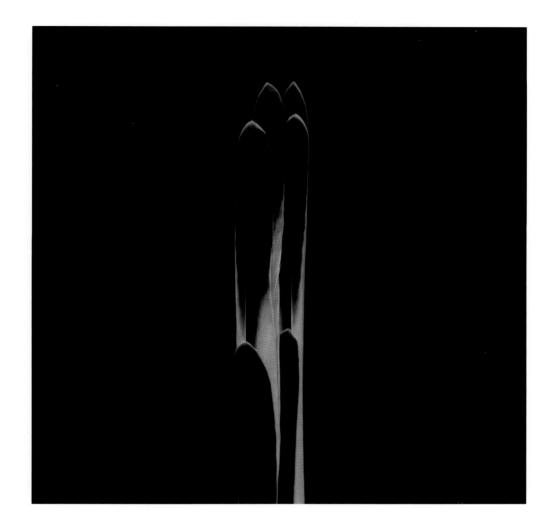

Scissor-tailed Flycatcher

Both male and female Scissor-tailed Flycatchers have elongated tail feathers but the longest are found on males. They measure as much as 25.5 cm / 10 inches, which is remarkable considering that the rest of the bird only measures 12.5 cm / 5 inches. The outer tail feathers are the longest, and when the tail is spread, they look like a pair of open scissors. The bird often spreads its tail in flight to allow quick and acrobatic turns when catching flies, or during courtship.

Superb Lyrebird

OPPOSITE AND NEXT PAGE

Wing and tail feathers have to be stiff and strong to provide the support the bird needs for flight. But other feathers are soft and downy, almost without shape or structure. Feathers may be used for flight, warmth and insulation, swimming, diving and hearing, as well as courtship display and mate selection.

King of Saxony
Bird-of-paradise

NEXT SPREAD

The King of Saxony Bird-of-paradise certainly has one of the most intriguing names in the avian kingdom. The males also have some of the most spectacular feathers of any bird in the world, a pair of powder-blue head wires twice the length of the bird's body (50 cm / 19 ¾ inches). Emanating from behind the eyes, these amazing plumes have tiny enamel-like plates, called flags, on the outer side of the central shaft. During courtship displays, the male moves the feathers around in all directions, like large antennae, hoping to entice the female into copulation.

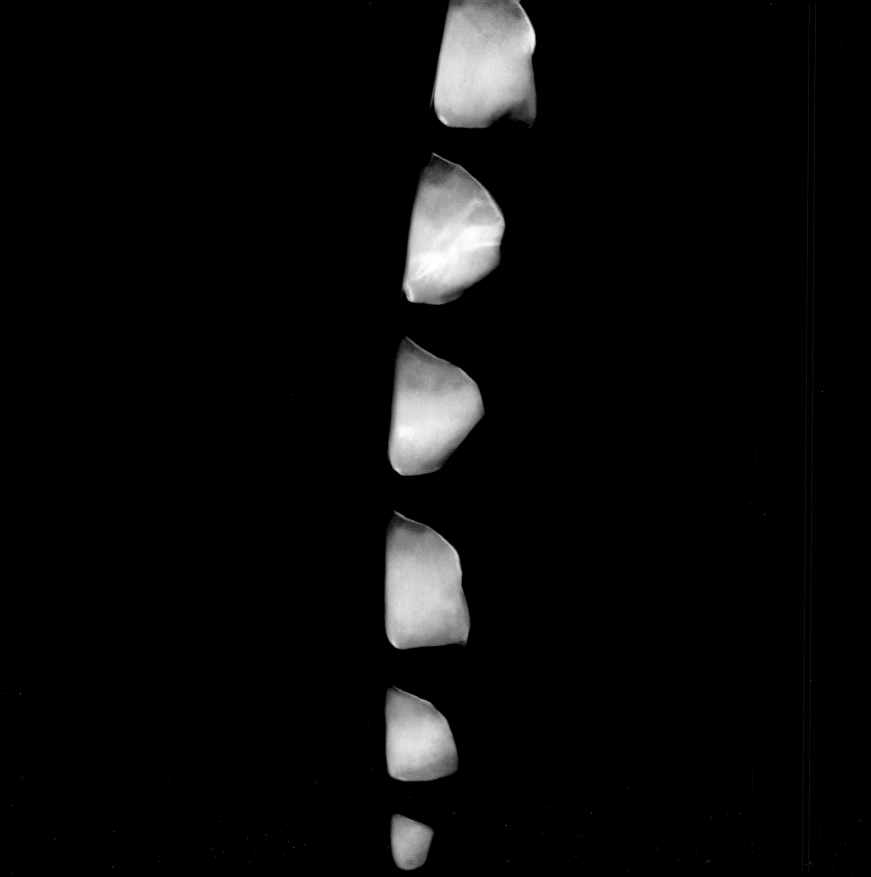

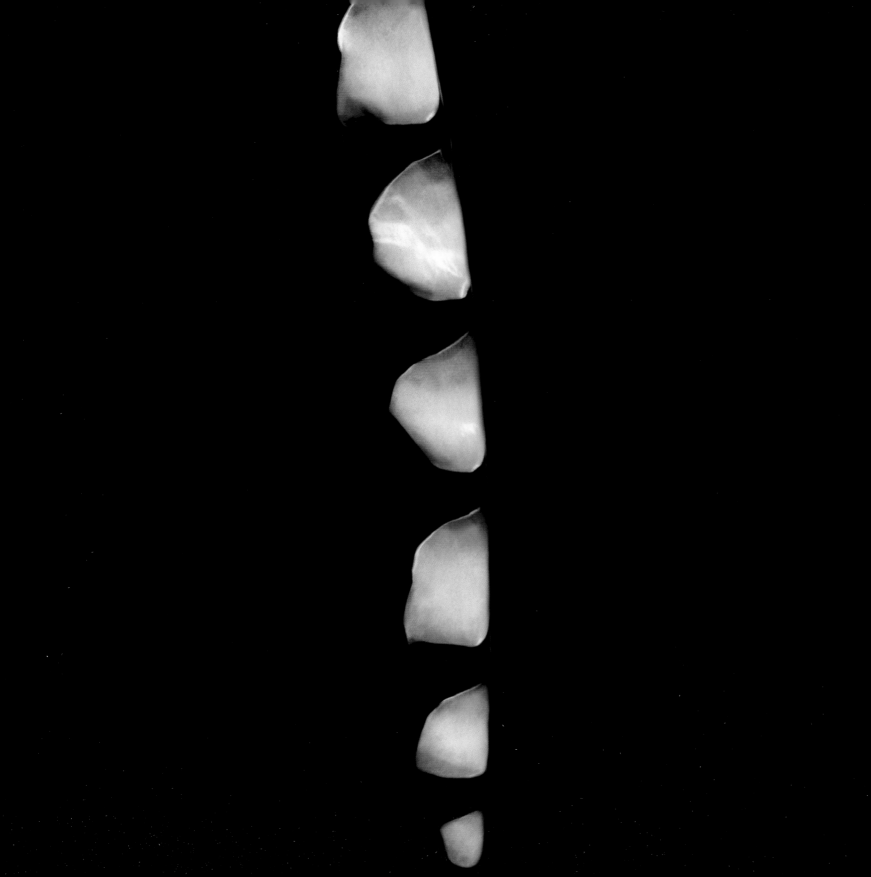

Satyr Tragopan

Also known as the Crimson Horned Pheasant, the Satyr Tragopan
is named after the satyrs of Greco-Roman mythology, woodland
deities often depicted with horns on their heads. With its crimson
neck and breast and black-edged white dots on darker plumage, the
Satyr Tragopan is a beautiful bird. During courtship, it inflates a
striking set of blue horns on its head, and a matching blue gular
wattle, a fold of skin hanging from its throat. Tragopan feathers
are highly valued for fly-fishing.

188

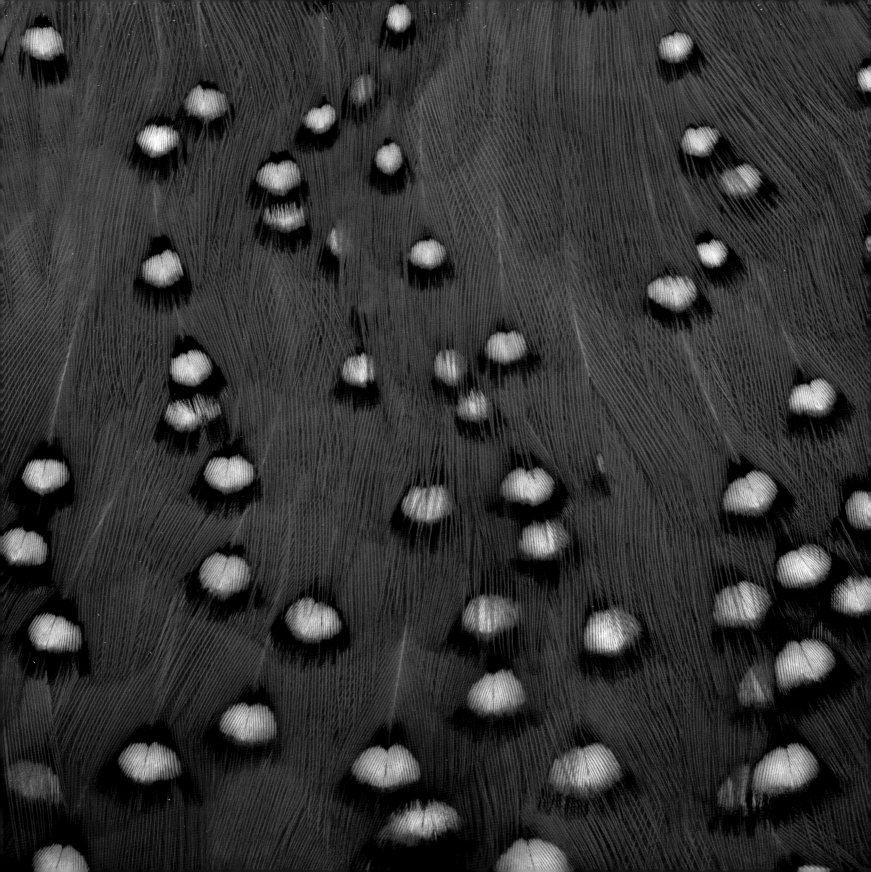

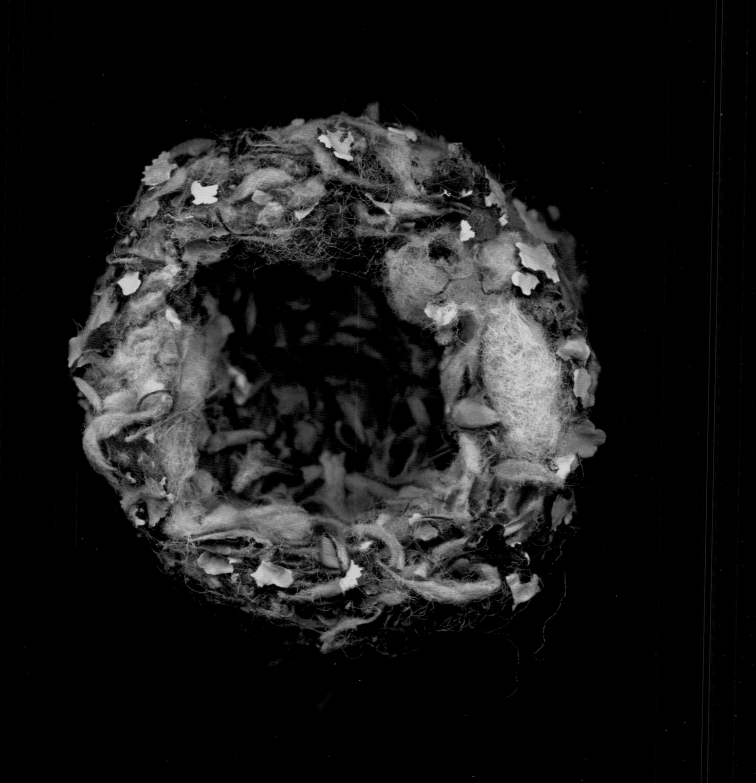

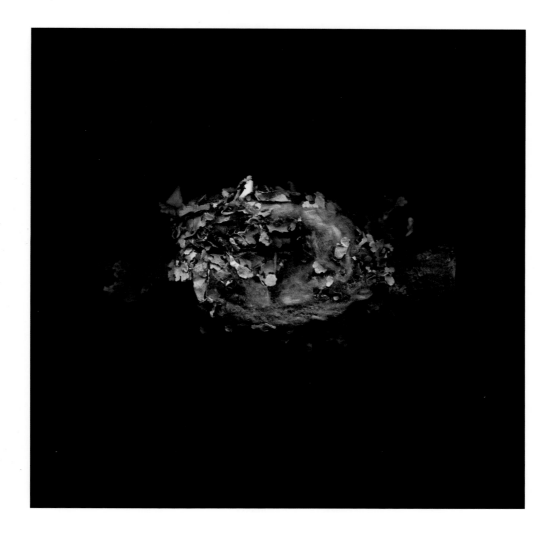

Ruby-throated Hummingbird Nests

OPPOSITE AND ABOVE

The nest of a Ruby-throated Hummingbird is almost always in a tree,
usually in an open area, and often close to water. It is built near the end
of a branch and may be as low as 1 m / 3 ¼ feet off the ground or as high
as 15 m / 49 ¼ feet. The tiny cup resembles knots on a tree and is
composed of lichens, bark and plant fibres, held in place by spider webs.
The inside of the nest is lined with hair, plant down and fibre and
occasionally feathers. The females build the nests alone.

Wilson's Bird-of-paradise

The beautiful violet central tail feathers of the male Wilson's Bird-of-paradise are unique to this species. The tail is not used for flight and offers no insulation. It is a result of sexual selection. Since complicated courtship display, extravagant plumage and skin coloration are all costly in energy to male birds, they signal good health and good genes to females. If females continuously choose males with the most elaborate display and the brightest plumage, these traits, which are inherited by the next generation, may become more and more exaggerated over time.

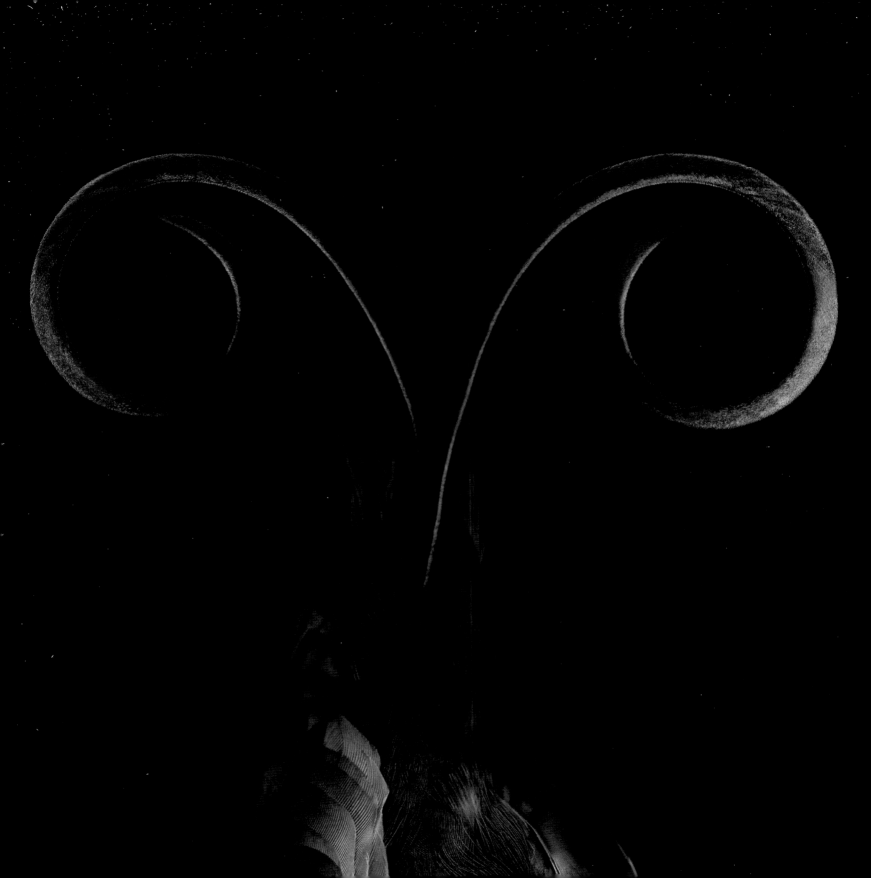

Greater Bird-of-paradise

Early skins of birds-of-paradise were often prepared without legs or feet and then shipped off to Europe, which led to the mistaken belief that the birds lived in the heavens, staying aloft with their beautiful plumes, never touching the ground. The Greater Bird-of-paradise, with its downy, golden brown flank plumes, is the largest member of the family. During courtship, the males show off their feathers by raising them over their backs while dancing back and forth along branches.

———

Great Grey Owl
NEXT SPREAD

The Great Grey Owl is the largest of the North American owls and the tallest owl in the world. But its thick, fluffy plumage masks its actual body size: its weight is considerably less than that of owls with a similar wingspan. The feather shown here is a filoplume. These simple, hair-like feathers have a stiff shaft or rachis, with either very few or no barbs. They are usually covered by other feathers and act as sensory receptors.

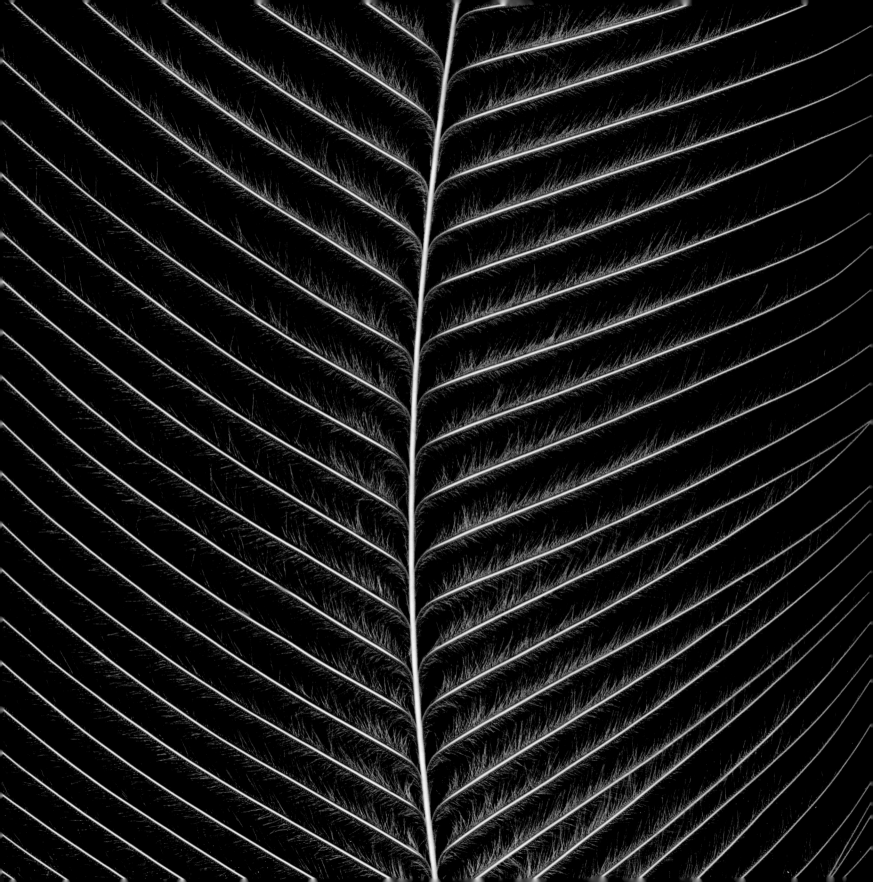

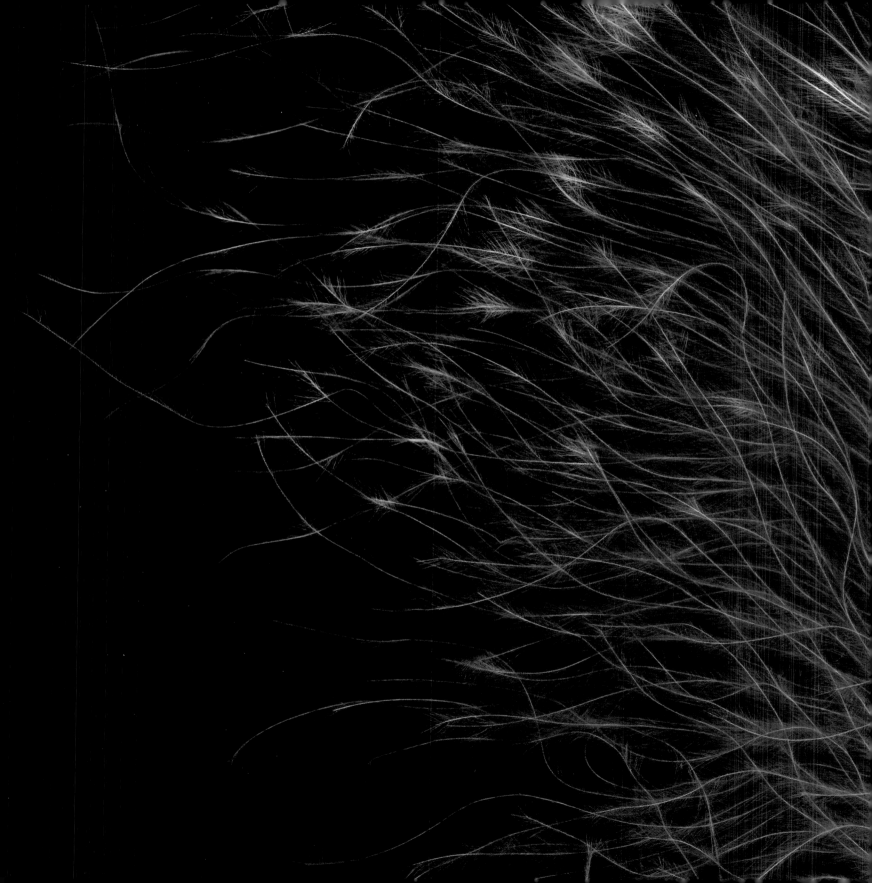

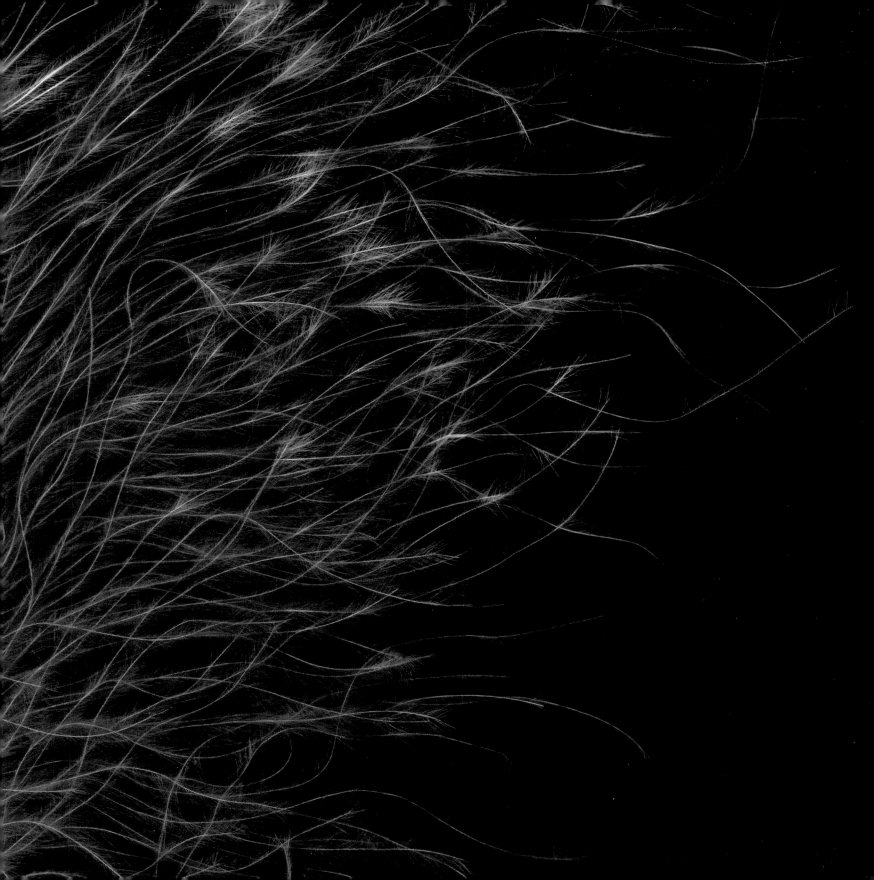

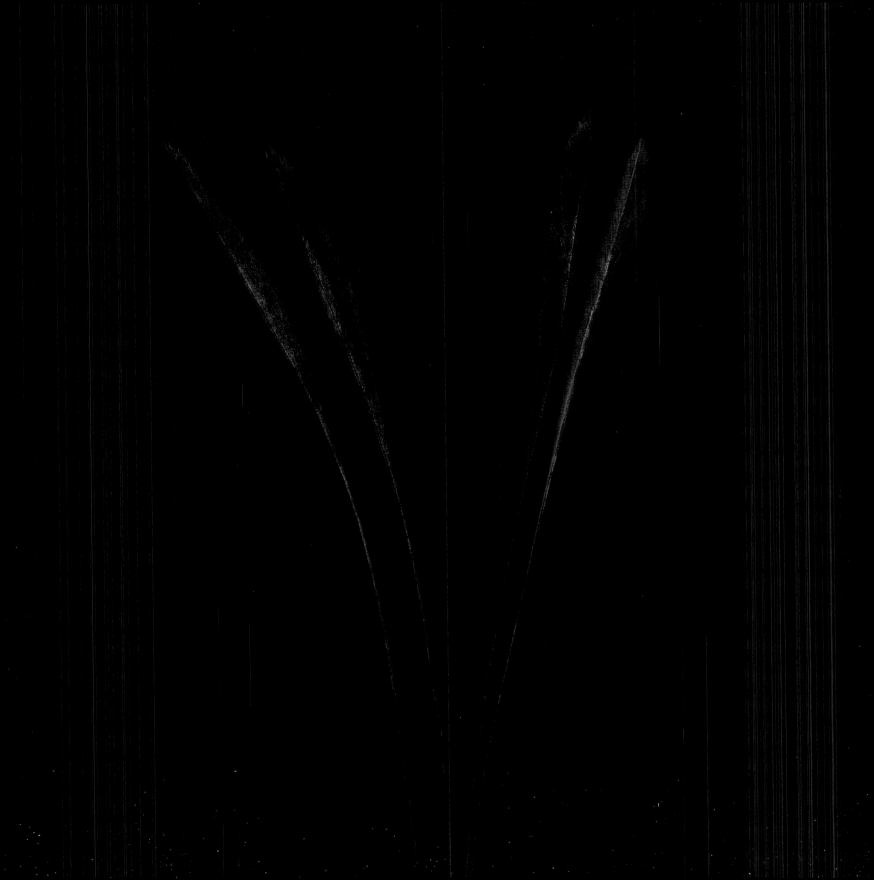

Shaft-tailed Whydah

Roughly the size of a sparrow, the Shaft-tailed Whydah is a
social parasite, laying its eggs in the nest of other species.
During the breeding season, male whydahs perform courtship
displays and mimic the song of the host species. Females visit
several males before making their selection. Favoured males
will get most of the matings, while less successful ones may
hardly get the chance to mate at all.

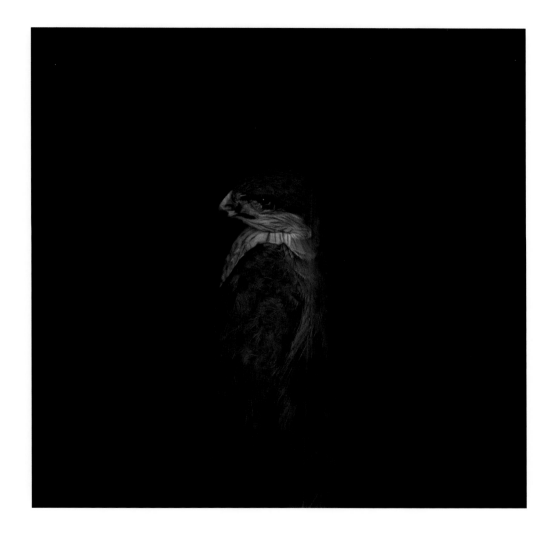

Sharp-shinned Hawk

The Sharp-shinned Hawk is the smallest of the three North American accipiters with short rounded wings and a long tail. This species has long been mostly a woodland hawk feeding on small songbirds and the occasional small mammal or insect. But recently sharp-shins have moved into more urban environments, where they prey on garden birds. Thanks to this new urban food source, they now often overwinter in more northern areas instead of migrating.

Western Crested Guineafowl

The Western Crested Guineafowl is native to Africa but has been introduced into southern Europe, northern South America, Australia and the West Indies. Almost all of the feathers on the body are grey/black speckled with white streaks and bars. The small, thin blue streaks atop the white spots match the colour of the blue skin on the unfeathered head and upper neck. Guineafowl have been domesticated and are also used effectively as 'watchbirds' and insect exterminators

American Robin Egg and Nest

NEXT SPREAD

The American Robin is found in many different habitats throughout much of North America, where it is undoubtedly one of the best known songbirds. Nest sites may be on the ground, on cliffs, in trees, or on man-made structures. The female selects the site and builds the nest, using mud and grasses but also incorporating rootlets, bark, leaves and often paper, plastic and cellophane. The first egg is laid three to four days after the nest is complete. The eggs are incubated for thirteen days, and the young remain in the nest for approximately the same time period.

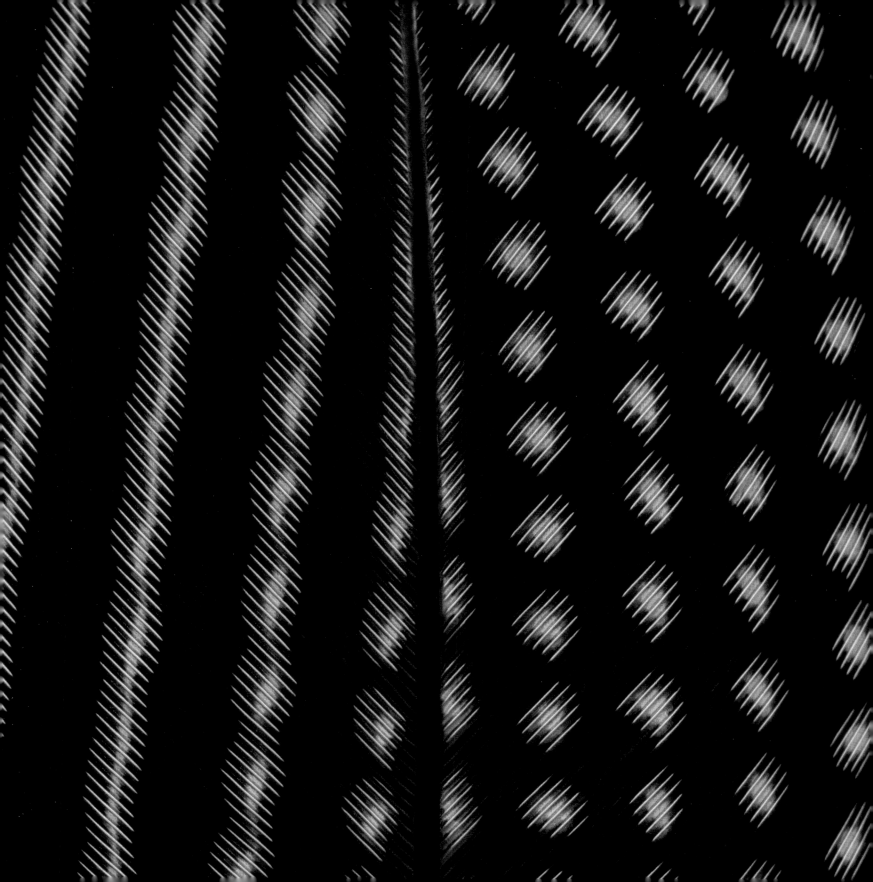

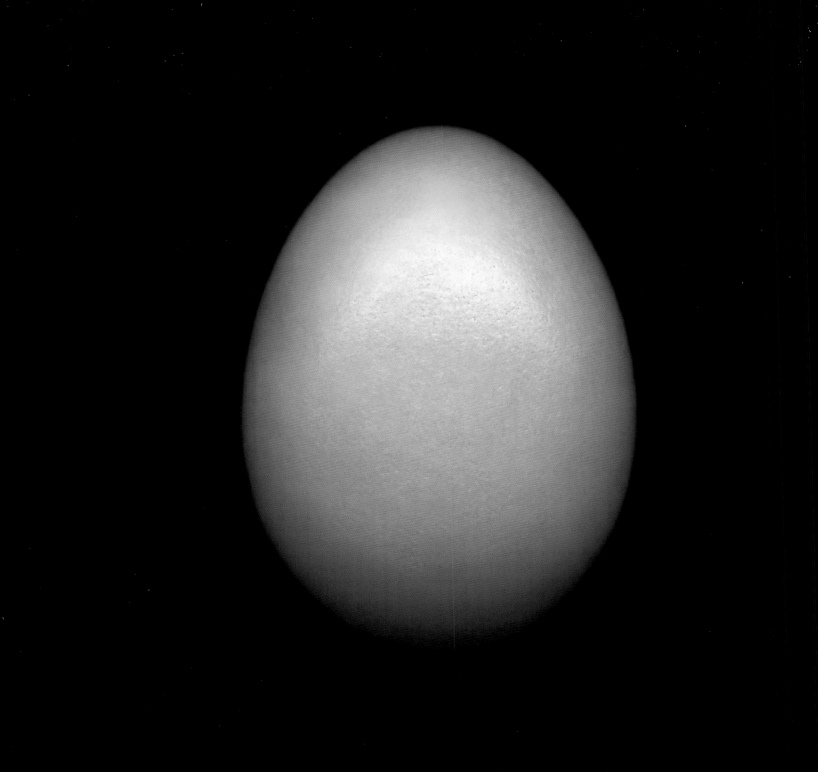

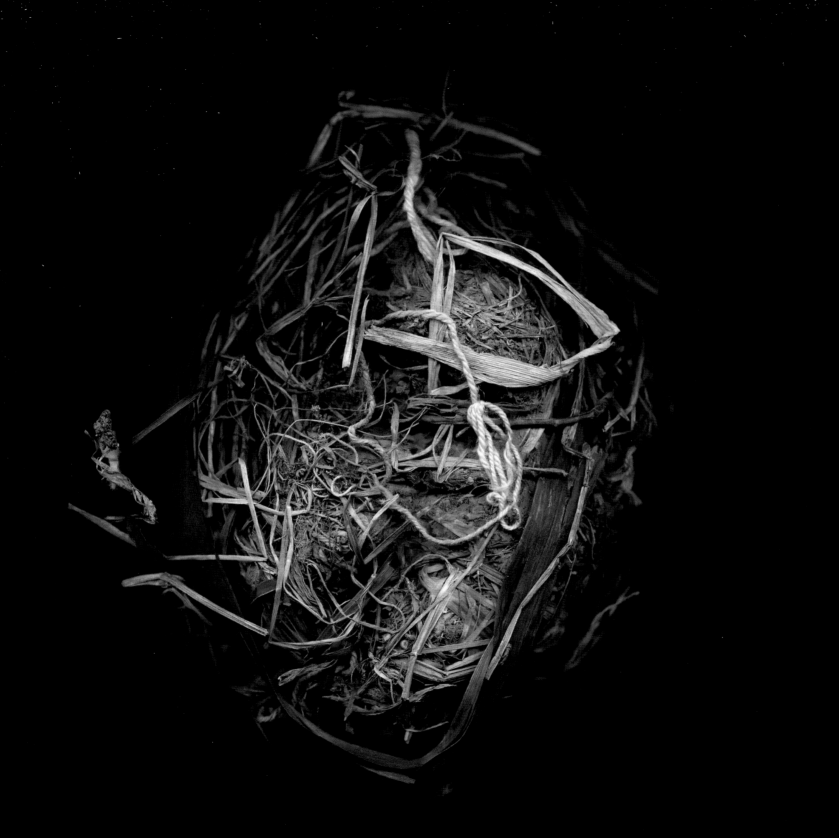

Greater Bird-of-paradise

One hundred years ago, the ornamental flank feathers of the Greater Bird-of-paradise were highly sought after in the millinery and fashion industry. At the peak of the plume trade in the early 1900s, these feathers were more valuable than gold, and some 30,000–80,000 bird-of-paradise skins were exported annually to European feather auctions. Despite its near extinction, today the Greater Bird-of-paradise is considered a common species throughout much of its range.

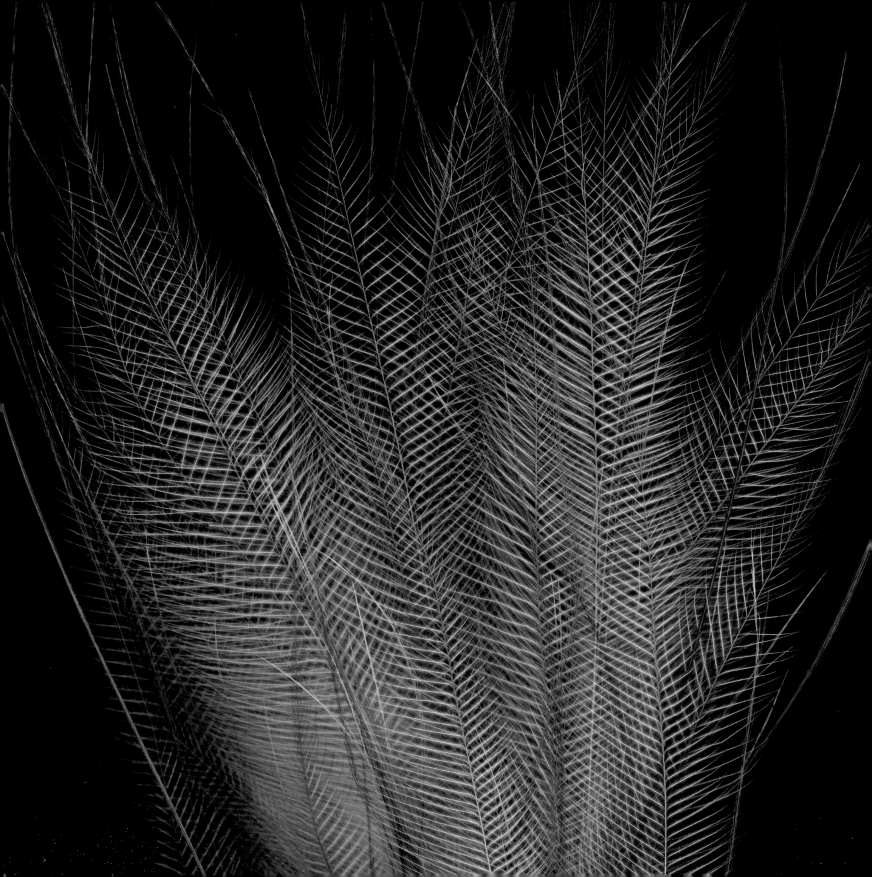

American Tree Sparrow Nest

The American Tree Sparrow is a ground-nesting sparrow which breeds along the tree line in northern North America, usually near lakes and bogs or on open tundra. The nest is placed in clumps of grass or low hummocks, often close to the base of small conifers, and made from moss, grasses, plant stalks, lichens and feathers. It is snugly lined with fine grasses and feathers, the latter frequently from ptarmigan or grouse, and holds four to six heavily speckled light blue eggs for twelve to thirteen days until they hatch.

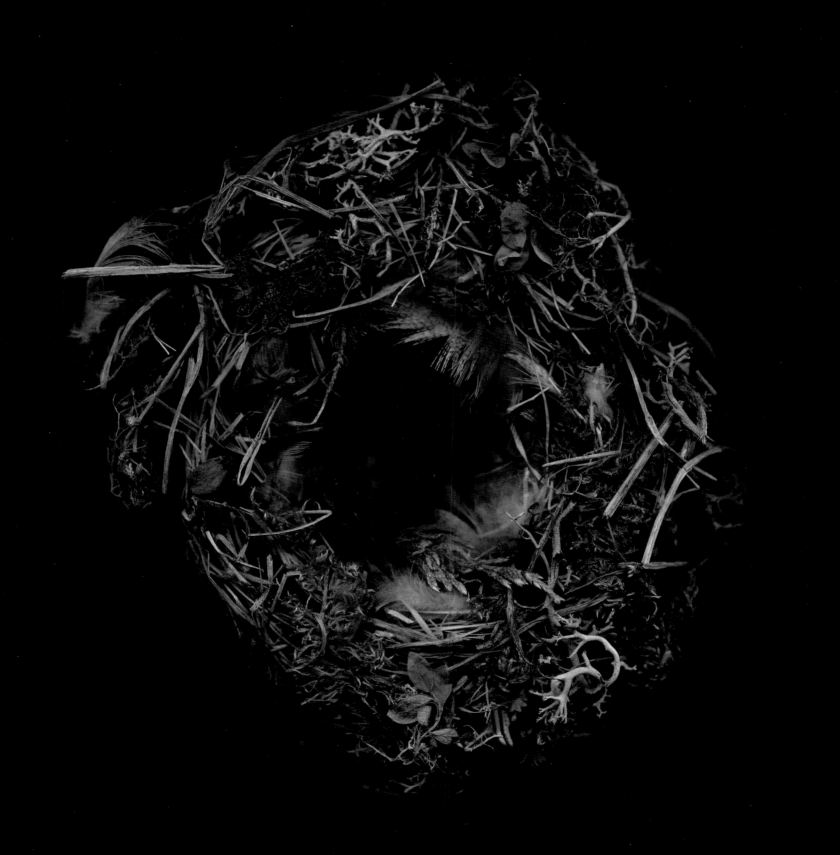

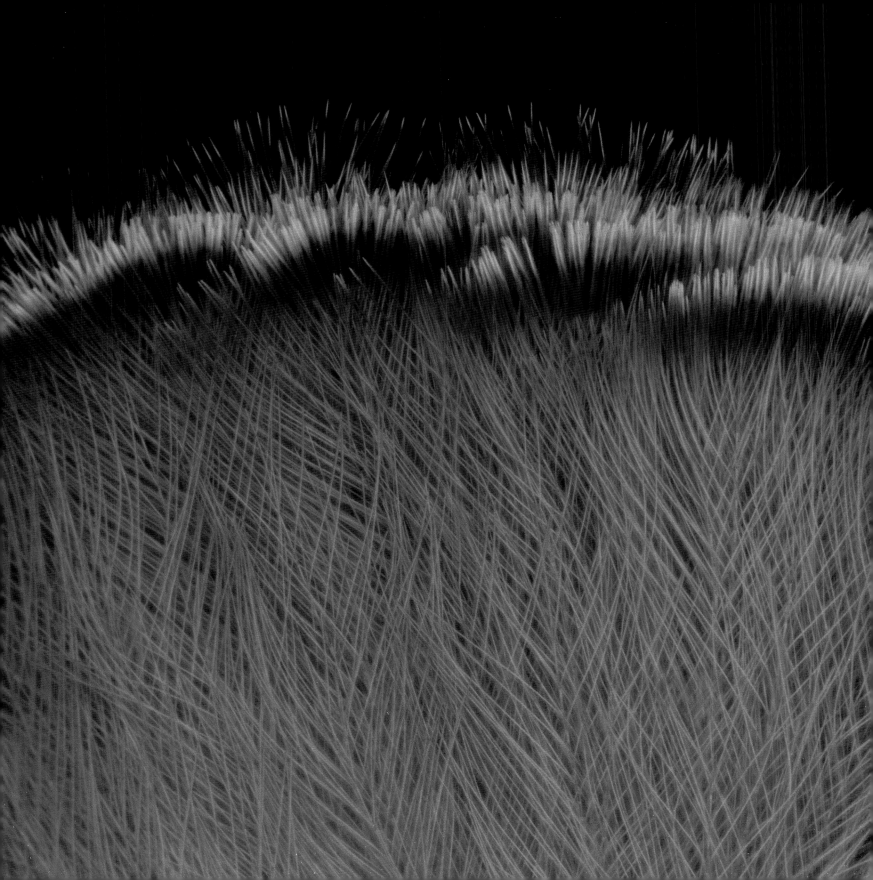

Guianan Cock-of-the-rock

Few birds are entirely orange. The Guianan Cock-of-the-rock is one of the
exceptions. The male has stunningly bright plumage and a conspicuous
crest on his head that looks like a slice of orange. The colour and quality
of the feathers displayed during the courtship dance are crucial to a
male's mating success. The males gather together in communal mating
grounds referred to as leks, where they engage in competitive displays
to attract females. Each hen carefully inspects several males and may
confirm her selection with a peck on his rump. Males are not involved
in nest building, incubation or care of the young.

Black Sicklebill

NEXT SPREAD

With its sabre-shaped tail and erectile black axe-like plumes emanating
from the sides of the breast, the Black Sicklebill is the longest bird-of-
paradise. Some of the terminal tips of these feathers look as if they had
been dipped in iridescent blue ink. During courtship displays, when
the breast feathers have been fully erected, they form a black feathered
cowl with a shining, thin circle of blue framing the head.

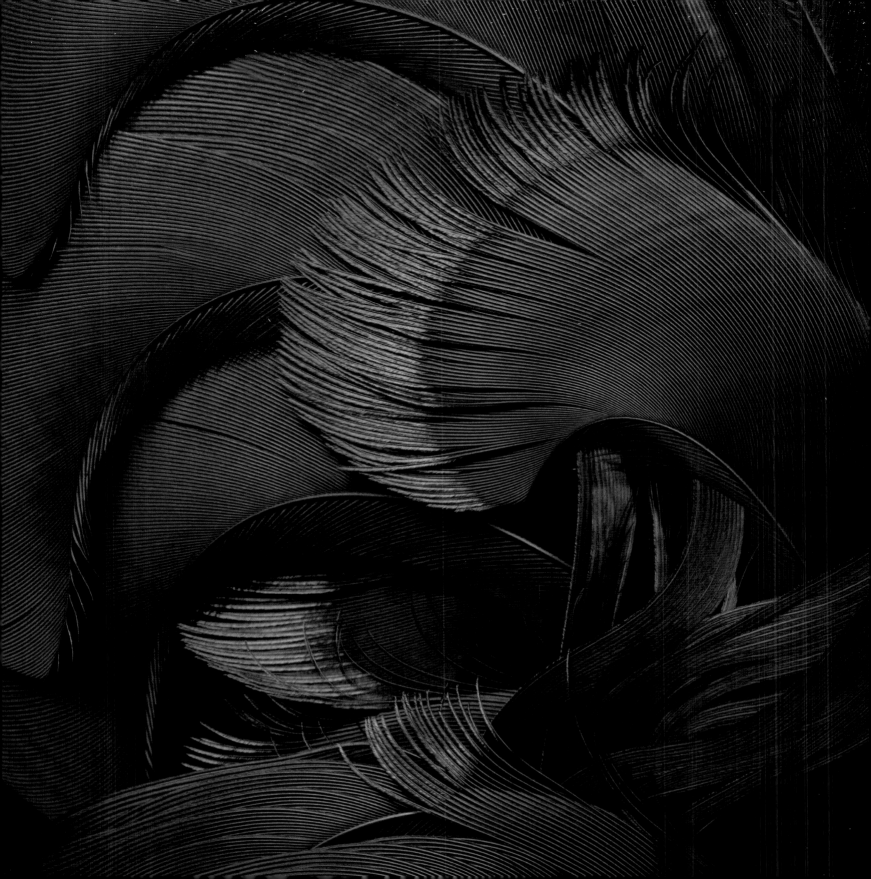

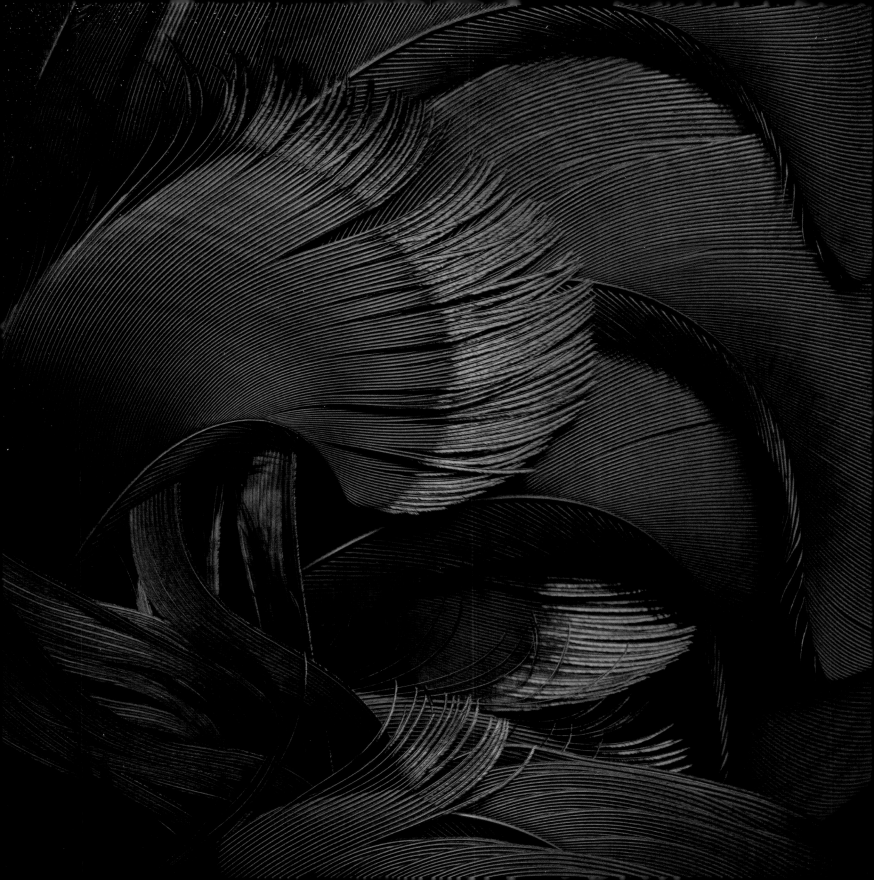

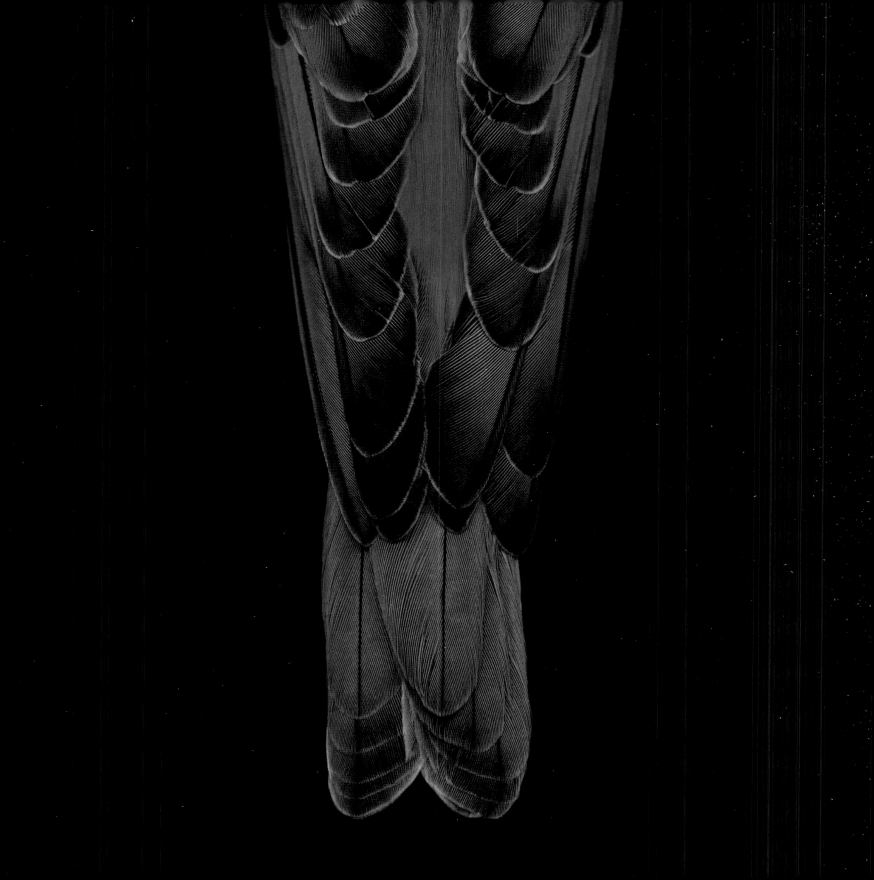

Mountain Bluebird

The plumage of the Mountain Bluebird is the richest blue of any of
the three species of bluebirds. The deepest tones are found on the
tail, back and wings of the male, while throat and breast are paler.
All three species are migratory, and their early spring return may
be one reason why bluebirds have long been seen as harbingers of
happiness. Another reason may be their lyrical song at early dawn,
heralding the start of a new day.

———

Blue-winged Teal

NEXT SPREAD

The feathers on a duck's wing are critical for flight and survival,
and must be maintained in the best possible shape. Preening several
times a day allows birds to clean and align feathers in the optimum
position and helps remove unwanted dust and parasites. It also
spreads the oily, waxy substance from their uropygial gland, which
helps to waterproof their feathers. The upper side of a duck's wing
is usually darker in colour. The increased pigmentation makes the
feather stronger and provides better camouflage.

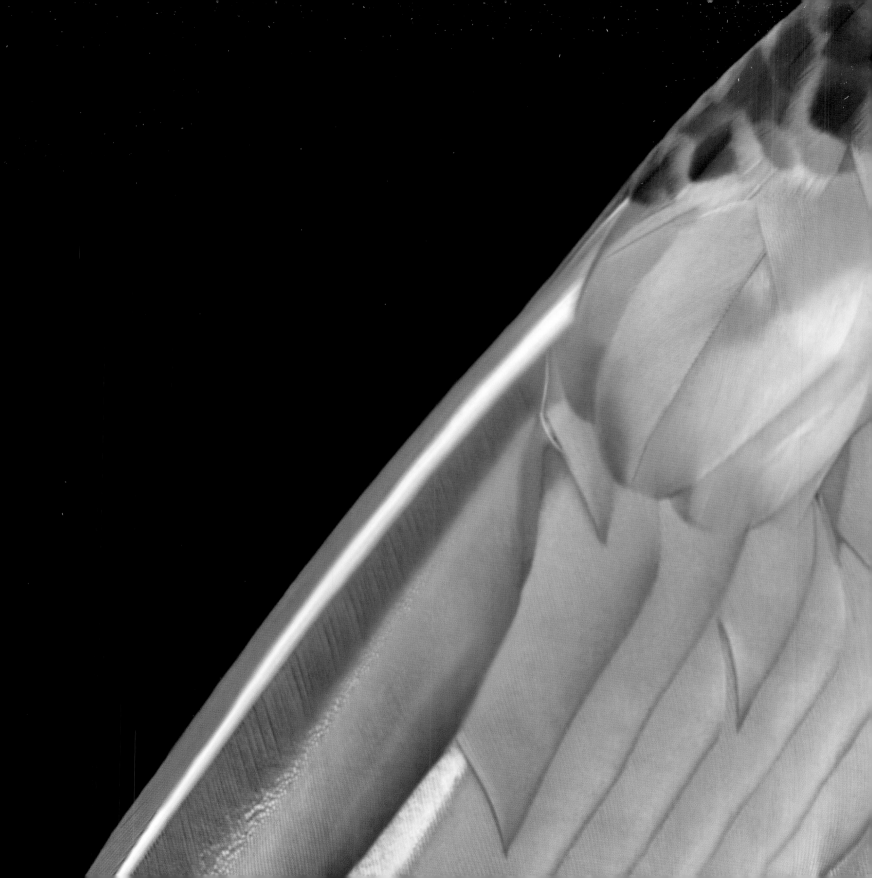

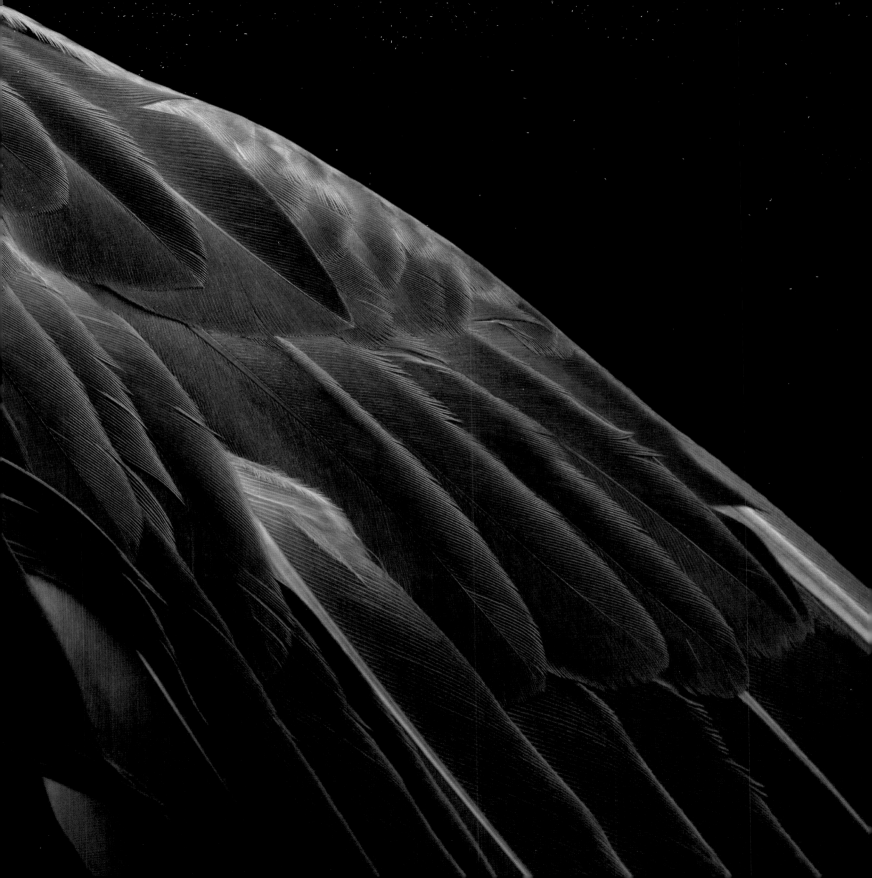

Common Scimitar-bill

There are three species of Scimitar-bills. They all have a long,
downcurved bill, which they use to probe into crevices and holes in trees
and on the ground when they search for insects and other invertebrates.
The outer layer of a bird's bill is known as the rhamphotheca. Made
of keratin, the key component of hair and nails in mammals, the
rhamphotheca is subjected to heavy wear and tear and therefore
grows continuously.

Long-tailed Sylph

There are over 340 hummingbird species recognised in the Americas today. They come in an extensive array of sizes and colours, and with a wide variety of astonishing tail and bill shapes. The striking tail of the male Long-tailed Sylph, shimmering in an iridescent greenish blue, is extremely long, reaching 15 cm / 6 inches, while the rest of the body, including the bill, extends to around 12.5 cm / 5 inches. Female sylphs have a preference for males with long tails.

Indian Peafowl

Remarkable for the beautiful iridescent eyespots that have made the bird so familiar to people everywhere, the peacock's tail coverts are contour feathers normally used to provide extra protection to the flight feathers. The upper part of these feathers, which contains the eyespots, is strong and stiff, while the lower part is wispy, resembling a semiplume. The close-up here beautifully shows the iridescent feather tip and the brown and white pattern on the lower part of the feather.

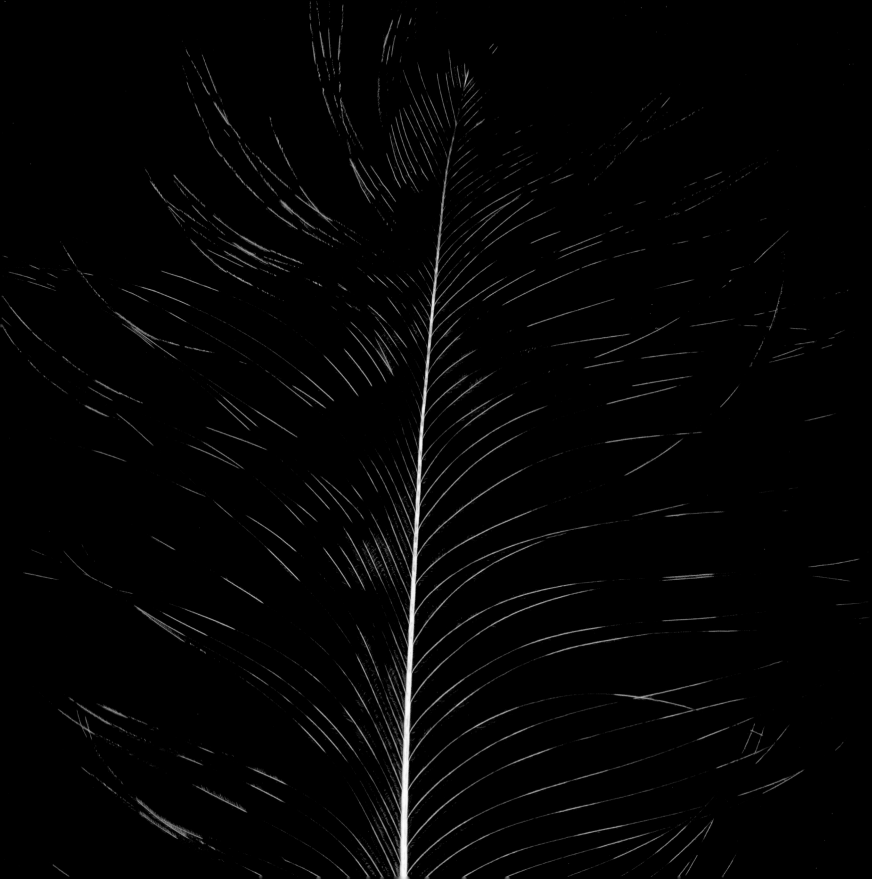

Osprey

Ospreys, colloquially known as fish hawks, eat almost exclusively fish.
They are often observed hovering high above shallow waters hunting
for their prey within 1 metre / 3 feet of the surface. The iris is yellow
in adults and somewhat darker in juveniles. Ospreys lack the prominent
eye ridge found in most raptors but the feathers above and the black
feathers in front and behind the eye help to protect the eye and reduce
glare from the water surface when the bird is hunting. Like most birds
of prey, Ospreys have proportionally more sensory receptors in the
retinas of their eyes than mammals, enabling them to see three to four
times farther than humans.

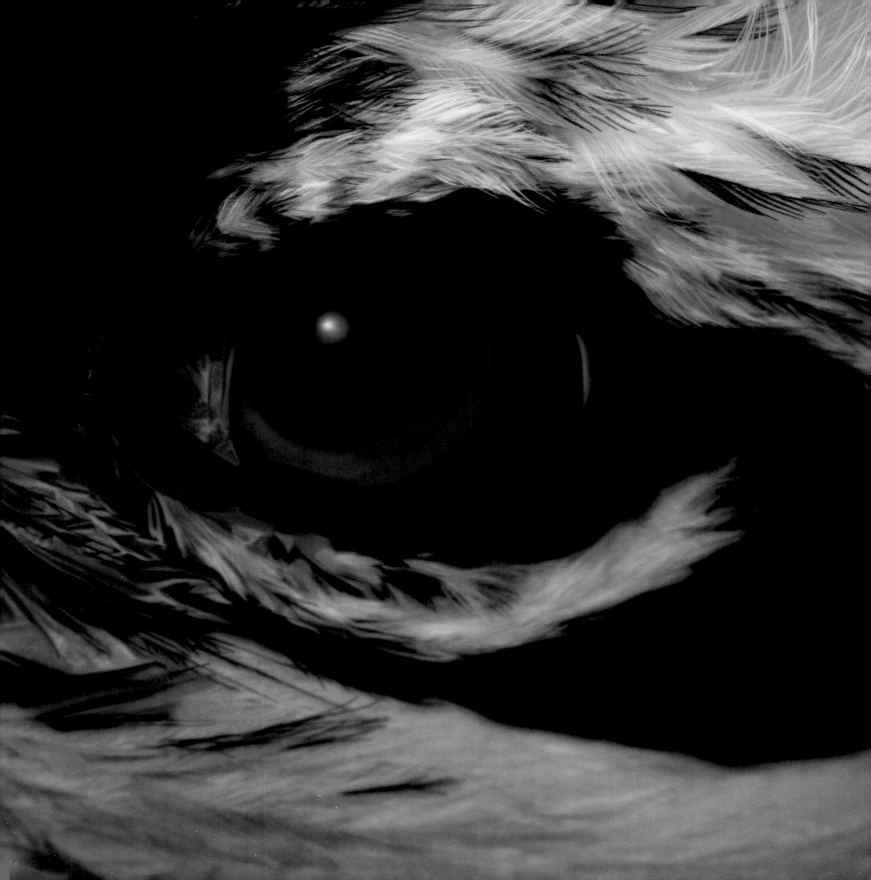

Razorbill Eggs

The Razorbill's egg is approximately twice the volume of a chicken egg. There is considerable variation in the streaking and blotching but the base colour remains more or less consistent across all eggs. Historically, Razorbill eggs and birds were an important food resource and were harvested annually in the spring in their breeding colonies throughout the North Atlantic. The Razorbill is now protected in North America under the Migratory Birds Convention Act but the species is still hunted in some European countries.

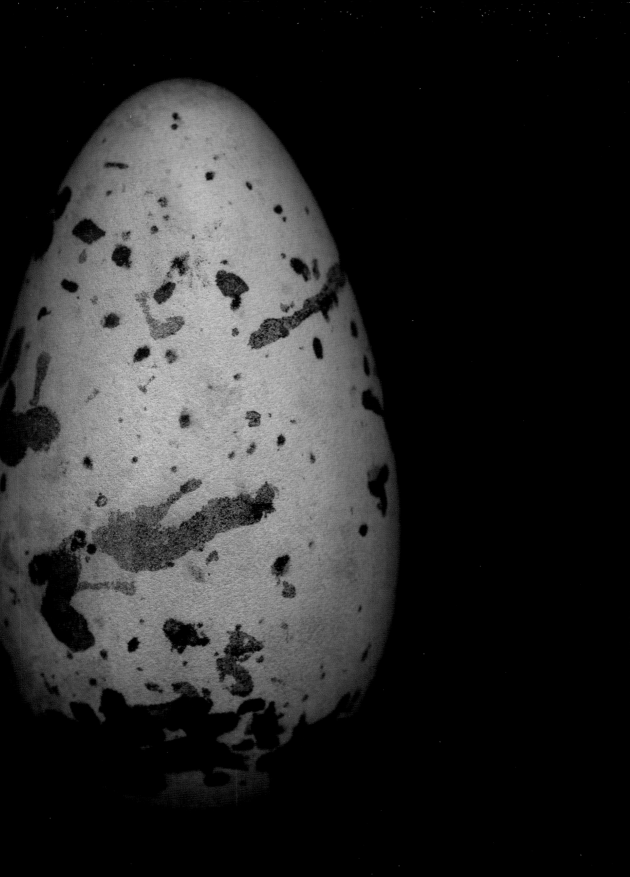

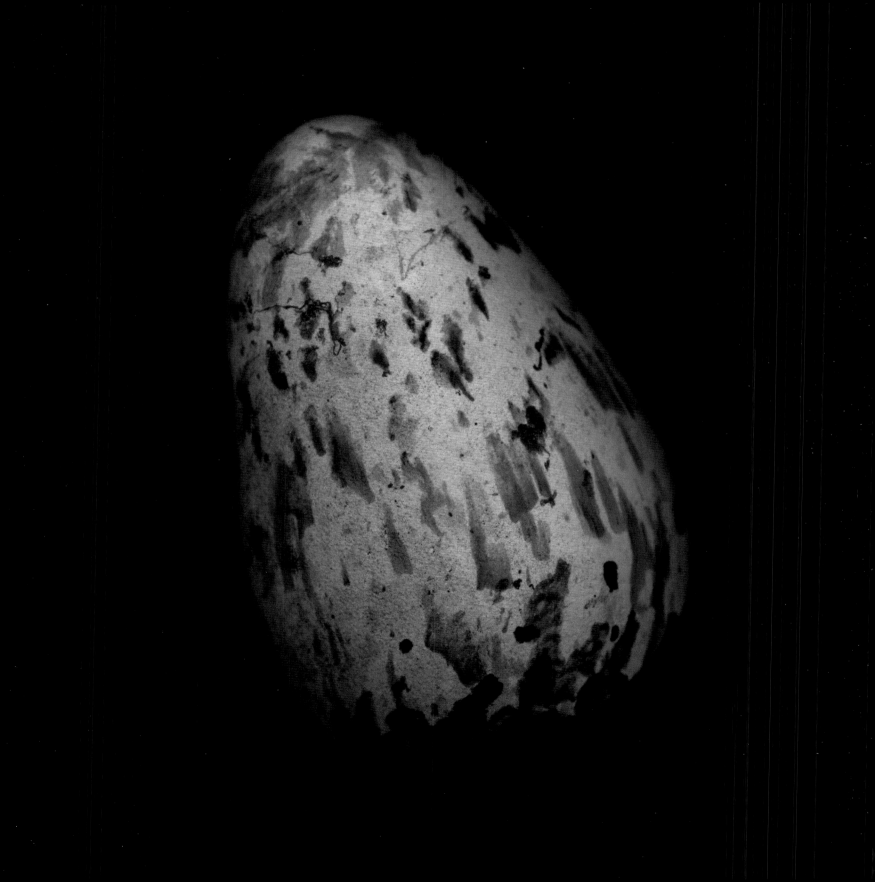

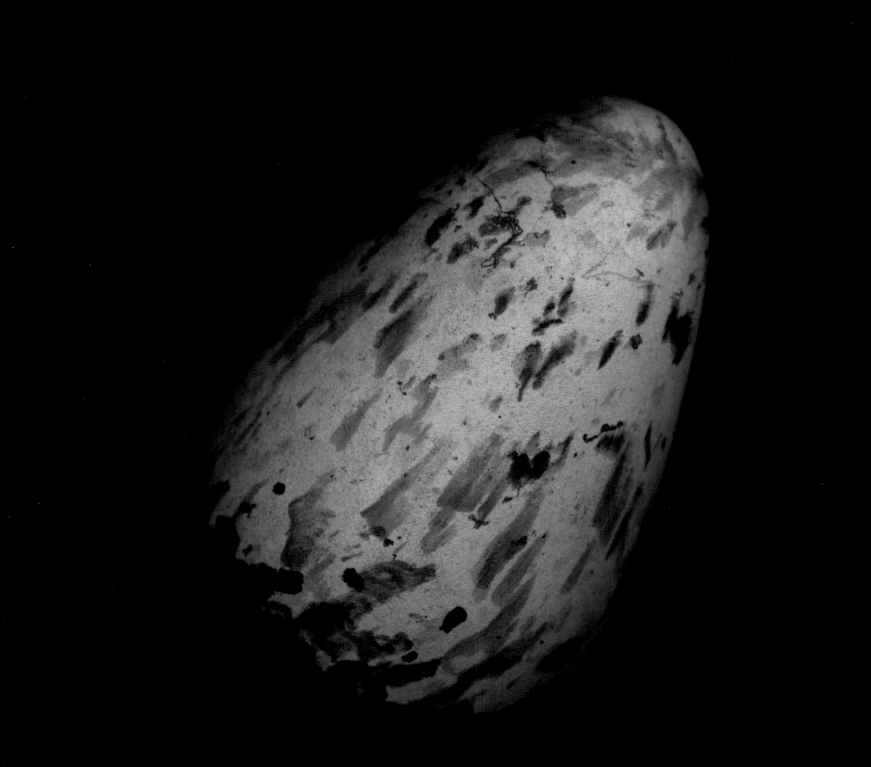

Southern Brown Kiwi

The Tokoeko, or Southern Brown Kiwi, one of five species of kiwis recognised today, is found only on New Zealand's South Island. The kiwi is New Zealand's national symbol. Kiwi feathers are unique: lacking barbules and the small accessory plumes known as aftershafts, they are soft and hair-like. They hang loosely on the body but still provide warmth and are water repellent. Kiwis moult throughout the year.

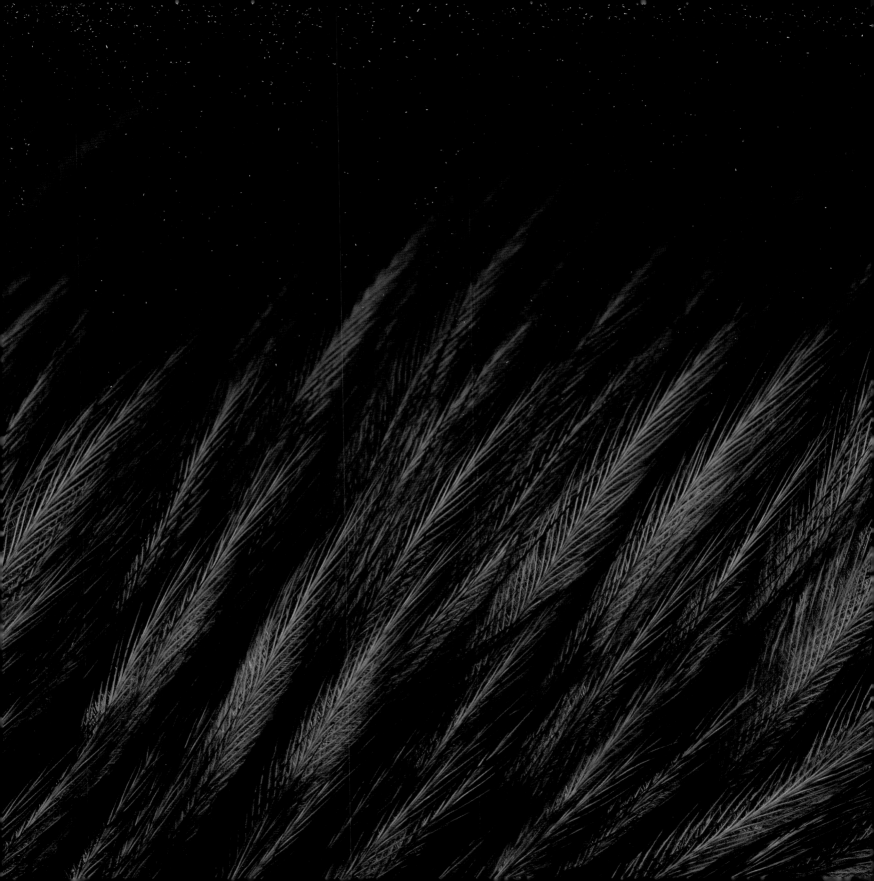

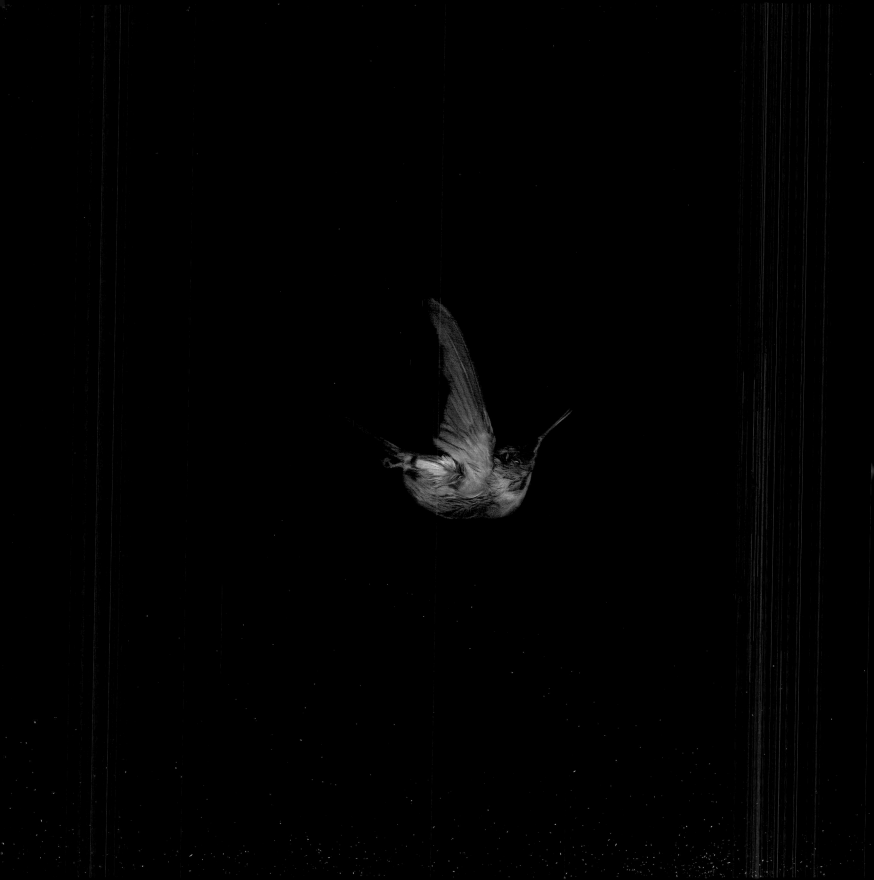

Vervain Hummingbird

The Vervain Hummingbird is the second smallest bird in the world after the closely related Bee Hummingbird from Cuba. Not much bigger than a bumblebee, this species is a little less than 6.5 cm / 2 ½ inches in length, bill included. It also produces some of the smallest eggs in the bird world, measuring less than 1.3 cm / ½ inches. Unlike almost all other species of hummingbird, the male and female look similar and do not have any iridescent feathering other than on the back.

Yellow-billed Cuckoo

The Yellow-billed and Black-billed Cuckoos of North America are solitary, elusive birds with slender bodies and long tails. The breeding ranges of the two species overlap, and their calls are similar, but they can be easily distinguished by their white tail spots. Those on the Yellow-billed Cuckoo are large and conspicuous, whereas the white markings on the Black-billed Cuckoo are much smaller. Both species lay their eggs in other birds' nests, with a preference for those with blue eggs, similar to their own.

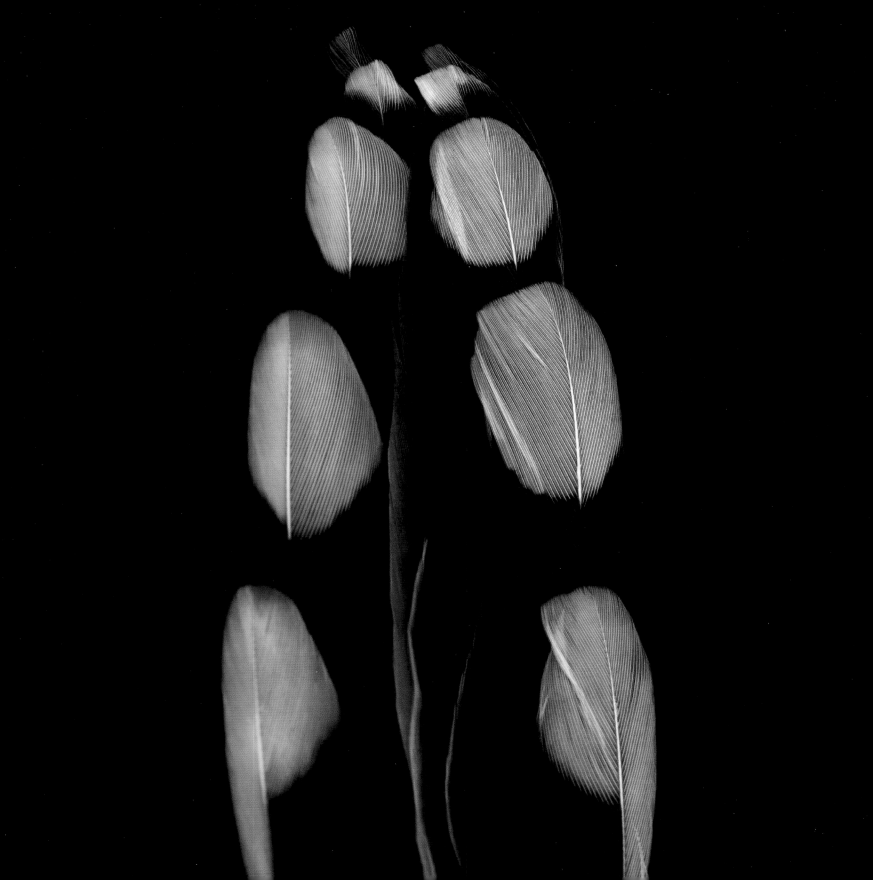

King Bird-of-paradise

The elongated central tail feathers on the male have been reduced to a central red shaft terminating in an astonishing iridescent green spiral disc. The tail wires extend past the tail by more than 10 cm / 4 inches, and the disc may be as wide as 1.5 cm / ⅝ of an inch. The cryptically coloured female lacks the elongated central tail feathers. Although hunted for its plumage in the past, the King Bird-of-paradise continues to be widespread and common throughout much of its range.

———

Rose-breasted Grosbeak

NEXT AND FOLLOWING SPREAD

The male Rose-breasted Grosbeak is a medium-sized songbird colloquially known as the 'cut-throat'. This species has a large powerful bill and feeds on insects, flower buds and seeds. It is considered by many to have one of the most beautiful songs in the Eastern Canadian forests, much like an American Robin but richer, sweeter and more polished. Both males and females sing. Rose-breasted Grosbeaks winter in Central America and northern South America. They are regularly trapped on their wintering grounds and have become popular cage birds because of their sweet songs.

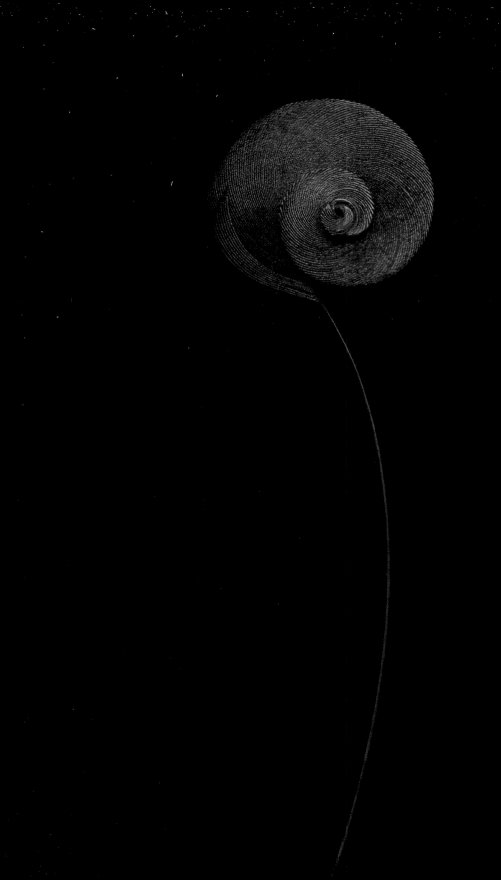

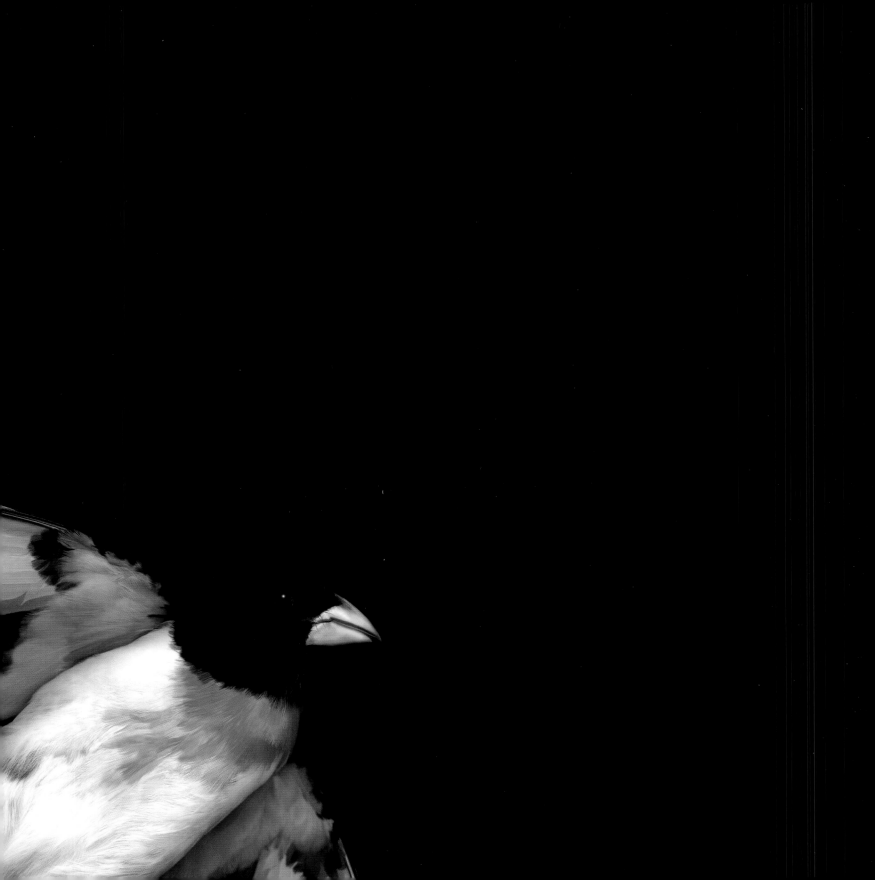

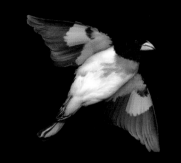

Index

American
Crow

—

pp. 127-28

SCIENTIFIC NAME
Corvus brachyrhynchos

FAMILY
Corvidae (Crows)

DISTRIBUTION
North America

HABITAT
Fields, open woodlands and forests

MIGRATION
In northern part of range

SIZE
48 cm / 19 inches

CONSERVATION STATUS
Low risk

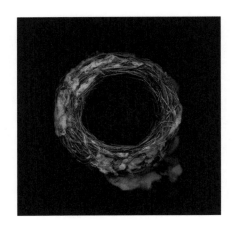

American
Redstart

—

pp. 154-55

SCIENTIFIC NAME
Setophaga ruticilla

FAMILY
Parulidae (New World Warblers)

DISTRIBUTION
North America

HABITAT
Deciduous woodlands

MIGRATION
Yes

SIZE
13 cm / 5 ¼ inches

CONSERVATION STATUS
Low risk

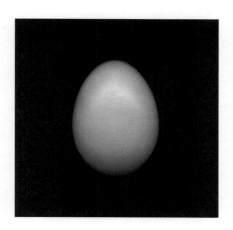

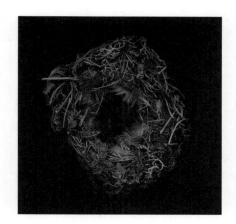

American Robin

—

pp. 139-41, 171, 203-04

SCIENTIFIC NAME
Turdus migratorius

FAMILY
Turdidae (Thrushes)

DISTRIBUTION
North and Central America

HABITAT
Woodland, farmland and urban areas

MIGRATION
Yes

SIZE
25 cm / 10 inches

CONSERVATION STATUS
Low risk

American Tree Sparrow

—

p. 209

SCIENTIFIC NAME
Spizella arborea

FAMILY
Emberizidae
(Buntings and New World Sparrows)

DISTRIBUTION
Northern Canada and Alaska

HABITAT
Boreal forest and tundra

MIGRATION
Yes

SIZE
16 cm / 6 ¼ inches

CONSERVATION STATUS
Low risk

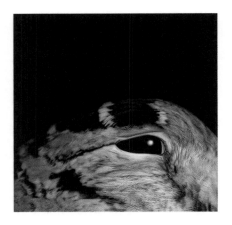

American Woodcock

—

p. 41

SCIENTIFIC NAME
Scolopax minor

FAMILY
Scolopacidae
(Snipes, Sandpipers and Phalaropes)

DISTRIBUTION
Eastern North America

HABITAT
Moist woodlands

MIGRATION
Yes

SIZE
28 cm / 11 inches

CONSERVATION STATUS
Low risk

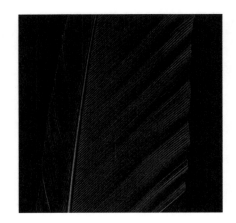

Bald Eagle

—

pp. 66-67

SCIENTIFIC NAME
Haliaeetus leucocephalus

FAMILY
Accipitridae (Hawks and Eagles)

DISTRIBUTION
North America

HABITAT
Sea coasts, rivers and lakes

MIGRATION
In northern part of range

SIZE
90 cm / 35 inches

CONSERVATION STATUS
Low Risk

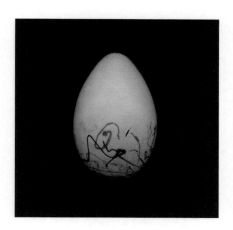

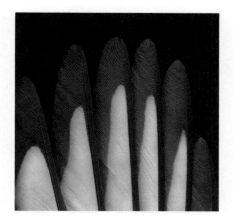

Baltimore Oriole

—

pp. 82–83

SCIENTIFIC NAME
Icterus galbula

FAMILY
Icteridae (New World Blackbirds)

DISTRIBUTION
Eastern North America

HABITAT
Deciduous open woodland

MIGRATION
In northern part of range

SIZE
21 cm / 8 ¼ inches

CONSERVATION STATUS
Low risk

Black-billed Magpie

—

pp. 99, 103

SCIENTIFIC NAME
Pica hudsonia

FAMILY
Corvidae (Crows)

DISTRIBUTION
Western North America

HABITAT
Open woodlands and rangelands

MIGRATION
No

SIZE
48 cm / 19 inches

CONSERVATION STATUS
Low risk

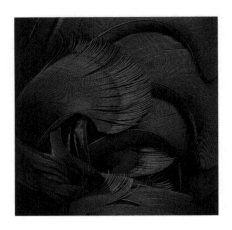

Black Sicklebill

———

pp. 22–23, 169, 212–13

SCIENTIFIC NAME
Epimachus fastosus

FAMILY
Paradisaeidae (Birds-of-paradise)

DISTRIBUTION
New Guinea

HABITAT
Forests

MIGRATION
No

SIZE
110 cm / 43 inches

CONSERVATION STATUS
Vulnerable

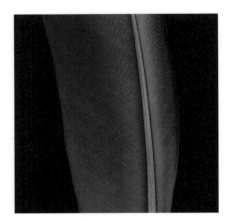

Blue and Yellow Macaw

———

p. 133

SCIENTIFIC NAME
Anodorhynchus hyacinthinus

FAMILY
Psittacidae (Parrots)

DISTRIBUTION
Northern South America

HABITAT
Lowland forests

MIGRATION
No

SIZE
80 cm / 32 inches

CONSERVATION STATUS
Low Risk

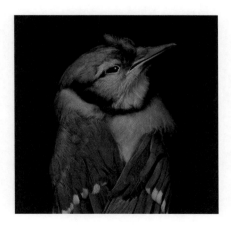

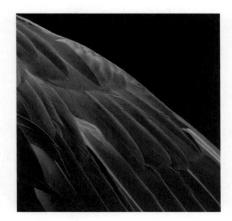

Blue
Jay

—

p. 85

SCIENTIFIC NAME
Cyanocitta cristata

FAMILY
Corvidae (Crows)

DISTRIBUTION
Central and Eastern North America

HABITAT
Woodland, parks and urban areas

MIGRATION
Yes

SIZE
28 cm / 11 inches

CONSERVATION STATUS
Low risk

Blue-winged
Teal

—

pp. 216-17

SCIENTIFIC NAME
Spatula discors

FAMILY
Anatidae (Ducks, Geese and Swans)

DISTRIBUTION
North America

HABITAT
Wetlands and lakes

MIGRATION
Yes

SIZE
40 cm / 16 inches

CONSERVATION STATUS
Low risk

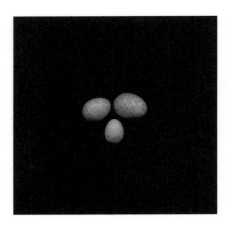

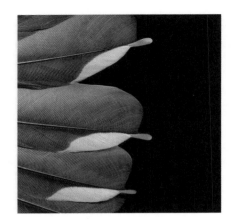

Brown-headed
Cowbird

—

p. 91

SCIENTIFIC NAME
Molothrus ater

FAMILY
Icteridae (New World Blackbirds)

DISTRIBUTION
North America

HABITAT
Grassland and successional habitat

MIGRATION
Yes

SIZE
19 cm / 7 ½ inches

CONSERVATION STATUS
Low risk

Cedar
Waxwing

—

pp. 21, 31, 143, 179

SCIENTIFIC NAME
Bombycilla cedrorum

FAMILY
Bombycillidae (Waxwings)

DISTRIBUTION
North America

HABITAT
Open woodland and urban areas

MIGRATION
Yes

SIZE
18 cm / 7 ¼ inches

CONSERVATION STATUS
Low Risk

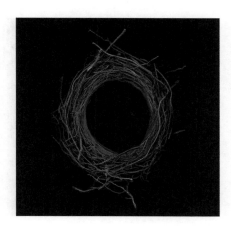

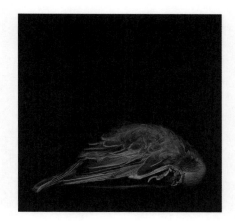

Chipping Sparrow

———

pp. 89-91

SCIENTIFIC NAME
Spizella passerina

FAMILY
Emberizidae
(Buntings and New World Sparrows)

DISTRIBUTION
North America

HABITAT
Fields, successional habitat, urban areas

MIGRATION
Yes

SIZE
14 cm / 5 ½ inches

CONSERVATION STATUS
Low risk

Common or European Starling

———

p. 159

SCIENTIFIC NAME
Sturnus vulgaris

FAMILY
Sturnidae (Starlings)

DISTRIBUTION
Europe and western Asia (native)

HABITAT
Rural and urban areas

MIGRATION
Yes

SIZE
20 cm / 8 inches

CONSERVATION STATUS
Low risk

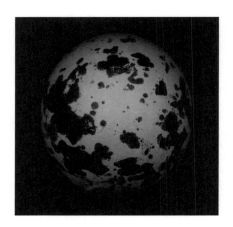

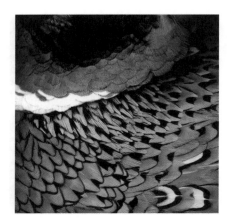

Common Murre

—

PP. 33-34

SCIENTIFIC NAME
Uria aalge

FAMILY
Alcidae (Auks)

DISTRIBUTION
North Pacific and Atlantic Ocean

HABITAT
Coastal marine

MIGRATION
Yes

SIZE
45 cm / 18 inches

CONSERVATION STATUS
Low risk

Common or Ring-necked Pheasant

—

p. 95

SCIENTIFIC NAME
Phasianus colchicus

FAMILY
Phasianidae
(Pheasants and Partridges)

DISTRIBUTION
Northern hemisphere

HABITAT
Woodland

MIGRATION
No

SIZE
81 cm / 32 inches

CONSERVATION STATUS
Low risk

Common Scimitar-bill

p.218

SCIENTIFIC NAME
Rhinopomastus cyanomelas

FAMILY
Phoeniculidae (Woodhoopoes)

DISTRIBUTION
Southern Africa

HABITAT
Open parkland

MIGRATION
No

SIZE
35 cm / 14 inches

CONSERVATION STATUS
Low Risk

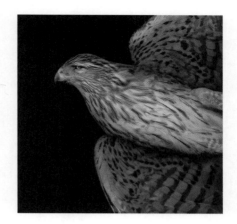

Cooper's Hawk

pp. 38-39

SCIENTIFIC NAME
Accipiter cooperii

FAMILY
Accipitridae (Hawks and Eagles)

DISTRIBUTION
United States and southern Canada

HABITAT
Woodland and urban areas

MIGRATION
Yes

SIZE
50 cm / 20 inches

CONSERVATION STATUS
Low risk

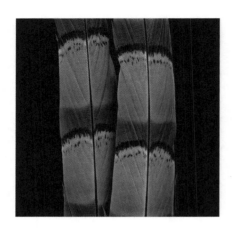

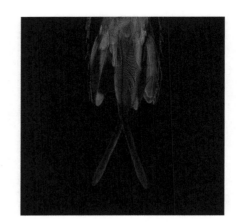

Copper Pheasant

—

p. 68

SCIENTIFIC NAME
Syrmaticus soemmerringii

FAMILY
Phasianidae
(Pheasants and Partridges)

DISTRIBUTION
Japan

HABITAT
Forest and successional habitat

MIGRATION
No

SIZE
127 cm / 50 inches

CONSERVATION STATUS
Low risk

Crimson Topaz

—

p. 147

SCIENTIFIC NAME
Topaza pella

FAMILY
Trochilidae (Hummingbirds)

DISTRIBUTION
Northeastern South America

HABITAT
Tropical forests

MIGRATION
No

SIZE
18 cm / 7 ½ inches

CONSERVATION STATUS
Low risk

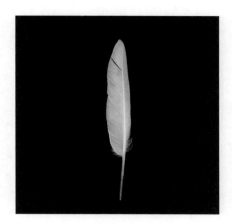

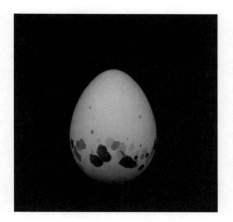

Domestic
Duck

—

p. 137

SCIENTIFIC NAME
Anas platyrhynchos

FAMILY
Anatidae (Ducks, Geese and Swans)

DISTRIBUTION
Worldwide

HABITAT
Rural

MIGRATION
No

SIZE
61 cm / 24 inches

CONSERVATION STATUS
Low Risk

Eastern
Wood-pewee

—

pp. 160-61

SCIENTIFIC NAME
Contopus virens

FAMILY
Tyrannidae (Tyrant-flycatchers)

DISTRIBUTION
Eastern North America

HABITAT
Deciduous woodland

MIGRATION
Yes

SIZE
16 cm / 6 ¼ inches

CONSERVATION STATUS
Low risk

Emu

———

pp. 108, 153

SCIENTIFIC NAME
Dromaius novaehollandiae

FAMILY
Dromaiidae (Emu)

DISTRIBUTION
Australia

HABITAT
Grassland

MIGRATION
No

SIZE
190 cm / 75 inches

CONSERVATION STATUS
Low risk

Fork-tailed
Flycatcher

———

p. 47

SCIENTIFIC NAME
Tyrannus savana

FAMILY
Tyrannidae (Tyrant-flycatchers)

DISTRIBUTION
Central and South America

HABITAT
Successional habitat

MIGRATION
Yes

SIZE
41 cm / 16 inches

CONSERVATION STATUS
Low Risk

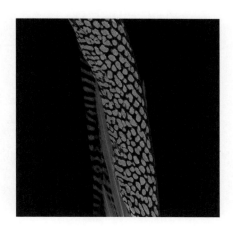

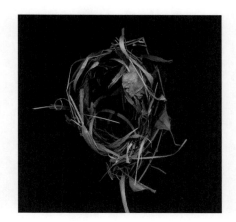

Golden
Pheasant

———

p. 157

SCIENTIFIC NAME
Chrysolophus pictus

FAMILY
Phasianidae
(Pheasants and Partridges)

DISTRIBUTION
Western China

HABITAT
Forests

MIGRATION
No

SIZE
100 cm / 39 inches

CONSERVATION STATUS
Low risk

Golden-winged
Warbler

———

p. 54

SCIENTIFIC NAME
Vermivora chrysoptera

FAMILY
Parulidae (New World Warblers)

DISTRIBUTION
Northeastern United States
and southern Canada

HABITAT
Successional habitat

MIGRATION
Yes

SIZE
12 cm / 4 ¾ inches

CONSERVATION STATUS
Low risk

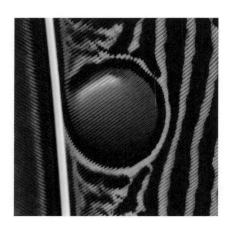

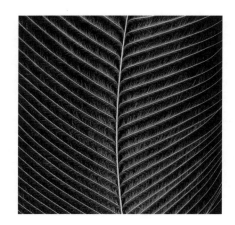

Great
Argus

———

pp. 19, 64–65

SCIENTIFIC NAME
Argusianus argus

FAMILY
Phasianidae
(Pheasants and Partridges)

DISTRIBUTION
Southeast Asia

HABITAT
Forests

MIGRATION
No

SIZE
140 cm / 55 inches

CONSERVATION STATUS
Near threatened

Greater
Bird-of-paradise

———

pp. 166–67, 195, 207

SCIENTIFIC NAME
Paradisaea apoda

FAMILY
Paradisaeidae (Birds-of-paradise)

DISTRIBUTION
New Guinea

HABITAT
Forests

MIGRATION
No

SIZE
43 cm / 17 inches

CONSERVATION STATUS
Low risk

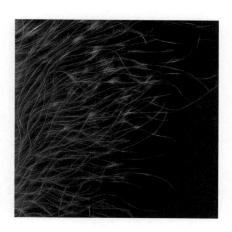

Great Grey Owl

———

pp. 123, 196-97

SCIENTIFIC NAME
Strix nebulosa

FAMILY
Strigidae (Typical Owls)

DISTRIBUTION
Northern Hemisphere

HABITAT
Boreal forests

MIGRATION
Irruptive

SIZE
69 cm / 27 inches

CONSERVATION STATUS
Low Risk

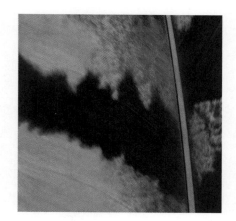

Great Horned Owl

———

pp. 76-77, 117, 119

SCIENTIFIC NAME
Bubo virginianus

FAMILY
Strigidae (Typical Owls)

DISTRIBUTION
North and South America

HABITAT
Woodland and parkland

MIGRATION
No

SIZE
60 cm / 24 inches

CONSERVATION STATUS
Low risk

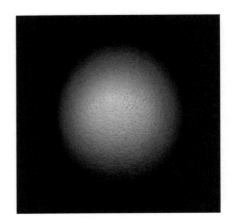

Greater Racket-tailed Drongo

———

p. 164

SCIENTIFIC NAME
Dicrurus paradiseus

FAMILY
Dicruridae (Drongos)

DISTRIBUTION
South Asia

HABITAT
Woodland and parkland

MIGRATION
No

SIZE
60 cm / 24 inches

CONSERVATION STATUS
Low risk

Greater Rhea

———

pp. 45, 109

SCIENTIFIC NAME
Rhea americana

FAMILY
Rheidae (Rheas)

DISTRIBUTION
Southern South America

HABITAT
Grasslands

MIGRATION
No

SIZE
140 cm / 55 inches

CONSERVATION STATUS
Low Risk

Grey
Junglefowl

———

pp. 71, 73

SCIENTIFIC NAME
Gallus sonneratii

FAMILY
Phasianidae
(Pheasants and Partridges)

DISTRIBUTION
Southern India

HABITAT
Forest and successional habitat

MIGRATION
No

SIZE
56 cm / 22 inches

CONSERVATION STATUS
Low risk

Guianan
Cock-of-the-rock

———

p. 210

SCIENTIFIC NAME
Rupicola rupicola

FAMILY
Cotingidae (Cotingas)

DISTRIBUTION
Northeastern South America

HABITAT
Rainforest

MIGRATION
No

SIZE
30 cm / 12 inches

CONSERVATION STATUS
Low risk

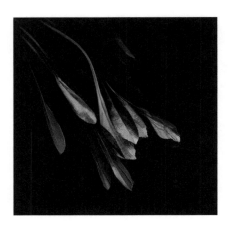

Himalayan Monal

———

p. 17

SCIENTIFIC NAME
Lophophorus impejanus

FAMILY
Phasianidae
(Pheasants and Partridges)

DISTRIBUTION
Southern Central Asia

HABITAT
Forests and alpine meadows

MIGRATION
Altitudinal migrant

SIZE
70 cm / 28 inches

CONSERVATION STATUS
Low Risk

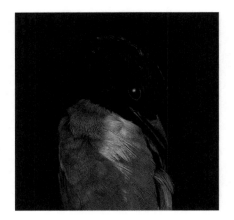

Hooded Pita

———

p. 131

SCIENTIFIC NAME
Pitta sordida

FAMILY
Pittidae (Pittas)

DISTRIBUTION
Southeast Asia

HABITAT
Forests and plantations

MIGRATION
No

SIZE
18 cm / 7 inches

CONSERVATION STATUS
Low risk

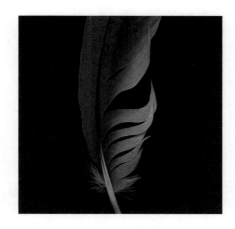

Hyacinth Macaw

———

pp. 100–01

SCIENTIFIC NAME
Anodorhynchus hyacinthinus

FAMILY
Psittacidae (Parrots)

DISTRIBUTION
East-central South America

HABITAT
Forests

MIGRATION
No

SIZE
100 cm / 40 inches

CONSERVATION STATUS
Vulnerable

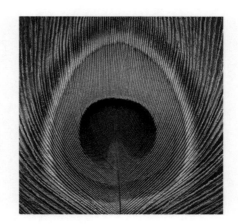

Indian Peafowl

———

pp. 63, 148, 163, 221

SCIENTIFIC NAME
Pavo cristatus

FAMILY
Phasianidae
(Pheasants and Partridges)

DISTRIBUTION
India and Sri Lanka

HABITAT
Woodland and forest edge

MIGRATION
No

SIZE
110 cm / 43 inches

CONSERVATION STATUS
Low risk

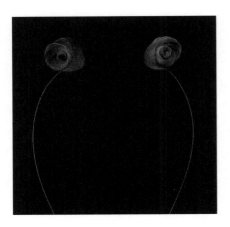

King
Bird-of-paradise

—

pp. 125, 235

SCIENTIFIC NAME
Cicinnurus regius

FAMILY
Paradisaeidae (Birds-of-paradise)

DISTRIBUTION
New Guinea

HABITAT
Forest

MIGRATION
No

SIZE
16 cm / 6 ½ inches

CONSERVATION STATUS
Low Risk

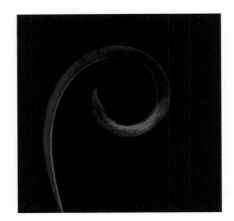

King of Holland
Bird-of-paradise

—

p. 112

SCIENTIFIC NAME
Cicinnurus magnificus x Cicinnurus regius

FAMILY
Paradisaeidae (Birds-of-paradise)

DISTRIBUTION
New Guinea

HABITAT
Forest

MIGRATION
No

SIZE
16 cm / 6 ½ inches

CONSERVATION STATUS
Low risk

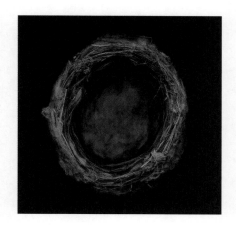

King of Saxony Bird-of-paradise

───

pp. 186-87

SCIENTIFIC NAME
Pteridophora alberti

FAMILY
Paradisaeidae (Birds-of-paradise)

DISTRIBUTION
New Guinea

HABITAT
Forest

MIGRATION
No

SIZE
22 cm / 8 ½ inches

CONSERVATION STATUS
Low risk

Least Flycatcher

───

p. 136

SCIENTIFIC NAME
Empidonax minimus

FAMILY
Tyrannidae (Tyrant-flycatchers)

DISTRIBUTION
Canada and northern United States

HABITAT
Deciduous woodland and parkland

MIGRATION
Yes

SIZE
13 cm / 5 ¼ inches

CONSERVATION STATUS
Low risk

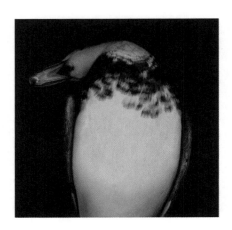

Long-tailed Duck

—

p. 173

SCIENTIFIC NAME
Clangula hyemalis

FAMILY
Anatidae (Ducks, Geese and Swans)

DISTRIBUTION
Arctic circumpolar

HABITAT
Tundra, marine and freshwater

MIGRATION
Yes

SIZE
56 cm / 22 inches

CONSERVATION STATUS
Low risk

Long-tailed Sylph

—

p. 219

SCIENTIFIC NAME
Aglaiocercus kingii

FAMILY
Trochilidae (Hummingbirds)

DISTRIBUTION
Northwestern South America

HABITAT
Montane forests

MIGRATION
No

SIZE
25 cm / 10 inches

CONSERVATION STATUS
Low Risk

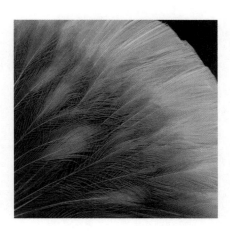

Magnificent
Bird-of-paradise

———

pp. 74–75, 106–07

SCIENTIFIC NAME
Cicicinnurus magnificus

FAMILY
Paradisaeidae (Birds-of-paradise)

DISTRIBUTION
New Guinea

HABITAT
Forest

MIGRATION
No

SIZE
26 cm / 10 inches

CONSERVATION STATUS
Low risk

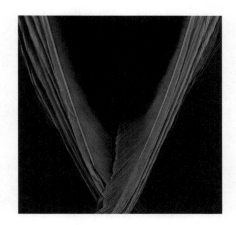

Makira
Starling

———

p. 121

SCIENTIFIC NAME
Aplonis dichroa

FAMILY
Sturnidae (Starlings)

DISTRIBUTION
Solomon Islands

HABITAT
Tropical forest

MIGRATION
No

SIZE
20 cm / 8 inches

CONSERVATION STATUS
Low risk

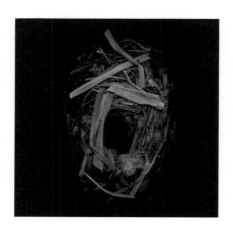

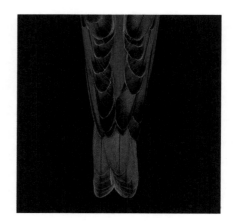

Marsh Wren

———

p. 168

SCIENTIFIC NAME
Cistothorus palustris

FAMILY
Troglodytidae (Wrens)

DISTRIBUTION
North America

HABITAT
Marsh

MIGRATION
Yes

SIZE
12 cm / 4 ¾ inches

CONSERVATION STATUS
Low risk

Mountain Bluebird

———

p. 214

SCIENTIFIC NAME
Sialia currucoides

FAMILY
Turdidae (Thrushes)

DISTRIBUTION
North America

HABITAT
Open terrain

MIGRATION
Yes

SIZE
18 cm / 7 inches

CONSERVATION STATUS
Low Risk

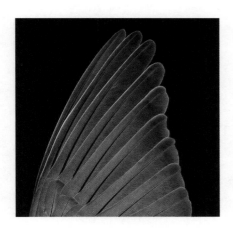

Mourning Dove

—

p. 86

SCIENTIFIC NAME
Zenaida macroura

FAMILY
Columbidae
(Pigeons and Doves)

DISTRIBUTION
North America

HABITAT
Open terrain

MIGRATION
In northern part of range

SIZE
30 cm / 12 inches

CONSERVATION STATUS
Low risk

Mute Swan

—

p. 59

SCIENTIFIC NAME
Cygnus olor

FAMILY
Anatidae
(Ducks, Geese and Swans)

DISTRIBUTION
Worldwide

HABITAT
Open water

MIGRATION
In northern part of range

SIZE
140 cm / 55 inches

CONSERVATION STATUS
Low risk

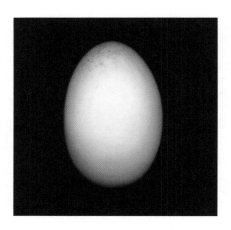

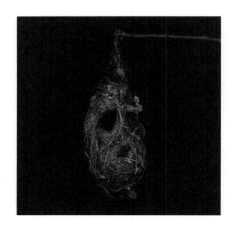

New Zealand Scaup

—

p. 29

SCIENTIFIC NAME
Aythya novaeseelandiae

FAMILY
Anatidae
(Ducks, Geese and Swans)

DISTRIBUTION
New Zealand

HABITAT
Open water

MIGRATION
No

SIZE
40 cm / 16 inches

CONSERVATION STATUS
Low risk

Olive-backed Sunbird

—

p. 145

SCIENTIFIC NAME
Cinnyris jugularis

FAMILY
Nectariniidae (Sunbirds)

DISTRIBUTION
Asia

HABITAT
Mangrove

MIGRATION
No

SIZE
12 cm / 4 ¾ inches

CONSERVATION STATUS
Low Risk

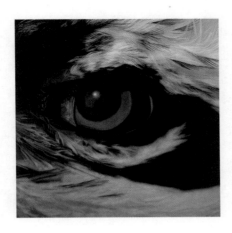

Osprey

———

pp. 50-51, 180, 223

SCIENTIFIC NAME
Pandion haliaetus

FAMILY
Pandionidae (Osprey)

DISTRIBUTION
Worldwide

HABITAT
Coastal, lakes, ponds

MIGRATION
In northern part of range

SIZE
56 cm / 22 inches

CONSERVATION STATUS
Low risk

Ostrich

———

pp. 48-49, 79

SCIENTIFIC NAME
Struthio camelus

FAMILY
Struthionidae (Ostrich)

DISTRIBUTION
Africa

HABITAT
Savannah

MIGRATION
No

SIZE
230 cm / 90 inches

CONSERVATION STATUS
Low risk

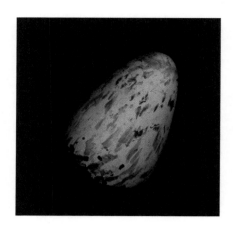

Razorbill

———

pp. 35-36, 225-27

SCIENTIFIC NAME
Alca torda

FAMILY
Alcidae (Auks)

DISTRIBUTION
North Atlantic

HABITAT
Rocky shore

MIGRATION
Yes

SIZE
43 cm / 17 inches

CONSERVATION STATUS
Low risk

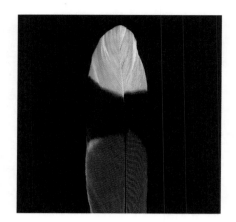

Red-billed Blue Magpie

———

p. 44

SCIENTIFIC NAME
Urocissa erythrorhyncha

FAMILY
Corvidae (Crows)

DISTRIBUTION
East Asia

HABITAT
Evergreen forest

MIGRATION
Yes

SIZE
65 cm / 62 inches

CONSERVATION STATUS
Low risk

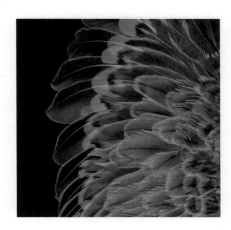

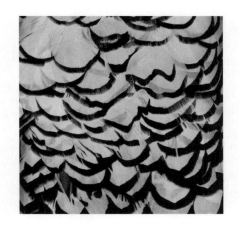

Red Knot

———

SCIENTIFIC NAME
Calidris canutus

FAMILY
Scolopacidae
(Snipes, Sandpipers and Phalaropes)

DISTRIBUTION
Worldwide

HABITAT
Tundra and coastal shore

MIGRATION
Yes

SIZE
24 cm / 9 ½ inches

CONSERVATION STATUS
Low Risk

Reeve's Pheasant

———

SCIENTIFIC NAME
Syrmaticus reevesii

FAMILY
Phasianidae (Pheasants and Partridges)

DISTRIBUTION
China

HABITAT
Evergreen forest

MIGRATION
No

SIZE
210 cm / 83 inches

CONSERVATION STATUS
Vulnerable

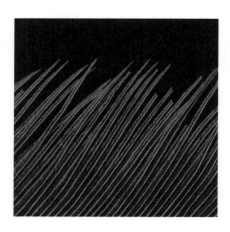

Resplendent Quetzal

———

p. 57

SCIENTIFIC NAME
Pharomachrus mocinno

FAMILY
Trogonidae (Trogons)

DISTRIBUTION
Central America

HABITAT
Cloud forest

MIGRATION
No

SIZE
40 cm / 16 inches

CONSERVATION STATUS
Near threatened

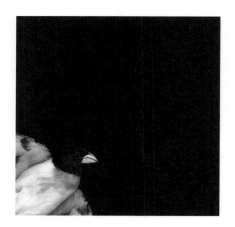

Rose-breasted Grosbeak

———

pp. 236-39

SCIENTIFIC NAME
Pheucticus ludovicianus

FAMILY
Cardinalidae (Cardinals)

DISTRIBUTION
North America

HABITAT
Woodland

MIGRATION
Yes

SIZE
20 cm / 8 inches

CONSERVATION STATUS
Low Risk

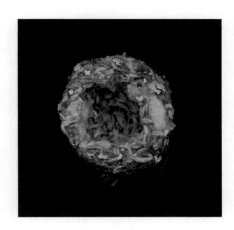

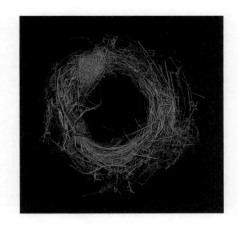

Ruby-throated Hummingbird

—

pp. 190–91

SCIENTIFIC NAME
Archilochus colubris

FAMILY
Trochilidae (Hummingbirds)

DISTRIBUTION
North America

HABITAT
Woodland, gardens

MIGRATION
Yes

SIZE
8 cm / 3 ¼ inches

CONSERVATION STATUS
Low risk

Rusty Blackbird

—

p. 115

SCIENTIFIC NAME
Euphagus carolinus

FAMILY
Icteridae (New World Blackbirds)

DISTRIBUTION
North America

HABITAT
Woodland

MIGRATION
Yes

SIZE
23 cm / 9 inches

CONSERVATION STATUS
Vulnerable

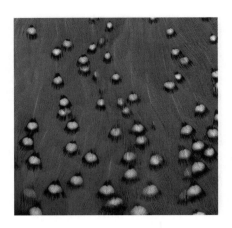

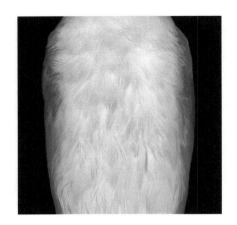

Satyr
Tragopan

——

p. 189

SCIENTIFIC NAME
Tragopan satyra

FAMILY
Phasianidae
(Pheasants and Partridges)

DISTRIBUTION
India, Tibet and Nepal

HABITAT
Rhododendron forests

MIGRATION
Altitudinal migrant

SIZE
70 cm / 28 inches

CONSERVATION STATUS
Near threatened

Scarlet
Ibis

——

p. 25

SCIENTIFIC NAME
Eudocimus ruber

FAMILY
Threskiornithidae
(Ibises and Spoonbills)

DISTRIBUTION
South America

HABITAT
Marsh

MIGRATION
No

SIZE
61 cm / 24 inches

CONSERVATION STATUS
Low Risk

Scissor-tailed Flycatcher

———

p. 181

SCIENTIFIC NAME
Tyrannus forficatus

FAMILY
Tyrannidae (Tyrant-flycatchers)

DISTRIBUTION
North America

HABITAT
Open woodland

MIGRATION
Yes

SIZE
38 cm / 15 inches

CONSERVATION STATUS
Low risk

Shaft-tailed Whydah

———

p. 198

SCIENTIFIC NAME
Vidua regia

FAMILY
Viduidae (Whydahs and Indigobirds)

DISTRIBUTION
Africa

HABITAT
Grassland

MIGRATION
No

SIZE
11–27 cm / 4¼–10½ inches

CONSERVATION STATUS
Low risk

Sharp-shinned Hawk

p. 201

SCIENTIFIC NAME
Accipiter striatus

FAMILY
Accipitridae (Hawks and Eagles)

DISTRIBUTION
North America

HABITAT
Forest

MIGRATION
Yes

SIZE
30 cm / 12 inches

CONSERVATION STATUS
Low risk

Southern Brown Kiwi

p. 229

SCIENTIFIC NAME
Apteryx australis

FAMILY
Apterygidae (Kiwis)

DISTRIBUTION
New Zealand

HABITAT
Forest

MIGRATION
No

SIZE
50 cm / 20 inches

CONSERVATION STATUS
Vulnerable

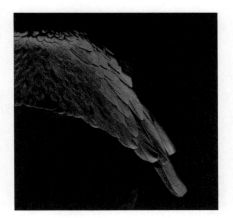

Southern Masked Weaver

—

pp. 176–77

SCIENTIFIC NAME
Ploceus velatus

FAMILY
Ploceidae (Weavers)

DISTRIBUTION
Africa

HABITAT
Grassland

MIGRATION
Yes

SIZE
14 cm / 5 ½ inches

CONSERVATION STATUS
Low risk

Superb Bird-of-paradise

—

pp. 42–43

SCIENTIFIC NAME
Lophorina superba

FAMILY
Paradisaeidae (Birds-of-paradise)

DISTRIBUTION
New Guinea

HABITAT
Tropical Forest

MIGRATION
No

SIZE
25 cm / 10 inches

CONSERVATION STATUS
Low risk

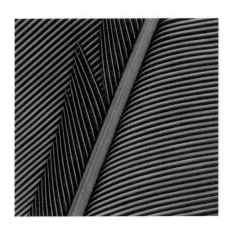

Superb
Lyrebird

———

pp. 81, 134-35, 183-84

SCIENTIFIC NAME
Menura novaehollandiae

FAMILY
Menuridae (Lyrebirds)

DISTRIBUTION
Australia

HABITAT
Forest

MIGRATION
No

SIZE
100 cm / 39 inches

CONSERVATION STATUS
Low risk

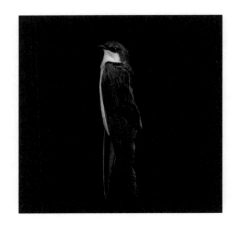

Tree
Swallow

———

p. 110

SCIENTIFIC NAME
Tachycineta bicolor

FAMILY
Hirundinidae (Swallows)

DISTRIBUTION
North America

HABITAT
Lake or Pond

MIGRATION
Yes

SIZE
14.5 cm / 5 ¾ inches

CONSERVATION STATUS
Low Risk

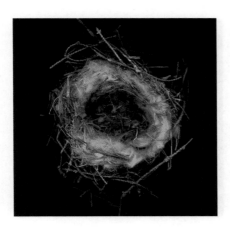

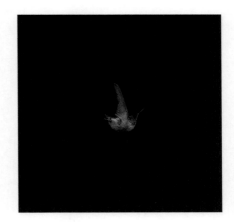

Two-barred or White-winged Crossbill

———

p. 52

SCIENTIFIC NAME
Loxia leucoptera

FAMILY
Fringillidae (Finches)

DISTRIBUTION
North America and Europe

HABITAT
Forest

MIGRATION
Irruptive

SIZE
17 cm / 6 ¾ inches

CONSERVATION STATUS
Low risk

Vervain Hummingbird

———

p. 230

SCIENTIFIC NAME
Mellisuga minima

FAMILY
Trochilidae (Hummingbirds)

DISTRIBUTION
South America

HABITAT
Forest

MIGRATION
No

SIZE
6 cm / 2 ½ inches

CONSERVATION STATUS
Low risk

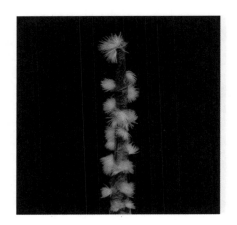

Western Crested
Guineafowl

———

pp. 174, 203

SCIENTIFIC NAME
Guttera verreauxi

FAMILY
Numididae (Guineafowl)

DISTRIBUTION
Central Africa

HABITAT
Semi-open habitats

MIGRATION
No

SIZE
70 cm / 28 inches

CONSERVATION STATUS
Low risk

White
Bellbird

———

p. 96

SCIENTIFIC NAME
Procnias albus

FAMILY
Cotingidae (Cotingas)

DISTRIBUTION
Caribbean

HABITAT
Tropical forest

MIGRATION
No

SIZE
20 cm / 8 inches

CONSERVATION STATUS
Low risk

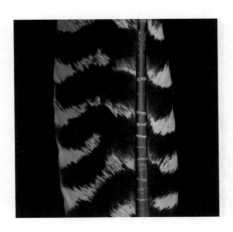

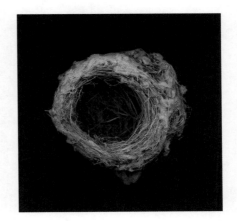

Wild
Turkey

———

p. 92

SCIENTIFIC NAME
Meleagris gallopavo

FAMILY
Meleagrididae (Turkeys)

DISTRIBUTION
North America

HABITAT
Open woodland

MIGRATION
No

SIZE
115 cm / 45 inches

CONSERVATION STATUS
Low Risk

Willow
Flycatcher

———

p. 53

SCIENTIFIC NAME
Empidonax traillii

FAMILY
Tyrannidae (Tyrant-flycatchers)

DISTRIBUTION
North America

HABITAT
Marsh

MIGRATION
Yes

SIZE
15 cm / 6 inches

CONSERVATION STATUS
Low risk

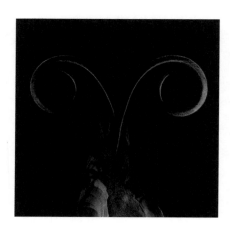

Wilson's Bird-of-paradise

———

pp. 113, 193

SCIENTIFIC NAME
Cicinnurus respublica

FAMILY
Paradisaeidae (Birds-of-paradise)

DISTRIBUTION
New Guinea

HABITAT
Tropical forest

MIGRATION
No

SIZE
21 cm / 8 ¼ inches

CONSERVATION STATUS
Near threatened

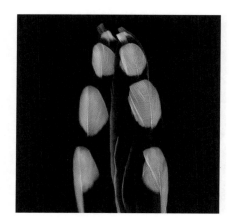

Yellow-billed Cuckoo

p. 233

SCIENTIFIC NAME
Coccyzus americanus

FAMILY
Cuculidae (Cuckoos)

DISTRIBUTION
New World

HABITAT
Open woodland

MIGRATION
Yes

SIZE
28 cm / 11 inches

CONSERVATION STATUS
Low risk

Glossary

AFTERSHAFT
Also known as afterfeather, this is a smaller feather growing from the base of the smooth, unpigmented shaft (the calamus).

BARBS
The small paired branches emanating from the rachis at an oblique angle to form the main structure of the feather vane.

BARBICELS
Minute hooklets also known as hamuli that keep the vane together by interlocking with each other.

BARBULES
Tiny, elongated branches coming off the barbs.

COVERTS
Small feathers that cover and protect the primary feathers on the wing and tail of a bird and help to smooth airflow during flight.

CRYPTIC COLOURATION
Coloration that makes animals difficult to see by providing camouflage against a background, breaking up the outlines of their body, or both.

FILOPLUMES
Very fine, hair-like feathers with only a few soft barbs near the tip.

GULAR WATTLE
A fleshy, wrinkled fold of skin, often brightly coloured, hanging from the throat (hence the term 'gular') or neck of certain birds such as chickens or turkeys, and some reptiles.

HEAD WIRE
Long modified feather used for courtship display.

INTEGUMENTARY SYSTEM
The organ system that forms a barrier to protect an organism from damage. In the case of birds, this consists of the skin and feathers.

PLUMACEOUS
Used to describe a feather without barbules or hooklets, having the shape and structure of a contour or body feather.

POLYGYNY
A pattern of mating in which a male animal has more than one female partner.

RACKETS
Elongated tail feathers with long, often bare shafts tipped by an enlarged terminal vane, found on a number of species such as hummingbirds and birds-of-paradise.

THEROPODS
A diverse group of dinosaurs which first appeared in the late Triassic period 230 million years ago. Birds evolved from theropods approximately 66 million years ago.

VANE
The flat, often curved part of the feather on either side of the rachis.

Author Biographies

Deborah Samuel was born in Vancouver, Canada. Her family moved to Toronto and then to Ireland before she was fourteen. She studied art in Ireland at Limerick College of Art and Design and then returned to Canada to study photography at Sheridan College.

Deborah was quickly recognised for her distinctive fashion photographs and portraits of celebrities, musicians and writers, such as Leonard Cohen, Margaret Atwood and Rush. Professional opportunities took her to New York and London before she settled in Los Angeles. During this time she worked for magazines such as *GQ*, *Rolling Stone*, *Esquire*, *Spin* and *Entertainment Weekly* and directed music videos for numerous record companies. Deborah's personal photography explored the pursuit of perfection in the media age. Later, her work evolved into studies of animals and nature, and in 2012 The Royal Ontario Museum hosted *Elegy*, a solo exhibition of her photographs of animal bones.

Deborah currently lives in Santa Fe, New Mexico where she keeps a studio, with a dog and two horses. She exhibits internationally and her work can be found in the collections of the Royal Ontario Museum, Winnipeg Art Museum and Santa Barbara Art Museum as well as in numerous private collections. *The Extraordinary Beauty of Birds* is her third book and follows on from *Dog* and *Pup*.

Mark Peck joined the Ornithology Department at the Royal Ontario Museum (ROM) in 1983. His present duties include: ornithology collections manager, gallery and programme development, fieldwork and ornithological research. He has been the ornithological curatorial representative for several ROM programmes and installations.

Acknowledgements

With heartfelt thanks and gratitude to The Royal Ontario Museum, Toronto for making this project possible, Mark Peck for taking me under your proverbial wing and being such a joy to work with, as well as Dave Ireland and Connie MacDonald, Kelvin Brown for your never-ending vision, Neil Peart for your beautiful words, Peter and Melanie Munk with much love and gratitude, Patti Silverstein for your tireless dedication, Linda Book for your thoughts and ever-present spirit, Wendy Fishman, Frank Penny, Ron Taft, Bob Reed and Ed Marquand for all your help.

Thank you Terry Smith, Eirini Demetelin, Colette Baron Reid, Beth Richards, Kirsten Scollie, Lorraine Samuel and all my sisters and brothers, Pam Stoynich, Debbie Taylor, Rudy Robinson, Emmanuelle Gattuso, Thierry Arditti, Hugh Syme, Kerry Knickle, Lulu Vibert, Shahed Kavousi, Alannah Banana, Katherine Carver, The Golden Girls, The Girl Camp Devotees, The Sunday Morning Coffee Crew, Sherry Tipton, Edward Fleming, Therese Martini, Barbara Skinder, Sox, Crow and Mac, Althea Gray, Howard Ottenheimer, Dr Donald Shina, Dr Susan Seedman, Joost Lammers, Dr Doug Thal, Stacie Shain, Geralyn Schell-Trimm and Louanne Abrams-Sargent, Rey Villalobos and the Villalobos Familia, Dennis Spangler, Vladymir Rogov, Larry Miller, Roger and Rilla Mulligan, The McCarthy Clan, Suzan Zeder and Gemstone Jim with love, Marty Walker, Susie and Richard Bauer, Patricia Silverman and Dick Hafner, and thank you Lorna Minz and Froukje Staal for inspiration.

Thank you to Lincoln Dexter and all at Prestel Publishing for your vision and dedication.

Thank you Dad, Mum, Helen, Graham, Mao, Jake, Lucy, Petey, Oscar, Zeus, Ginny and Pat for being the threads in this work.

© Prestel Verlag, Munich · London · New York, 2016
A member of Verlagsgruppe Random House GmbH
Neumarkter Straße 28, 81673 Munich

Front Cover: Indian Peafowl, see page 62

Prestel Publishing Ltd.
14-17 Wells Street
London W1T 3PD

Prestel Publishing
900 Broadway, Suite 603
New York, NY 10003

Library of Congress Control Number is available; British Library Cataloguing-in-
Publication Data: a catalogue record for this book is available from the British Library

Editorial direction: Lincoln Dexter
Editorial assistance: Will Westall
Copy-editing: Martina Dervis and Malcolm Imrie
Graphic design: Amy Preston and Amélie Bonhomme
Production management: Friederike Schirge
Separations: Reproline Mediateam, Munich
Printing and binding: DZS Grafik, d.o.o., Ljubljana
Paper: Tauro and Gardamatt

Verlagsgruppe Random House FSC® N001967

Printed in Slovenia

ISBN 978-3-7913-8203-6

www.prestel.com